Praise for *Picturing America's Pastime*

"I am honored that a photo of me is included in this beautiful book. Page by page, *Picturing America's Pastime* provides a glimpse into the history of the game I love, full of extraordinary images. From players on the field and fans in the stands to stars and lesser-known players from as far back as the history of the sport goes—it's all there in these pages. There's no better way to celebrate the game than pouring through this one-of-a-kind collection from the Hall of Fame's unequalled photo archive."

—Rod Carew, National Baseball Hall of Fame Class of 1991

"I met a woman named Tess in Boston who was in her nineties and joyfully recalled sitting on a box near the first row at Fenway Park in The Babe's time, and he'd hand her ice cream, then walk to the batter's box. In *Picturing America's Pastime*, I recall her, as The Babe is pictured with a girl scout. This is the history to whom the Hall of Fame is dedicated, of the lines drawn from Oscar Charleston to Henry Aaron, Minnie Miñoso to El Duque, our grandfathers to all of us, a reminder that baseball is the arboretum where stands our family trees."

—Peter Gammons, 2004 BBWAA Career Excellence Award Winner

"My favorite thing about the Hall of Fame is the way it brings baseball to life on any day of any year. And I got that same feeling as I turned the pages of *Picturing America's Pastime*. You can pick literally any page and transport yourself back to another place, another time, to conjure up a memory, to look into the eyes of a forgotten legend or to imagine what it must have been like to watch someone like Warren Spahn pitch. What a beautiful, evocative book."

—Jayson Stark, 2019 BBWAA Career Excellence Award Winner
and senior baseball writer for *The Athletic*

"The fabulous photographic assets of the Baseball Hall of Fame are on display gorgeously, if teasingly, in *Picturing America's Pastime*. Only a visit to the Hall's archives will confirm that there is, indeed, more. This dazzling book revives for me, and provides for the reader, the thrill of discovering the unexpected."

—John Thorn, Official Historian of Major League Baseball

PICTURING AMERICA'S PASTIME

PICTURING AMERICA'S PASTIME

Historic Photography from the Baseball Hall of Fame Archives

NATIONAL
★ ★ ★
BASEBALL

HALL OF FAME

Cover Design: Elina Diaz
Cover Photo/illustration: National Baseball Hall of Fame and Museum
Layout & Design: Elina Diaz

For permission requests, please contact the publisher at:
Mango Publishing Group
2850 S Douglas Road, 2nd Floor
Coral Gables, FL 33134 USA
info@mango.bz

For special orders, quantity sales, course adoptions and corporate sales, please email the publisher at sales@mango.bz. For trade and wholesale sales, please contact Ingram Publisher Services at customer.service@ingramcontent.com or +1.800.509.4887.

Picturing America's Pastime: Historic Photography from the Baseball Hall of Fame Archives

Library of Congress Cataloging-in-Publication number: 2021933916
ISBN: (print) 978-1-64250-533-7, (ebook) 978-1-64250-534-4
BISAC category code: SPO003030, SPORTS & RECREATION / Baseball / History

Printed in the United States of America

This volume is dedicated to those who made it possible: the generous individuals who, for over eight decades, have donated baseball photographs to our institution, and the myriad men, women, and children who have taken (and thankfully continue to take) photographs picturing America's pastime.

Foreword

by Randy Johnson, National Baseball Hall of Fame Class of 2015

When I was on the pitcher's mound, especially later in my career, I always had a plan for how I would work to the hitter. As a starter, you know when you're going to pitch. You know the team you're facing. You know the lineup. And you have a preconceived idea about how each at-bat will play out. Then the game begins, and all that could change, depending upon what's going on. That's when you get creative.

I've been retired from baseball for a decade. But that planning, that opportunity—and especially that creativity—are still in play for me. Only now, it's through photography.

My love of cameras and photos goes back to my high school days. I went to USC to play baseball—but also to study photojournalism. Once there, the doors started opening. I shot for *The Daily Trojan* at USC, giving me a bigger, broader canvas for pictures. Concerts, events, landscapes—they were all there in Los Angeles. It took me to the next level as a photographer.

It's a process, just like baseball...just like anything. You have to understand how to pitch before you can be successful. Photography is no different.

I pitched in the major leagues for 22 seasons. I was photographed every day I went to work. But I was so close to it that I never took the opportunity to use my own camera in that context. I might look back now and regret it a little bit, but my photography took a back seat for many years while I was playing baseball.

I was always learning my craft when I played. Now, I'm learning all over again. And thanks to the people I've met during my career, I've had the opportunity to learn from some of the best photographers around.

These days, I travel the world and look for iconic landscapes, like the Leaning Tower of Pisa; the Coliseum in Rome, at four thirty or five in the evening when the sun is setting; or the Eiffel Tower, lying on my back and shooting upward towards the top.

I take joy in shooting concerts, too. Since I retired, I am able to work in many places where I had no access when I was in high school or college. Back then, I might go

to a concert and be able to shoot one or two songs. Now, it's all-access—and that means everything.

Access allows creativity, and creativity allows you to explore different options. It's like pitching: on the mound, the "access" is your ability to throw a variety of pitches. That access opens up your creative process to explore different ways to achieve the goal, which is recording an out.

The access in photography allows you to capture an image that others may have not seen.

You'll see it in the coming pages—the best photographers not only have the access, but they also see what most do not. They dare to be different in their approach, their vision, and even their interaction.

When the person behind the camera connects with their subjects, they get the unforgettable picture. And thousands of those timeless images are preserved in the National Baseball Hall of Fame's unparalleled collection—many of which were shot by artists who literally helped create the genre.

Baseball and the camera came into being at roughly the same moment in time, and the way they have evolved together has kept fans cheering for more than a century. I have been on both sides of the shutter, and they are equally intriguing.

Acknowledgments

Thanks goes to the entire staff of the National Baseball Hall of Fame and Museum, with special thanks to the following individuals for their invaluable efforts in coordinating, researching, writing, editing, and preparing the text and photographs included in this book: Gabrielle Augustine, Kelli Bogan, Bill Francis, Sean Gahagan, John Horne, Jeff Jones, Cassidy Lent, Scot Mondore, Craig Muder, John Odell, Mary Quinn, Nicole Retzler, Jon Shestakofsky, Tom Shieber, and Erik Strohl.

Additionally, we thank Hall of Famer Randy Johnson, as well as Jane Kinney Denning, Elina Diaz, Brenda Knight, Lisa McGuinness, Chris McKenney, and Robin Miller of Mango Publishing, and Valerie Tomaselli of MTM Publishing.

The National Baseball Hall of Fame and Museum does not purchase artifacts, ephemera, photographs, or other items related to baseball, instead accepting only donations from those who love our National Pastime and want to share its history. Our thanks goes to the following donors whose photographs are included in this book and are housed in the Dean O. Cochran Jr. Photograph Archives: Jack Allman, Dr. Philip W. Askenase, Edna Bancroft, Shirley Marion Cobb Beckworth, Cirus A. Bennett, Mark Twain Berlow, Norman D. Bradley, Jonathan Busser, Aubrey J. Carter, *Chicago Today*, Ethel Sommer Clarke, Dottie Collins, Eddie Collins, Emily Jane Collins, Peter S. Craig, Joe Cronin, The Department of the Army, Charles Doyle, John Doyle, The Drackett Products Company, Christopher Ellithorp, The Estate of Frank Frisch, Darrell C. Gardner, Jim Gates, Randall Gibson, Greater Ashland Foundation, Stella Groh, Bob Hahn, Ed Hamman, Joseph Harper, George Woodman Hilton, Amy Holder, Michael Joseph Hornung, Esserine M. Huggins, Larry Hughes, Travis Jackson, Norman Joss, The Kitsuse Family, Edith Kopp, Judith A. Levinthal, *Look*, Brad Mangin, James A. McKinnis, Doug McWilliams, Miss Hall's School, Robert E. Moren, The National League, *New York World-Telegram*, Brian J. Nielsen, Dick Perez, Father Robert G. Quinn O.P., David Leroy Reeves, Edith F. Rhoads, John Rogers, Jack Rutkowski, Tom and Angela Sarro, Don Sparks, The Harry M. Stevens Collection, Samuel Stratton, Dorothy Crandall Sweet, Rick Swig, *Times-Union Democrat*, Ron Vesely, José Villegas, Bill Wambsganss, War Department (Bureau of Public Relations), Kent Whitaker and family, Roy Willits, Warren T. Windle, and Renae Youngberg.

Introduction

They are microscopic crystals of silver salts, bonded to cellulose nitrate, cellulose acetate or even glass. Chemically, they react to light and leave behind a depiction. Sometimes, they are merely dots on paper—so small that our eyes mistake them for one figure. These days, many are nothing more than digital codes that must be translated by a computer to give them any meaning.

They are called photographs, pictures, and snapshots. And yet, they are so much more: these images are who we are.

For more than 150 years, photography has been a living miracle—the culmination of dreams that have captivated people for as long as eyes have seen. Frenchman Nicéphore Niépce is often credited with the production of the first photograph in the late 1820s. Around that same time—across the Atlantic Ocean—America was beginning its love affair with baseball.

Throughout the 19th century, photography and baseball became inextricably intertwined, each fueling interest in the other. Two centuries later, this book pays tribute to that confluence.

The National Baseball Hall of Fame and Museum's "Picturing America's Pastime" exhibit is a glimpse at our exquisite baseball photography collection. Built on the shoulders of legendary photojournalists, amateur shutterbugs, and countless unnamed individuals who wielded their cameras to capture images of the National Pastime, the Hall of Fame's collection includes approximately 350,000 unique images preserved through negatives, photographs, slides, and digital images.

The introduction of two technologies—photography and newspaper printing of photos—dawned as organized baseball was born. By the beginning of the 20th century, the American public's thirst for baseball could only be quenched by mass media.

With motion pictures in their earliest stages of development and television as nothing more than a pipe dream, still photography was the only medium that could deliver player images to fans. Newspapers capitalized on this demand, creating the template

for modern sports departments—with multiple writers at the metro dailies assigned to the baseball beat.

Soon, photographers specializing in portraits and action shots had a burgeoning market for their product. And as wire services established processes by which photographs could be transmitted around the country and the world, the images of ballplayers living on one coast could quickly be seen on the other.

Even the advent of movies, radio, and television failed to stem the demand for still images. And as cameras became more affordable, the subject of baseball became more popular.

For the first half of the 20th century, baseball was more than just the National Pastime. Playing and watching the game was likely the single biggest form of recreation in the United States. Thousands of amateur teams—representing businesses, social clubs, and civic organizations—soon found themselves being seen through the photographer's lens. And as youth baseball spread throughout the land, team photos earned prominent places on fireplace mantles and graced the pages of now-defunct town newspapers.

The Museum regularly receives inquiries from folks who have discovered an image of a long-forgotten squad, lacking names or dates to complete the puzzle. But the pictured players have earned a measure of immortality—thanks to baseball and the click of a shutter.

Picturing America's Pastime presents images from three different centuries with the goal of illustrating a body of art that features most every genre of baseball photography. This volume includes famous photos of Hall of Fame legends, anonymous faces that capture the spirit of the game, and everything in between.

Take Babe Ruth—quite possibly the game's most photographed figure. On the pages that follow, his iconic left-handed swing is captured on June 14, 1921, as he watches a home run that traveled an estimated 470 feet. But the image contains much more: Ruth's powerful hands, his classic follow-through, the Polo Grounds' stands teeming with thousands of fans, and even an advertisement for the Hotel Commodore, which had opened just two years earlier and remains standing over a century later.

Like so many photos in the Hall of Fame collection, this one had the ability to stop time. No matter the changes that were to come, this moment was forever preserved.

And when time stops in a photo, the image captures the intended subject as well as the unintended surroundings. Bill Veeck, who loved the game so much that he often left the owner's box to sit in the stands, was photographed at Borchert Field in Milwaukee in 1943, when he owned the Brewers of the American Association. Veeck is surrounded by fans, many of whom would likely never learn that he would be elected to the Hall of Fame in 1991.

For Veeck himself, the photo captured him prior to his service in the United States Marines, during which he lost a leg in an artillery accident. Borchert Field was demolished in 1953 when the Boston Braves moved to Milwaukee and into County Stadium. The life span of ballparks has decreased throughout the decades as the game's popularity has soared, leaving photographs as the only evidence of the most physical connection between a team and its fans.

On September 16, 2000, 41,248 fans at Enron Field saw their Astros score a run in the bottom of the 10th inning to defeat the Pirates 10-9. Photographer James McKinnis captured the action in the first inning, as Pittsburgh's John Vander Wal batted against José Lima with Brian Giles on second base. Though the photo is in black and white, we can still "see" the green outfield grass, including that of Tal's Hill in center field. A feature that harkened back to older ballparks, the rise was removed in 2017 due to player safety concerns. But McKinnis' photo preserves the memories.

Then there's the portrait of the Peddie Institute team of 1891. This college prep school in Mercer County, New Jersey—not far from Princeton University—endures to this day. Its baseball team from 130 years ago also lives on through this photo, though the players' names have been lost to history.

Strewn about the scene are young men wearing a variety of uniform styles (collared and turtleneck shirts, striped caps, and decorative ties), easily recognizable tools of the game (bats and a ball), and antiquated equipment (high top shoes, a rudimentary catcher's mitt, and an archaic mask). If this hodgepodge of players had been told their legacy would live to see the 21st century, they probably would not have believed it. But their connection to our timeless National Pastime made it so.

The heroic men who played in the Negro leagues would probably never have imagined how strong their legacy remains—thanks in part to thousands of surviving photographs. A 1936 photo of the powerful Pittsburgh Crawfords team shows the players kneeling in front of a team bus outside of Greenlee Field. Future Hall of Famers Cool Papa Bell,

Oscar Charleston, Bill Foster, Josh Gibson, Judy Johnson, and Satchel Paige all played for the Crawfords that season. It is not hyperbole to suggest that they would have given the World Series champion New York Yankees a run for the title if they had been allowed to compete alongside the white ballplayers.

Following Jackie Robinson's historic rookie season in 1947, the game diversified. The photographers of the day—like *Look* magazine's Robert Lerner—documented the changing face of the game. Lerner's portrait of White Sox star Orestes "Minnie" Miñoso portrays the contrasts of the times.

Set against the backdrop of Comiskey Park on August 29, 1951, Miñoso wears a glove that appears to have seen better days. And yet Miñoso was just starting a big league career that would span five decades and see him consistently bat over .300. With his 1949 American League debut, he became the first dark-skinned Latin American player to appear in what had been the all-white major leagues.

Lerner, meanwhile, is just one of dozens of famous photographers whose work is preserved in the Museum's collection.

Charles M. Conlon, the celebrated father of the art of baseball imagery, began his career in newspapers as a wordsmith before turning his hobby of landscape photography into a career. His era spanned from the days of glass-plate negatives to those of film, and he produced in excess of 30,000 images over five decades of capturing images on the ball field. Our knowledge of the look of many players from the early 20th century is directly attributable to Conlon's work.

The same can be said for Carl Horner, whose portraits of early 20th century players turned up on hundreds of the day's baseball cards—including the sport's most sought-after collectible, the T206 Honus Wagner from the American Tobacco Company. An immigrant from Sweden who set up a photo studio in Boston, Horner had access to players from both the American and National Leagues and established a reputation for finely detailed work.

Seventy-plus years later, Doug McWilliams became the new Carl Horner—with his work, if not his name, familiar to millions of fans. A Bay Area native, McWilliams labored as a corporate photographer before following his love of baseball into a new career. After producing a portrait of Athletics star pitcher Vida Blue for a promotional postcard in 1971, McWilliams was hired by the Topps gum company to travel to spring training in Arizona and shoot portraits for baseball cards. His brilliant use of color

and impeccable mastery of light can be seen in each of the many thousands of player photographs he took. If you have ever held a baseball card from the 1970s in your hand, you have likely admired McWilliams' work.

The names of the players and photographers in this book represent but a fraction of the total depth of the Hall of Fame's collection. Baseball has permeated American society for nearly 200 years, and for most of that time, our game has been documented by photographers at every level. Thousands of images in our archives are of teams and players that survive only in anonymous form—captured in a moment frozen in time.

Baseball gave them a sense of pride and accomplishment. Photographs gave them immortality.

This book honors the spirit of both.

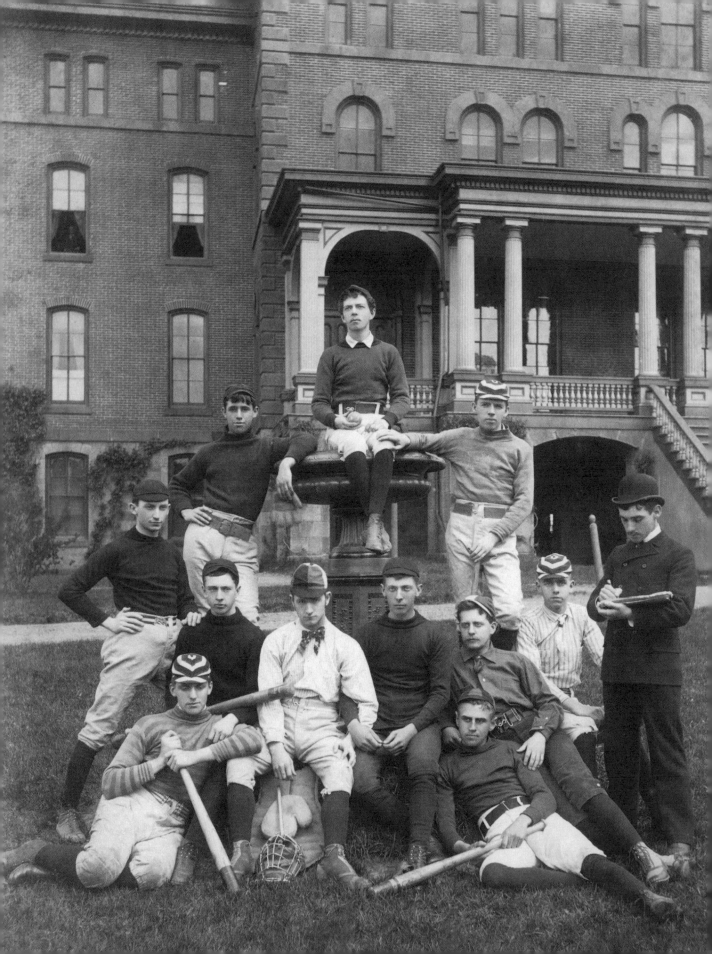

"In the game played May 2 with Freehold Military Institute at Freehold, our boys had an easy time of it. It was thought they would shut Freehold out altogether, and likely could have done so, but under the circumstances, they then thought it best to allow them to run up an almost equal score if they wished to part as friends."

—*Peddie Chronicle*, June 1891

Members of the baseball team at Peddie Institute, a private boarding school in Hightstown, New Jersey, gather for a group photograph just days after the final game of their 1891 season. As seen in front of Wilson Hall, the school's main building, the mismatched uniforms and mélange of poses suggest a ragtag collection of high schoolers, yet the expressive faces of the young men (save that of the scorekeeper, jotting notes in his book) exude a quiet confidence.

Photograph by John C. Sunderlin

"When working with the camera,
I am interested in color as a sensation,
as it is seen by the eye."

—Photographer Arthur Rothstein, 1963

Boston Braves pitching ace Warren Spahn displays his trademark high leg kick during spring training in Bradenton, Florida, in March of 1952. The motion, taught to Spahn by his father, helped the young southpaw deceive hitters, the ball seeming to come out of his uniform rather than his hand. Using the strange but fluid delivery throughout his 21-year big league career, Spahn won 363 games, the most ever by a left-handed pitcher.

Photograph by Arthur Rothstein

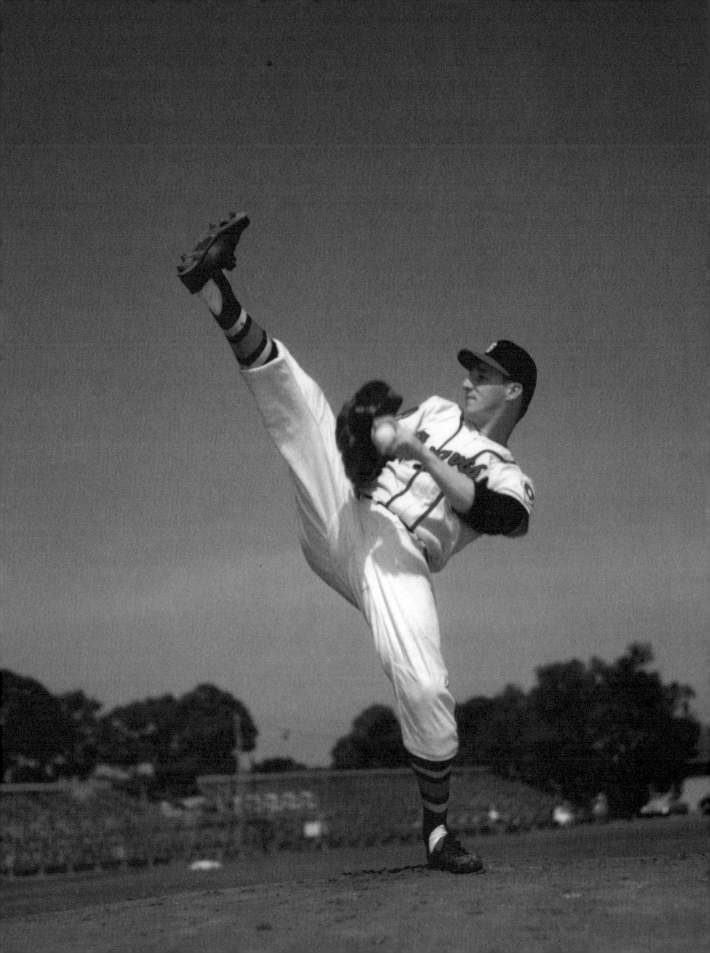

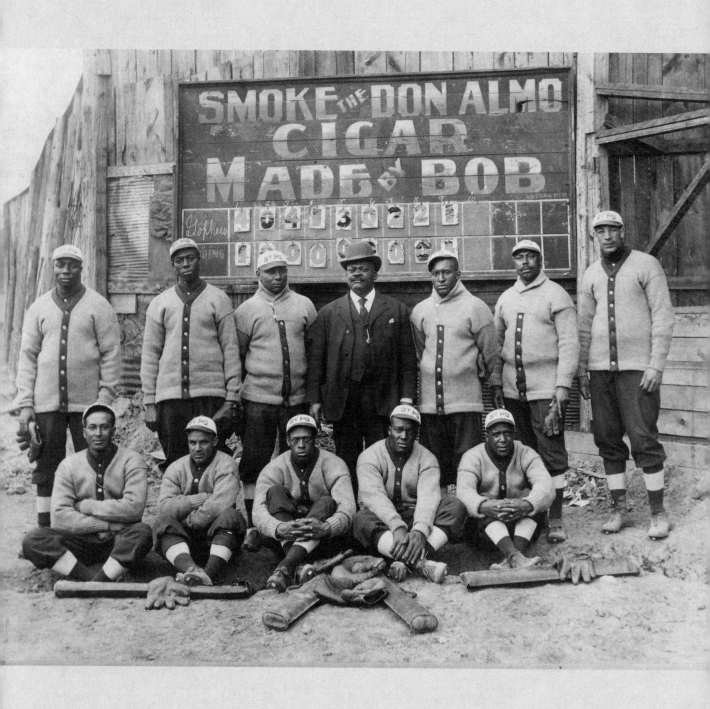

"Westerners are baseball mad.
It is baseball seven days a week....
They prefer going to a ball game
to going to church. They go by train,
trolley and auto, scores of miles.
When they return home, they are
so full of the feats of the heroes
of the diamond they can think
of nothing else."

—*Grand Forks (North Dakota) Herald*, July 15, 1911

Members of the St. Paul Gophers proudly position themselves in front of a scoreboard in Hibbing, Minnesota, May 22, 1909. Founded two years earlier and continuing for a handful of years, the Gophers were one of the country's top barnstorming Black teams. As recorded on the scoreboard, the Gophers pasted the host Hibbing club 17-2, in what the press called, "the worst drubbing Hibbing ever got."

Photographer unidentified

"Arm and wrist hitters are those
who make good. I have always hit
with my arms, and so has Lajoie.
So have all the other good hitters
I have known.... A good grip
on the bat is what drives the ball."

—Honus Wagner, 1918

In 1912, Pittsburgh Pirates legend Honus Wagner grips his bat, showing off his bulging forearms and enormous hands. How large were the Dutchman's paws? An age-old apocryphal story tells of a time when Wagner was about to field a routine ground ball when a rabbit suddenly scurried across the diamond. Wagner reached down with his massive hands, grabbed the ball and the rabbit in one fell swoop, and threw the whole kit and caboodle to first base. The runner was out by a hare.

Photograph by Charles M. Conlon

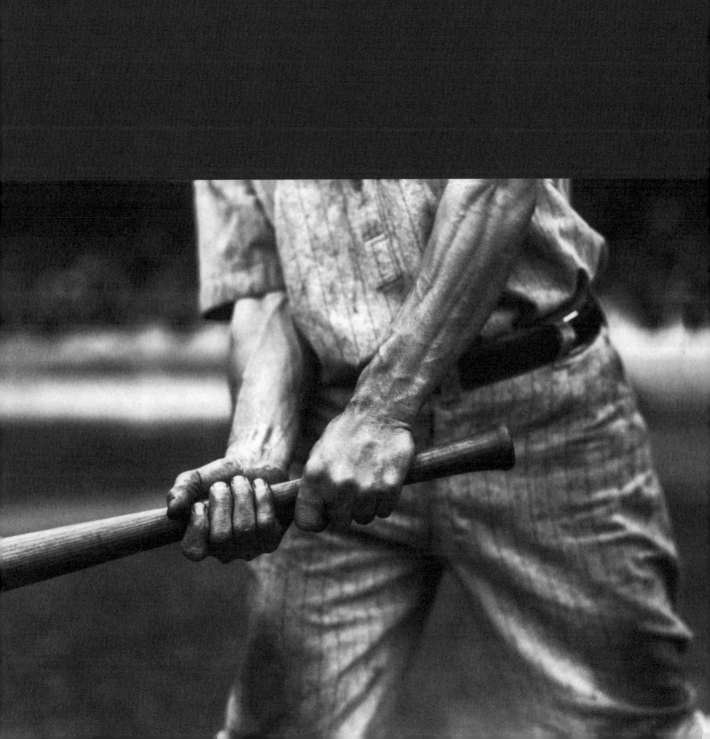

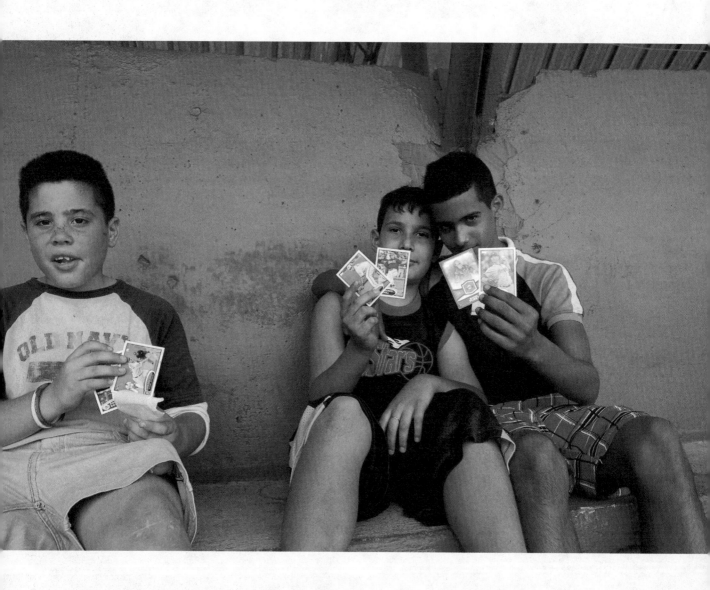

"Baseball is forever, of course, which is why little boys have been trading baseball cards since the turn of the century. The faces change, but the game remains the same."

—Author Angus Garber III, *Baseball Legends: The Greatest Players, Best Games,* and *Magical Moments—Then and Now,* 1989

A trio of boys in the dugout at Estadio Nelson Fernández in San José de las Lajas, Cuba, in 2013, show off their new major league baseball cards. Around the world or around the corner, children of all ages have long collected, pored over, and cherished baseball cards. From the tiny black-and-white cigarette premiums of the 1880s to the bubblegum-stained cardboard of the 20th century, and on through the full-color glossy images of today's (and tomorrow's) diamond stars, baseball cards unite fans across time and borders.

Photograph by Jack Rutkowski

"It seemed as if every player in the league [was] anxious to show how much he loved Joss by doing something to help in making the day a success. If all the volunteers who offered their services for the Joss day could have been accepted, we would have had enough players to furnish several teams. It merely went to show how universally Addie was esteemed by his fellow players."

—Cleveland Naps Vice President Ernest Barnard, 1911

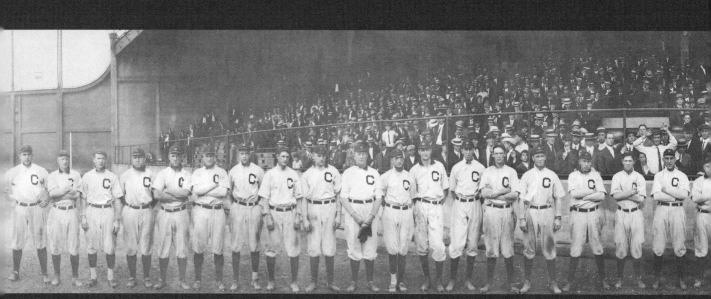

S ide by side in front of the packed grandstand at Cleveland's League Park
stand the Cleveland Naps and a team of American League stars.
That day, July 24, 1911, Cleveland hosted a benefit exhibition game to honor
their recently deceased teammate, pitcher Addie Joss, whose unexpected death
at age 31 from tubercular meningitis stunned the baseball world. In an age
before pensions and other financial safety nets, the tragedy left his widow and
children with no support, but the event raised nearly $13,000 for the family.

Panoramic Photographs

Panoramas are a perfect format for photographing baseball. The wide,
sweeping view allowed photographers to capture an entire stadium or
the members of a team (or two opposing teams) lined up side by side.
Specialized cameras equipped with long roll film moved on a clockwork
mechanism, slowly "panning" across the scene from left to right.
This allowed Cleveland outfielder Jack Graney (third from left),
captured at the beginning (left side) of the exposure, to run behind the
photographer to the other end of the line to appear a second time at the
far right.

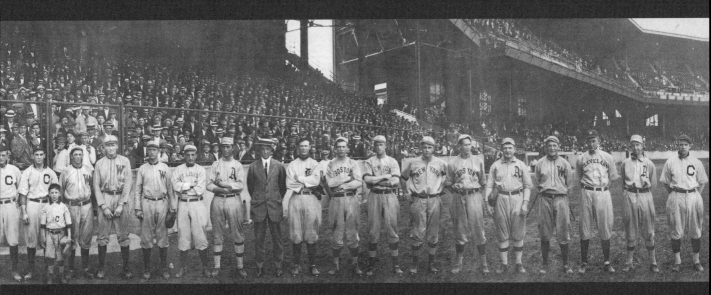

Photographer unidentified

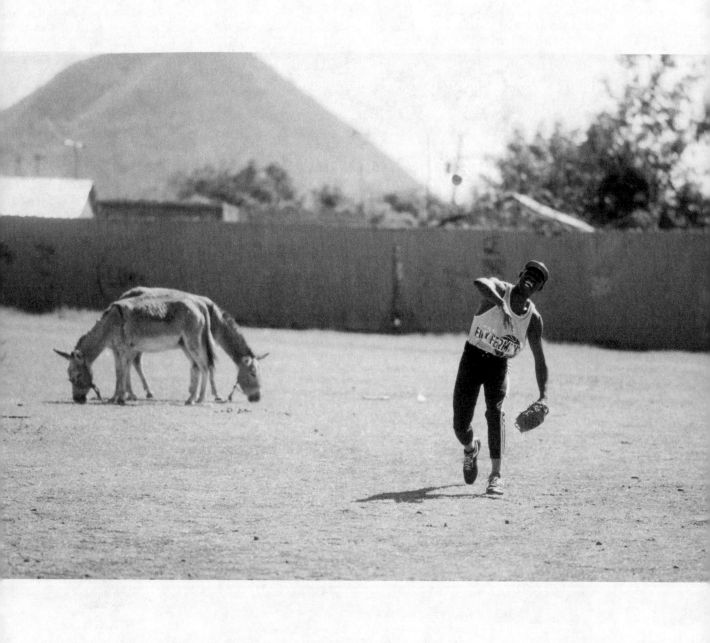

"In the Dominican Republic, baseball has a place all out of proportion to the normal one of sport in society. There is nothing comparable to it in the United States, nothing as central, as dearly held as baseball is for Dominicans."

—Author Alan M. Klein, *Sugarball*, 1991

In a Dominican Republic barrio in 1996, with twin donkeys standing in the background, a young player hurls a ball to the infield, giving his best impression of the rocket arm of Dominican superstar Vladimir Guerrero. While pitted fields such as this one may appear to be a detriment to play, they help aspiring ballplayers become sure-handed fielders, ready for most any bounce, good or bad.

Photograph by José Luis Villegas

"The Frenchman is the man to watch. He is the greatest natural batter in the world."

—Batting great Joe Jackson on Nap Lajoie, 1912

Philadelphia Athletics veteran Nap Lajoie surveys the field in 1915. The American League's first superstar, Lajoie led the league in almost every major offensive category in 1901. But he jumped his National League contract to join the Athletics that year, and a 1902 court order barred him from playing in Pennsylvania. To keep Lajoie in the league, he was transferred to Cleveland, where he was so beloved that the team soon became known simply as the "Naps."

Photograph by Charles M. Conlon

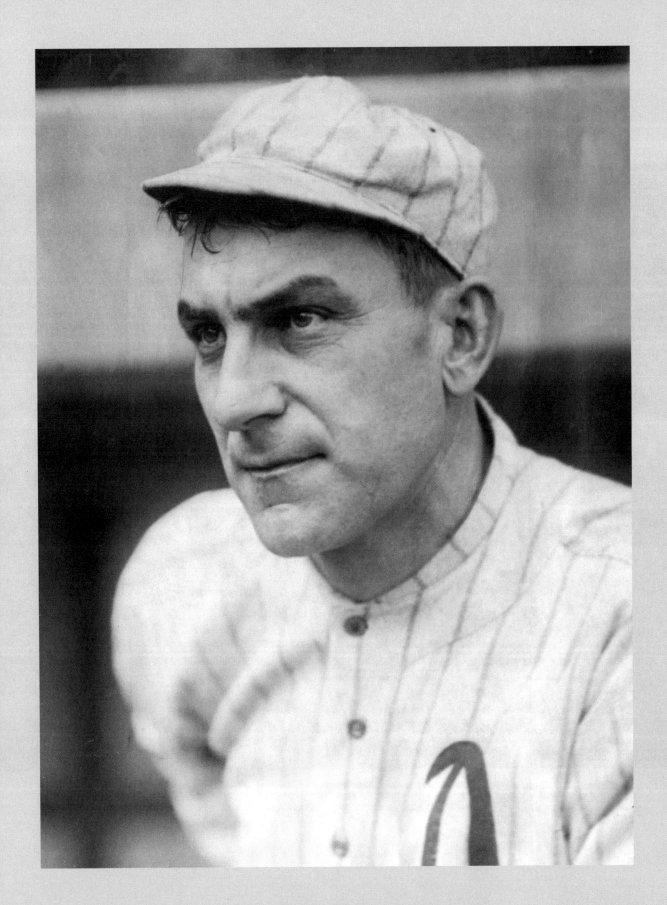

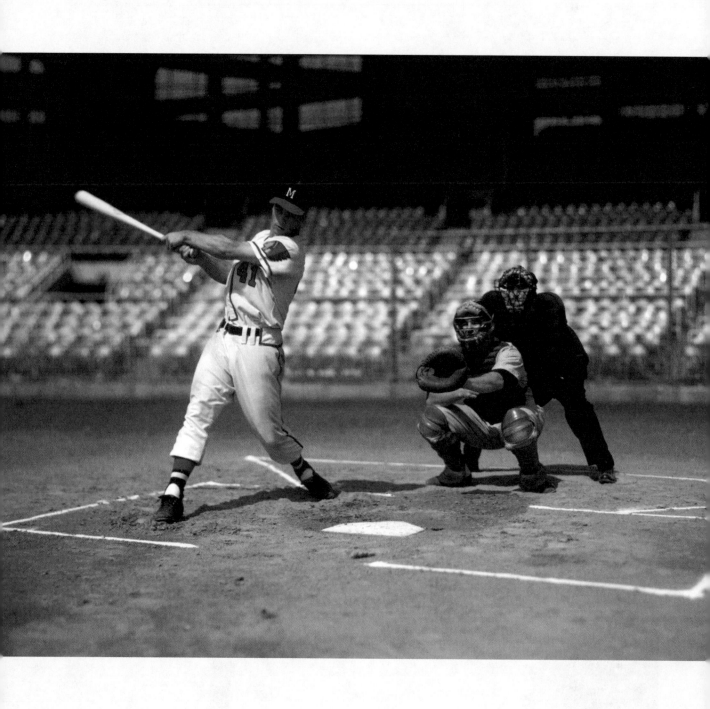

"There was Eddie Mathews, with startling good looks and thick black brows and arms like hams that stuck out from his body."

**—Sportswriter and former minor leaguer Pat Jordan,
A False Spring, 1975**

At Milwaukee's County Stadium in 1953, Eddie Mathews swings, and each part of his motion is in perfect harmony. In that season, just his second in the big leagues, Mathews was regarded as potentially the best third baseman the game had ever seen—combining power, plate discipline, and fielding prowess as few ever had. The only player ever to suit up for the Braves in Boston, Milwaukee, and Atlanta, the slugging Texan was just the seventh hitter to reach the 500-home run mark.

Photograph by Robert Lerner

"I always rated Ned Hanlon as the
greatest leader baseball ever had.
I don't believe that any man lived who
knew as much baseball as he did."

—Longtime manager Connie Mack, 1937

A hard-charging outfielder for 13 big league seasons and later a successful manager, Ned Hanlon prepares to catch a ball in 1887...or so it would seem. A close look reveals that the baseball is actually dangling by a string, not photographically captured mid-flight. Studios of the era often used this and other tricks like painted backdrops and faux grass in an effort to make up for the shortcomings of the day's photo technology, but their attempts met with only partial success.

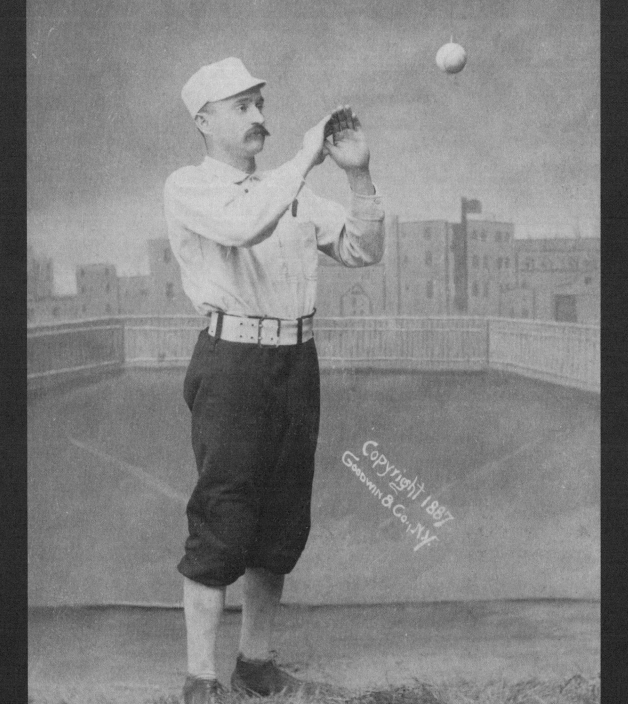

Hanlon C.F. Pittsburghs.

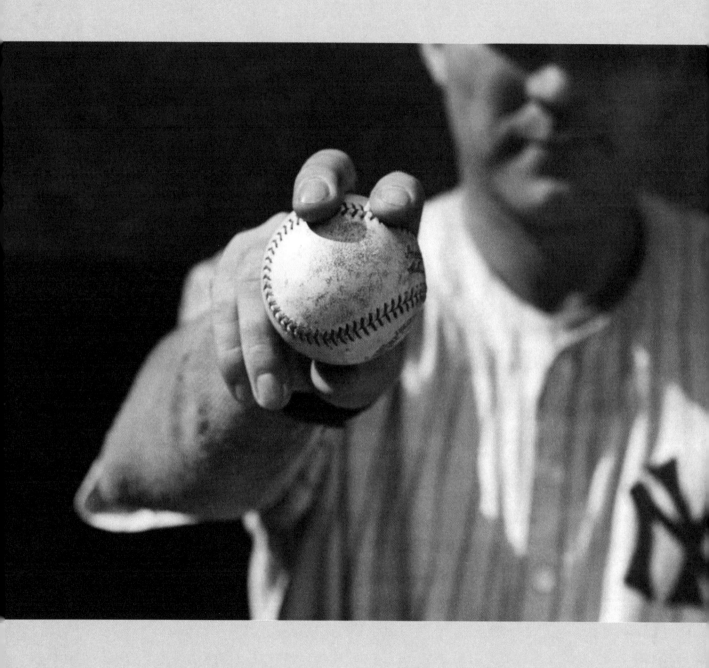

"You see, you spend a good piece
of your life gripping a baseball;
and in the end, it turns out that it was
the other way around all the time."

—Pitcher Jim Bouton, 1970

Charles Herbert "Red" Ruffing demonstrates his four-seam fastball grip, circa 1938. Two-seam fastball. Cut fastball. Roundhouse curve. Nickel curve. Circle change. Knuckleball. Slider. Sinker. Splitter. Screwball. Spitball. It seems (or shall we say "seams"?) that baseball's lexicon of pitches is a limitless list of names concocted to amuse the pitchers who throw them and befuddle the batters who try to hit them.

Photograph by William C. Greene

"The Atlantics had brought along
with them a large number
of photographs of the team,
which they purposed selling to the
baseball enthusiasts in the various
cities included in their tour."

—The Illustrated Buffalo Express, October 17, 1897

P eering through 150 years of wear and tear are the starting nine
of Brooklyn's Atlantic Base Ball Club of 1868. A powerhouse from baseball's
early days, the Atlantics also had a knack for stylish attire: their jerseys adorned
with an elegant old-English "A" and the bottoms of their blue trousers tied
with small belts to keep their cleats from catching on loose pant legs.
The innovation was soon rendered obsolete when ball clubs adopted knickers.

Photographer unidentified

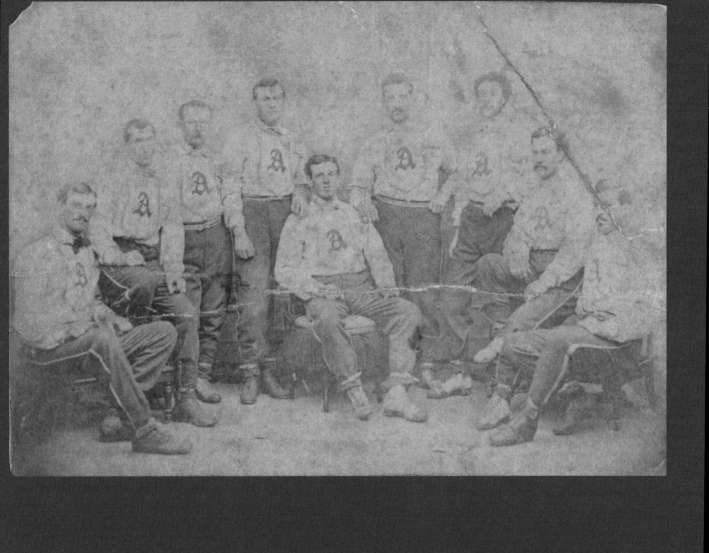

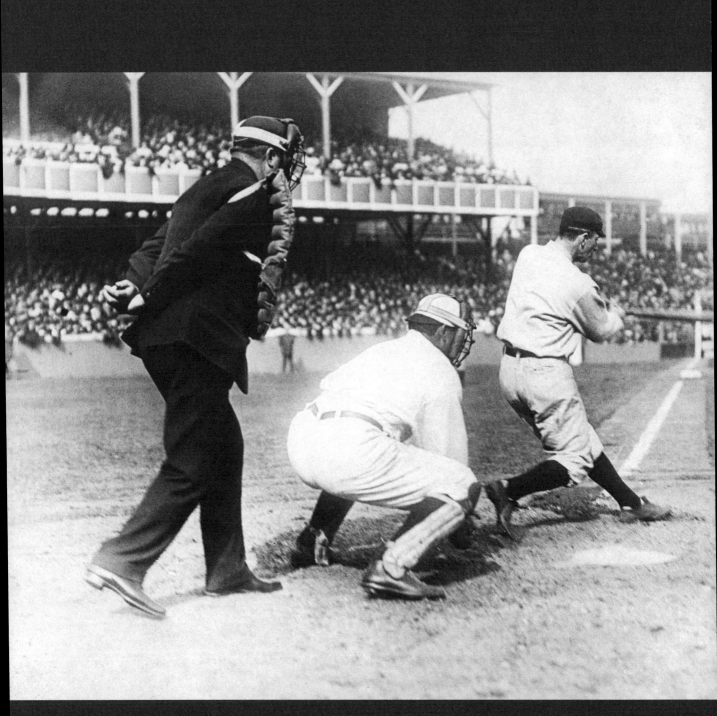

"A considerable element of danger enters into the activities of the photographer. Balls are frequently batted with such force that he is unable to get out of their way, and battered cameras and bruised bodies are not uncommon."

—Photographer Charles M. Conlon, 1911

At the Polo Grounds in 1909, a Phillies batter takes a healthy cut during a game against the home team, the New York Giants. For years, photographers occupied the field while games were underway in order to capture close-up action shots. While injuries to cameramen did sometimes occur, it was not until accidents affected the outcomes of key contests that the leagues began to bar photographers from the field during play.

Photograph by Charles M. Conlon

"When you become a player in the All-American Girls Baseball League, you have reached the highest position that a girl can attain in this sport.... We hand you this manual to help guide you in your personal appearance. We ask you to follow the rules of behavior for your own good as well as that of the future success of girls' baseball."

—A Guide for All American Girls: How to Look Better, Feel Better, Be More Popular, circa 1943

Grand Rapids Chicks players Twila Shively, Inez Voyce, Ruth Lessing, and Connie Wisniewski meet with their manager, former major leaguer Johnny Rawlings, prior to a game in 1947. The AAGPBL insisted their ballplayers do much more than just play baseball. The women were required to attend charm school, maintain feminine styles of the day, wear makeup on the field, and don uniform tunics that all but invited painful cuts and scrapes from everyday action on the diamond.

Photographer unidentified

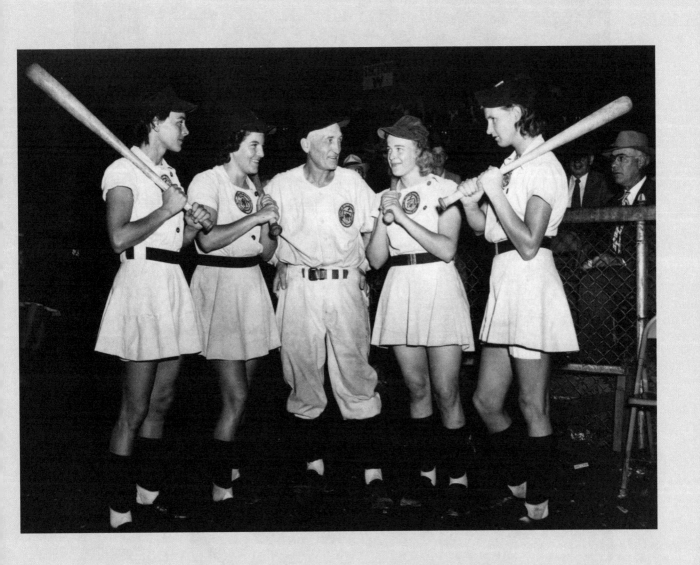

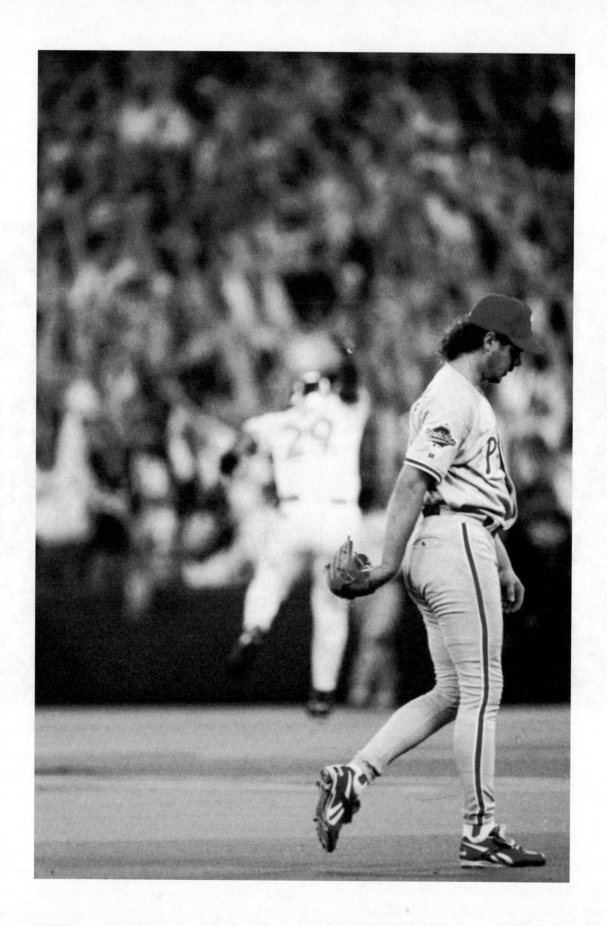

"I wanted to throw a fastball away.
I threw it down and in.
It was a bad pitch."

**—Mitch Williams after losing the final game of the
1993 World Series**

While Toronto's Joe Carter jubilantly leaps in the background, Phillies closer Mitch Williams appears deflated after surrendering a World Series-ending home run to the Blue Jays slugger on October 23, 1993. The three-run, come-from-behind homer immediately imparted legendary status to Carter, a celebrated figure in the lore of baseball north of the border. But there is a cruel balance in baseball. For every hero there is a victim; for every moment of triumph there is tragedy—a life lesson if there ever was one.

Photograph by Ron Vesely

"Young Hannegan ... imparted such a twist to the balls he pitched that it was almost impossible to hit them squarely and fairly into the field."

—*The New York Clipper*, September 22, 1860

Sitting and standing side by side in this *carte de visite* are the members of the 1866 Union Base Ball Club of Morrisania, a Bronx neighborhood located just east of today's Yankee Stadium. Club members of note included future Hall of Fame shortstop George Wright (fourth from right), arguably the greatest player of baseball's pre-professional era, and Benny Hannegan (third from right), a handsome former pitcher who puzzled batters years earlier with what may have been some of the game's first-ever curveballs, or "twists."

Photograph by William G. Grotecloss

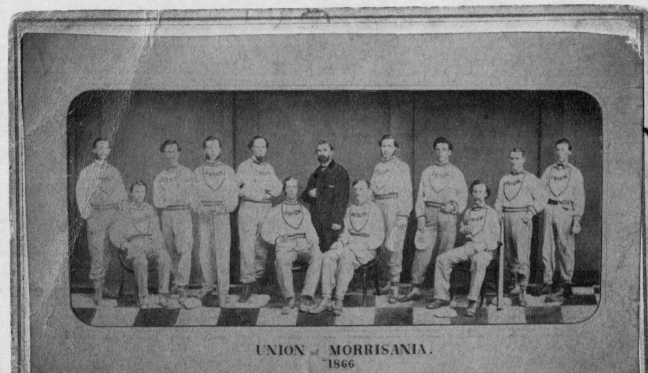

UNION of MORRISANIA.
1866

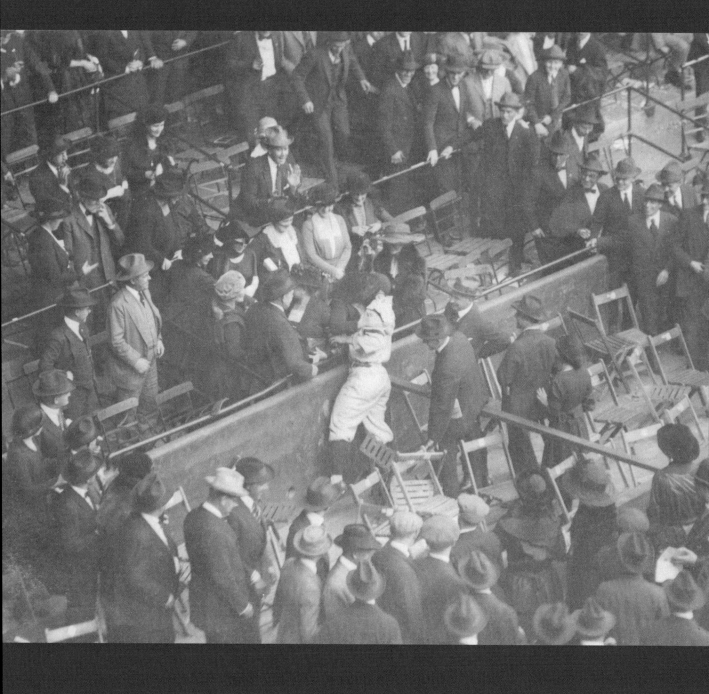

"Tris Speaker, sensing the coming outburst of enthusiasm, made a dash from center field toward the grandstand where his mother and other relatives occupied a lower tier box. His progress was slow, but once he reached the rail, he vaulted over the iron front and into his mother's arms like a small school boy."

—*The Boston Globe*, October 13, 1920

Cleveland Indians player-manager Tris Speaker turns a baseball tradition on its head, dashing into the stands to give a hug and kiss to his mother, following Cleveland's 3-0 victory over the Brooklyn Dodgers to win the 1920 World Series. It was an emotional year for the Indians, who overcame a tight three-team pennant race and the tragic midseason death of their beloved shortstop Ray Chapman to ultimately capture the World Championship.

Photograph by Byron Filkins

"I never wanted people to think that I was playing because I was the manager. My coaches told me repeatedly, 'You really need to be playing more.' I fought that a little bit. It was more difficult to me being a player-manager than the actual managing part was."

—Don Kessinger, 2003

Chicago White Sox utility player Johnny Hodapp (left) chats with player-manager Lew Fonseca in 1932. Up until the 1950s, the dual role of player-manager was not an uncommon sight. In total, more than 200 big leaguers have done double duty in this fashion. But in recent decades, combining these jobs has been a rarity, with the most recent men to accept the challenge having been Frank Robinson (1975–76), Joe Torre (1977), Don Kessinger (1979), and Pete Rose (1984–86).

Photographer unidentified

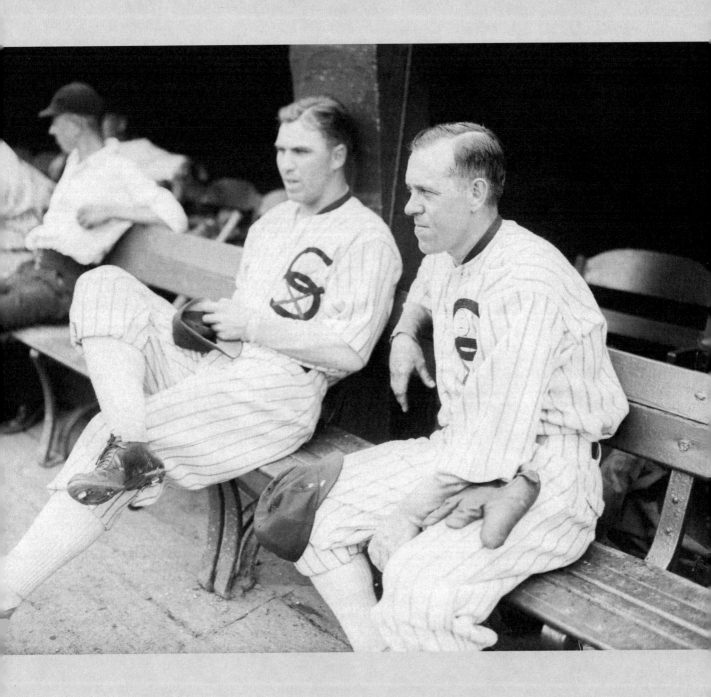

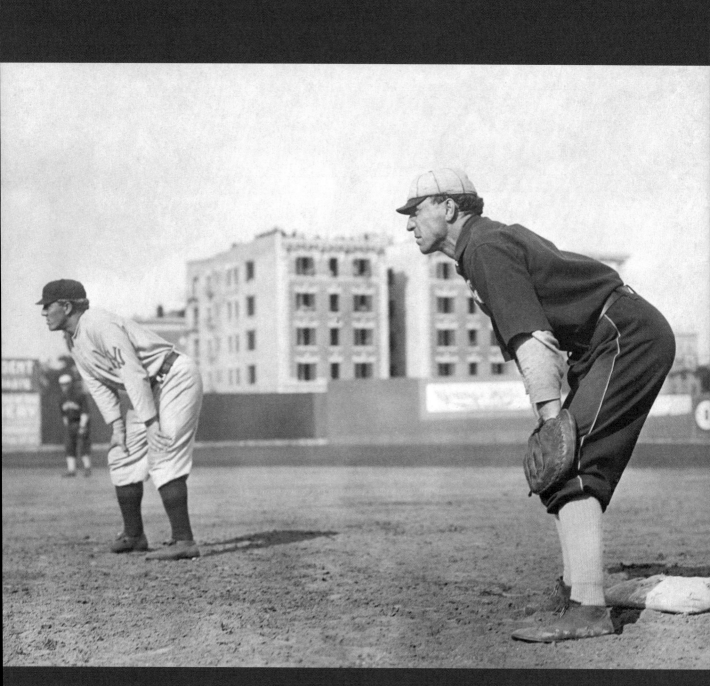

"George Davis has during the greater part of the present season played the utility role with the Chicago White Sox…. Davis has been playing the national game for so many years that nobody just remembers when he first broke in."

—*The Belvidere (Illinois) Daily Republican*, September 4, 1909

In one of his very last big league games, White Sox veteran George Davis patrols first base at New York's Hilltop Park in mid-August of 1909. A veteran of 20 seasons in the majors, Davis first broke in as a pro ball player in an era when pitchers were confined to a box (not a mound), foul balls didn't count as strikes, and games commonly featured just one umpire. But it was baseball. Still is.

"Who is responsible for the outrages upon common sense and artistic taste thrust upon the market as photographic backgrounds?"

—Artist and photographer George Hanmer Croughton, 1888

Shortstop Jack Rowe of the National League Detroit Wolverines poses in front of a painted faux-forest background, circa 1886. Early photographers used a variety of scenery to enhance their studio portraits, and a painted backdrop, floor cloth, and mounds of imitation grass were common tools of the early cameramen's trade. Still...a ballplayer batting in a woodland setting, replete with flowers and a babbling brook?

Photograph by Frank N. Tomlinson

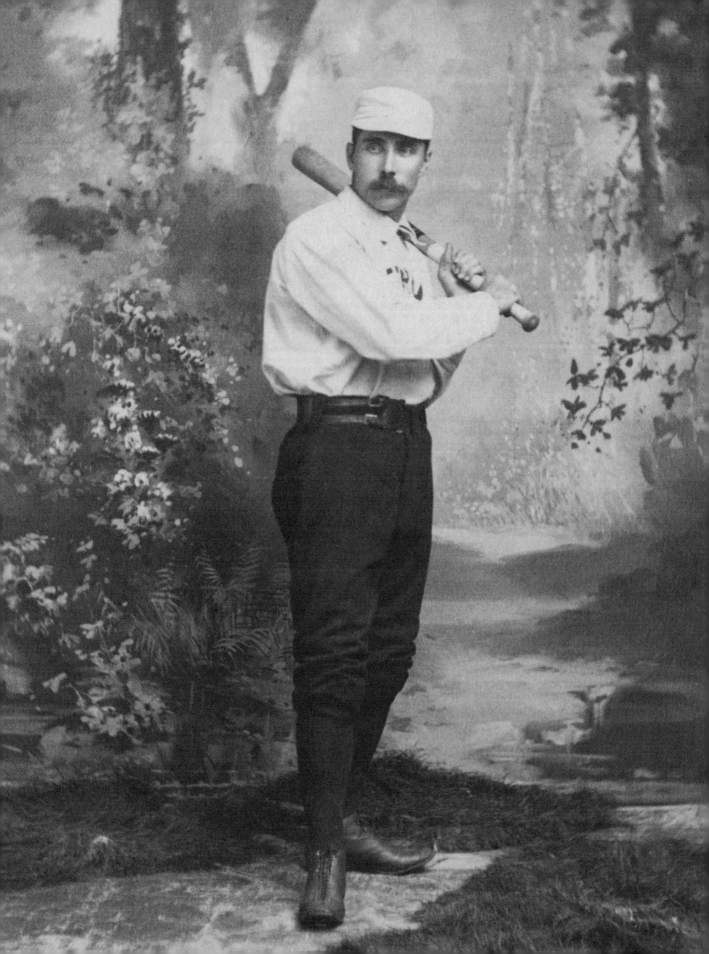

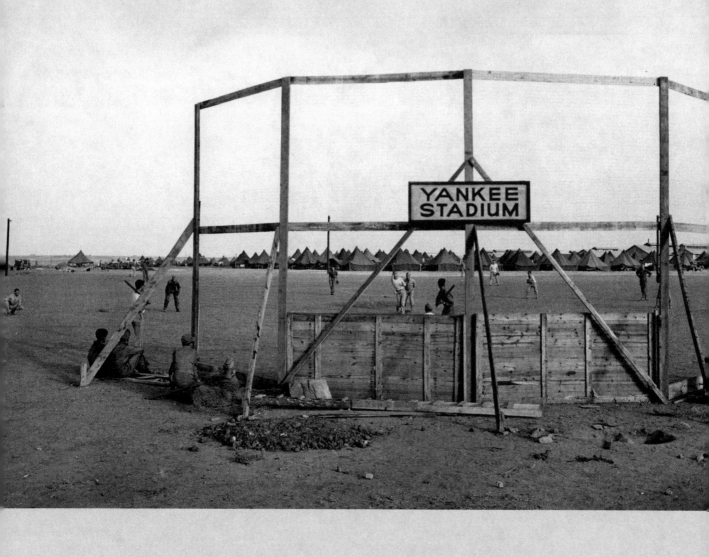

"I could sense even in the American training camps I had visited that the boys' greatest trouble was homesickness. If they were homesick in Fort Sill, Oklahoma, Fort Bragg, North Carolina, or Camp Dix, New Jersey, how would they feel in the desert of North Africa?... Baseball was one way of bringing them closer to home—and that was the most important thing I could offer them."

—Baseball comedian Al Schacht, who entertained US troops during World War II, 1945

On July 16, 1943, US soldiers stationed at Port Lyautey, Morocco, play ball at "Yankee Stadium," one of seven baseball diamonds at the North African military base. Uprooted from familiar surroundings, American forces overseas used baseball to entertain and boost the morale of homesick service members. On the home front, baseball games offered patriotic fundraising opportunities to help support the boys overseas.

Photographer unidentified

"Nowhere in collegiate circles does king baseball enjoy the popularity which is accorded the national past-time at Smith. And there's a good reason. For years Smith has put out nines that were unequaled anywhere....We are mindful of 'Bun' Hayes, who has not been away from the pen long enough for his performances to be forgotten. This twirler is now classed with some of the best deliverers."

—*The Golden Bull*, Johnson C. Smith University Yearbook, 1930

The Johnson C. Smith University varsity baseball team assembles in front of a packed grandstand at Wearn Field, Charlotte, North Carolina, prior to a game against rival Livingstone College on April 1, 1929. Upon graduation, the university's star pitcher, Bun Hayes (standing in back row with leather jacket), continued his baseball career in the Negro leagues, playing for the Baltimore Black Sox and Washington Pilots among other clubs.

Photographer unidentified

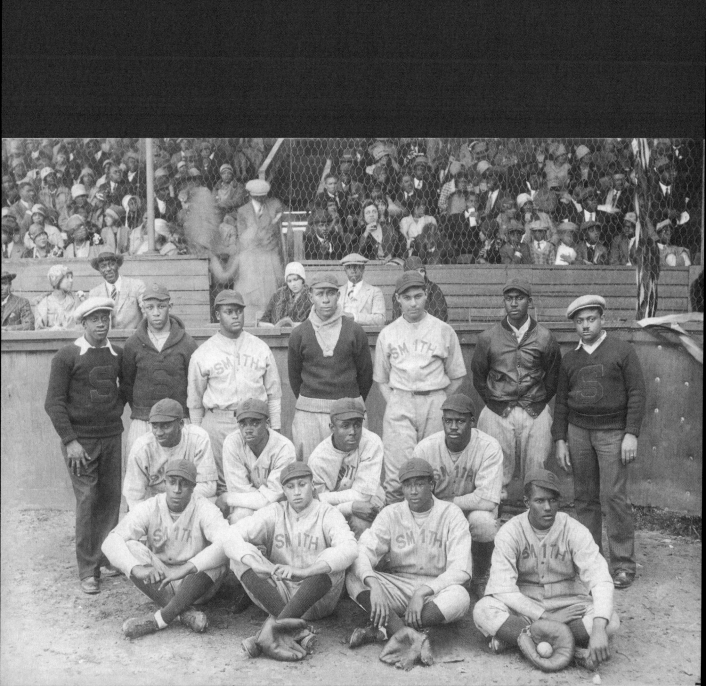

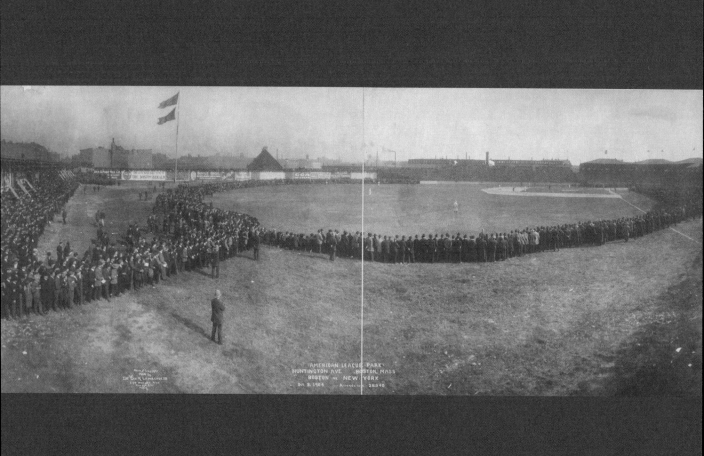

AMERICAN LEAGUE PARK
HUNTINGTON AVE. BOSTON, MASS
BOSTON vs NEW YORK
Oct 8. 1904 Attendance 28,040

61

> **"There is nothing in the constitution or playing rules of the National League which requires its victorious club to submit its championship honors to a contest with a victorious club of a minor league."**

—John T. Brush, owner of the National League champion New York Giants, 1904

Amidst a crowd that overwhelms the stands and spills into the outfield, the Boston and New York American League clubs meet for a doubleheader at the Huntington Avenue Grounds on October 8, 1904. The home club rewarded their Beantown fans with a pair of victories, wresting first place from the New Yorkers and clinching the league pennant two days later. But John Brush stood by his threat not to face what he disparaged as a "minor league" champion, and no World Series was played that year.

"The bands played, President Roosevelt turned on the lights, everybody said 'Oh!' in a highly pleased way … and 20,422 paying baseball fans got fandom's first introduction to night baseball in the big league."

—Sportswriter James T. Golden Jr., *The Cincinnati Enquirer*, May 25, 1935

Through sunglasses, a young fan watches as the Phillies take on the visiting Tampa Bay Devil Rays at Philadelphia's Citizens Bank Park on June 16, 2006. Today, the vast majority of major league games are played under the lights, but baseball established itself as our national game when it was solely a *daylight* pastime. It was not until 1930, with the country in the throes of the Great Depression, that the Kansas City Monarchs introduced night baseball to the Negro National League, and it was another five years before the white major leagues followed suit.

Photograph by Milo Stewart Jr.

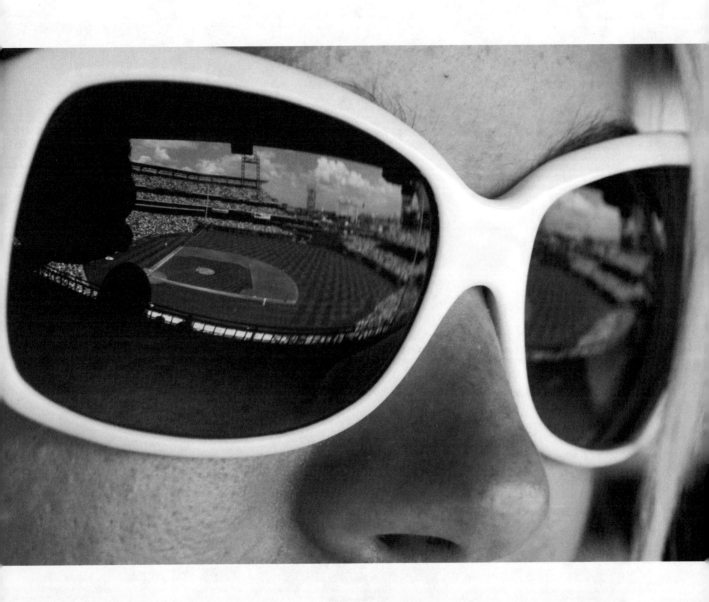

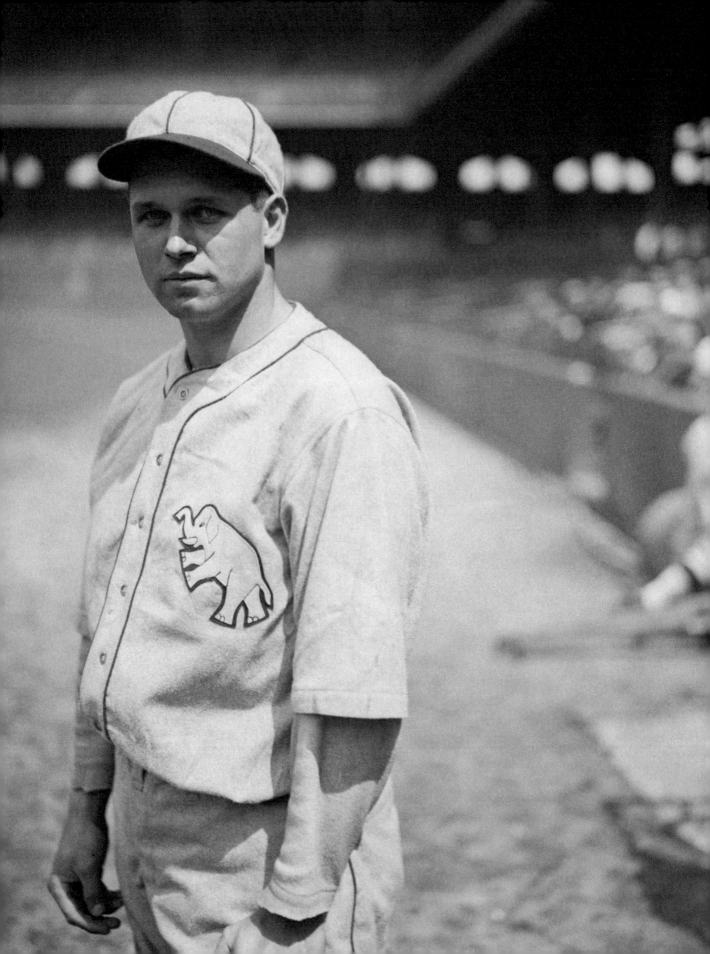

"The Philadelphia club is not making any money. It has a big white elephant on its hands."

—John McGraw, 1902

Abudding star for the Philadelphia Athletics, Jimmie Foxx stands casually near the stands at Chicago's Comiskey Park, circa 1926. The story of the rather unusual logo seen on Foxx's jersey began over two decades earlier when Giants manager John McGraw made his elephantine remark. Rather than balk at the comment, Athletics manager Connie Mack embraced it and even adorned his club's uniforms with the image of a pachyderm from 1918 through 1927.

Photographer unidentified

"With the Birmingham ball club, the only big thing we had was Satchel. Everybody in the South knew about Satchel Paige, even then. We'd have 8,000 people out—sometimes more—when he was pitching, which was something in Birmingham."

—Outfielder Jimmie Crutchfield in *Only the Ball Was White* by Robert Peterson, 1970

The sun shines brightly on pitching legend Leroy Robert "Satchel" Paige at Chicago's Comiskey Park near the end of the 1952 season. Even before Paige made his long-overdue debut in the white major leagues in 1948, his name and reputation, forged over numerous seasons in the Negro leagues, were known throughout the country. His fame followed him to the Cleveland Indians, St. Louis Browns, and Kansas City Athletics, and ballparks in those cities often sold out when he was scheduled to start.

Photograph by Robert Lerner

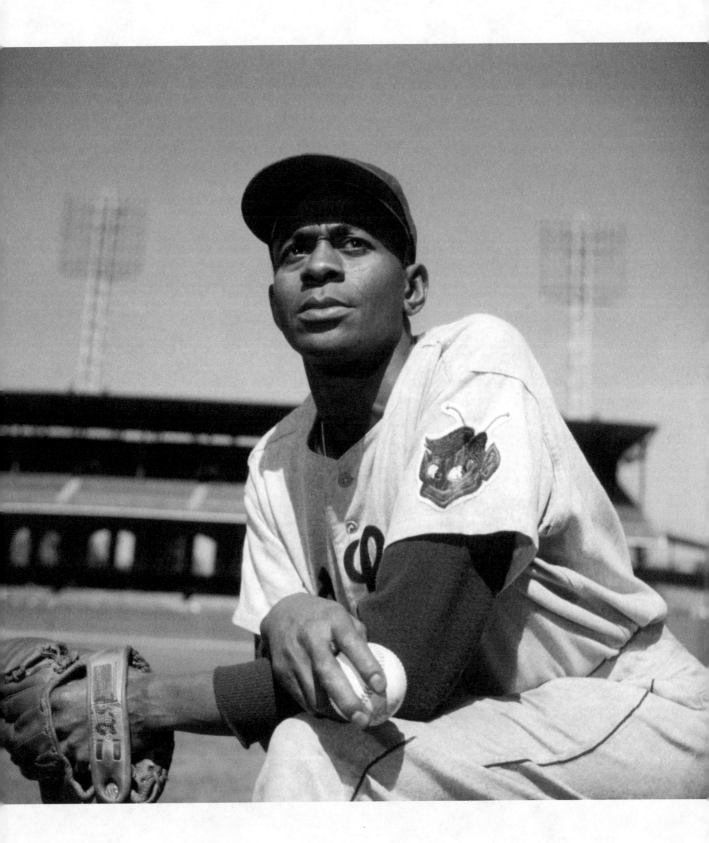

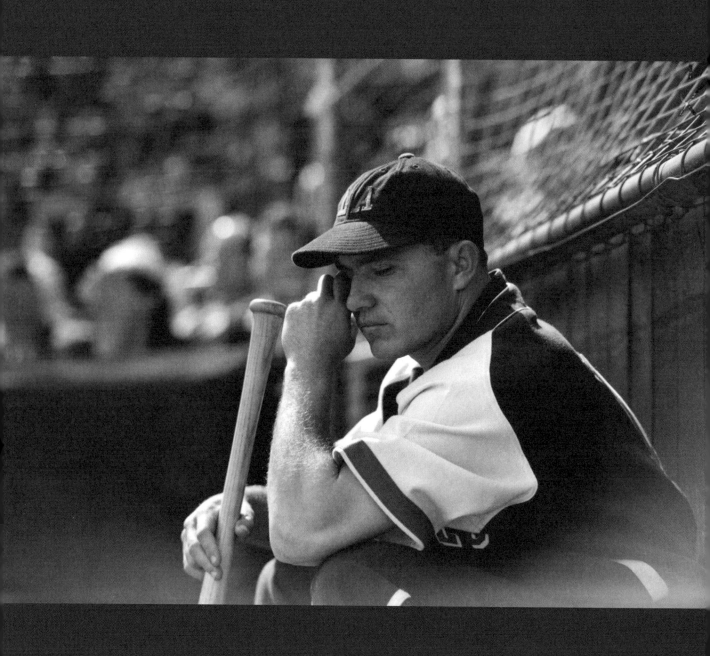

"The longer I live, the longer I realize that batting is more a mental matter than it is physical. The ability to grasp the bat, swing at the proper time, take a proper stance, all these are elemental. Batting rather is a study in psychology."

—Hitting legend Ty Cobb, 1950

Lou Novikoff, outfielder with the Pacific Coast League's Los Angeles Angels, takes a moment to focus before coming to bat at San Diego's Lane Field, circa 1940. Baseball is a team sport, and yet most every play begins with the one-on-one battle between batter and pitcher. The ability to mentally prepare for that confrontation is, and has long been, an unheralded key to the success of a hitter.

Photographer unidentified

"The public, so far as it knew of
our playing, was shocked, but in
our retired grounds, and protected
from observation even in these
grounds by sheltering trees,
we continued to play in spite
of a censorious public."

—Vassar baseball club member Sophia Foster Richardson, 1897

Wearing colorful hats and sporting their club name about their waists, the Resolutes of Vassar College gather for a team picture in front of the school's Calisthenium and Riding Academy (now Avery Hall) in 1876. With the invention of softball still a decade in the future, these young women were hardball players. Over the years, they competed against other intramural clubs with names such as Laurel, Abenakis, and Precocious. With these clubs, Vassar became the first college to offer women the chance to play baseball.

Photographer unidentified

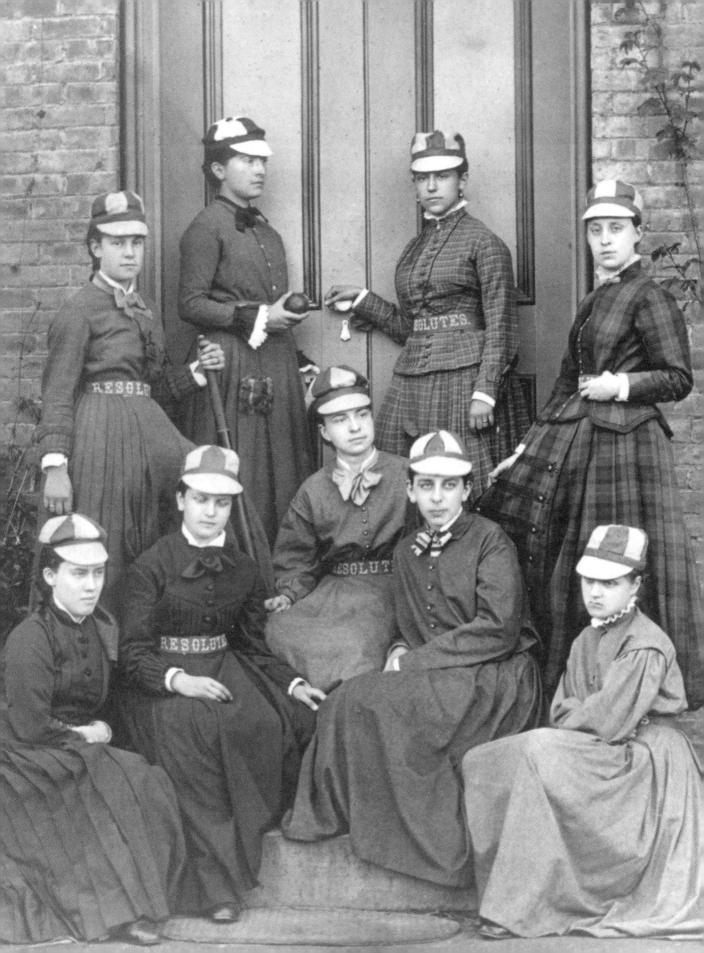

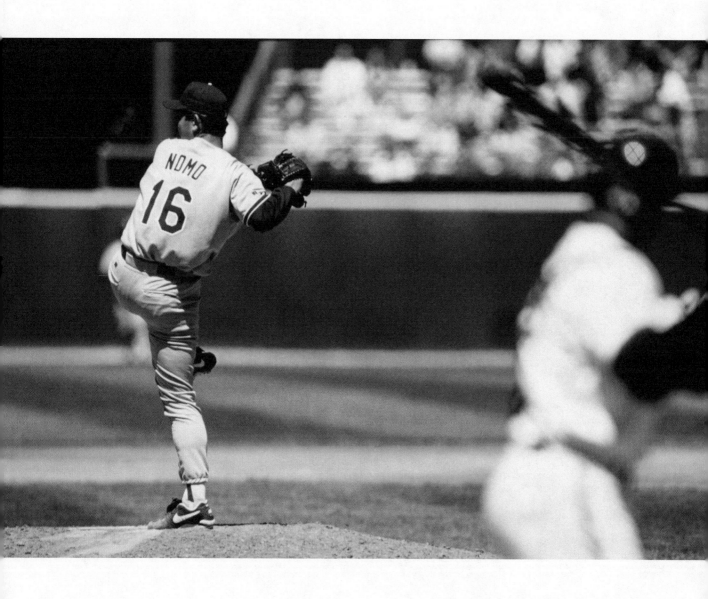

"Nomo fires [the ball] with an explosion of leg-spinning, back-bending, head-turning, arm-whipping contortionism."

—Sportswriter Tom Verducci, *Sports Illustrated*, September 11, 1995

Aptly nicknamed "The Tornado," Dodgers pitcher Hideo Nomo corkscrews his body to show only his name and number to the helpless batter before unwinding to deliver a pitch during his major league debut on May 2, 1995. After dominating baseball in his native Japan for five seasons, Nomo set his sights across the Pacific. Bringing his unorthodox pitching motion and devastating forkball with him, Nomo unleashed "Nomomania" on baseball fans around the world.

Photograph by Brad Mangin

"Yeah, I idolized Willie—so did half my friends—and then years later I found myself playing in the major leagues against him."

—Former shortstop and manager Joe Cronin, 1980

Cleveland Indians third baseman Willie Kamm shows off his modified headgear in the early 1930s. While the cap may look moth-eaten, Kamm actually cut the holes in the crown for extra ventilation. Of additional note, the button nestled in the Cleveland "C" was a collectible pin issued by the Orbit Gum Company to promote their Tattoo Chewing Gum. Appropriately, the picture on the button was of Willie himself.

Photograph by Forrest S. Yantis

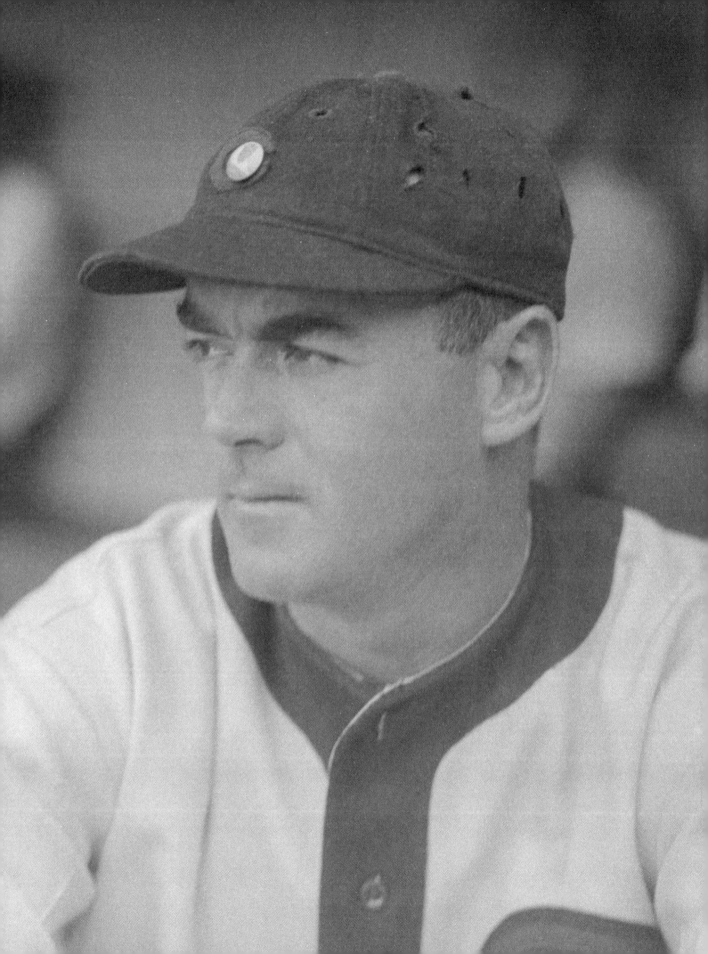

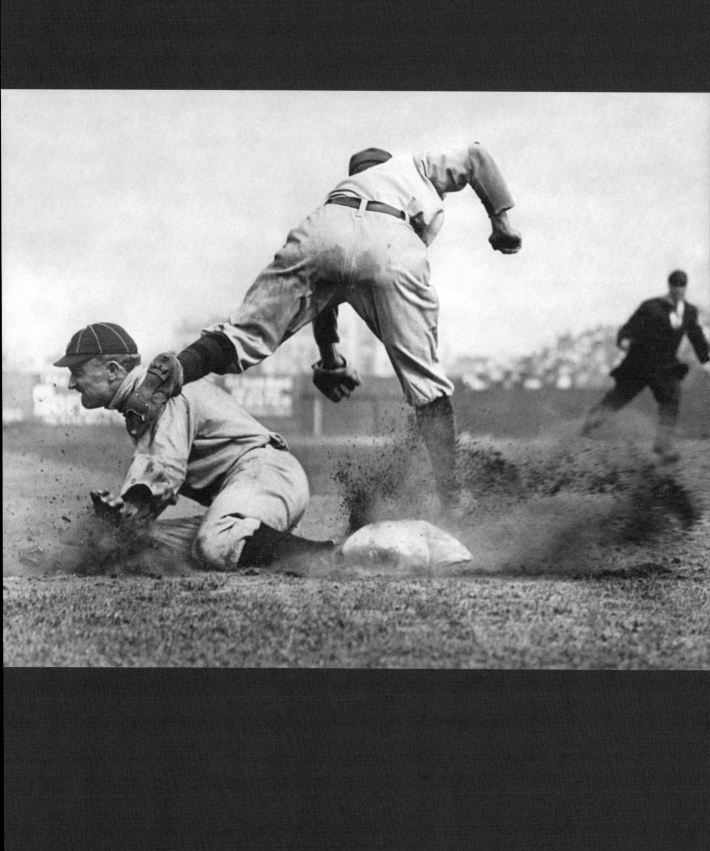

"When Cobb stole, he *stole*. Spikes flew, and he did not worry where. I saw Ty's clenched teeth, his determined look. The catcher's peg went right by Jimmy [Austin] as he was thrown on his face. I went home kicking myself. I said, 'Now, there was a great picture and you missed it.' I took out my plates and developed them. There was Cobb stealing third. In my excitement, I had snapped it, by instinct."

—Photographer Charles M. Conlon, 1937

Detroit Tigers great Ty Cobb barrels into New York Highlanders third baseman Jimmy Austin at New York's Hilltop Park on July 23, 1910. While the image captures the notorious baserunner's grit and the infielder's agility, what is not visible is the bum arm of New York's hapless third-string catcher, Fred Mitchell. In the first inning, Cobb capitalized on Mitchell's weakness, stealing second, then third, and scoring on Mitchell's wild side-arm throw that sailed into the outfield. A picture may be worth a thousand words, but it never reveals the entire story.

Photograph by Charles M. Conlon

"God, how he loved the Cubs and the Cubs fans.... Thank you to Cub fans for being his friends, for being his family, and for always being there for him. You'll never know how much that meant to him."

—Vicki Santo, Ron Santo's widow, at his Hall of Fame induction, 2012

Cubs third baseman Ron Santo signs his name for fans at Wrigley Field in 1962 as two boys hold a glove—presumably inscribed with Santo's "John Hancock"—as if it is a talisman. The pursuit of autographs did not start with baseball, but perhaps no other profession has generated the amount of passion for signatures as has the National Pastime. And yet today, a hobby that was once about preserving the moment when an admirer met their idol has become a billion-dollar industry focused more on monetary value than on a player-fan connection.

Photograph by Don Sparks

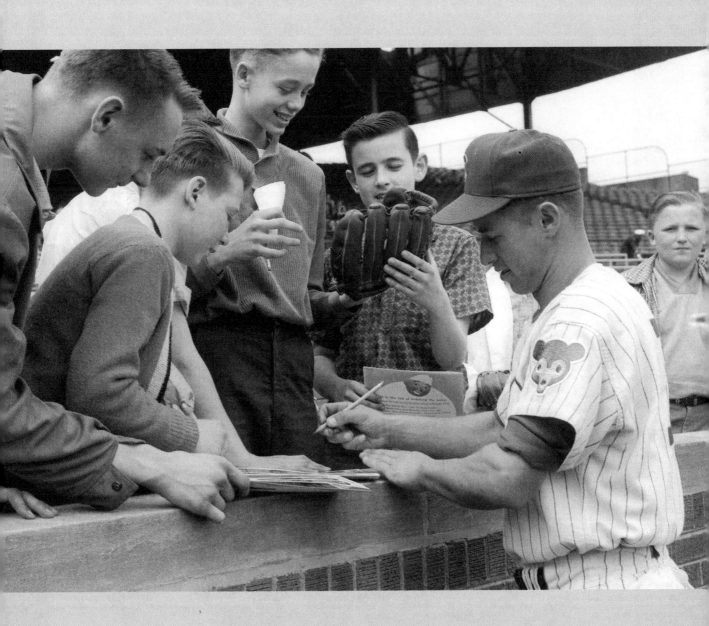

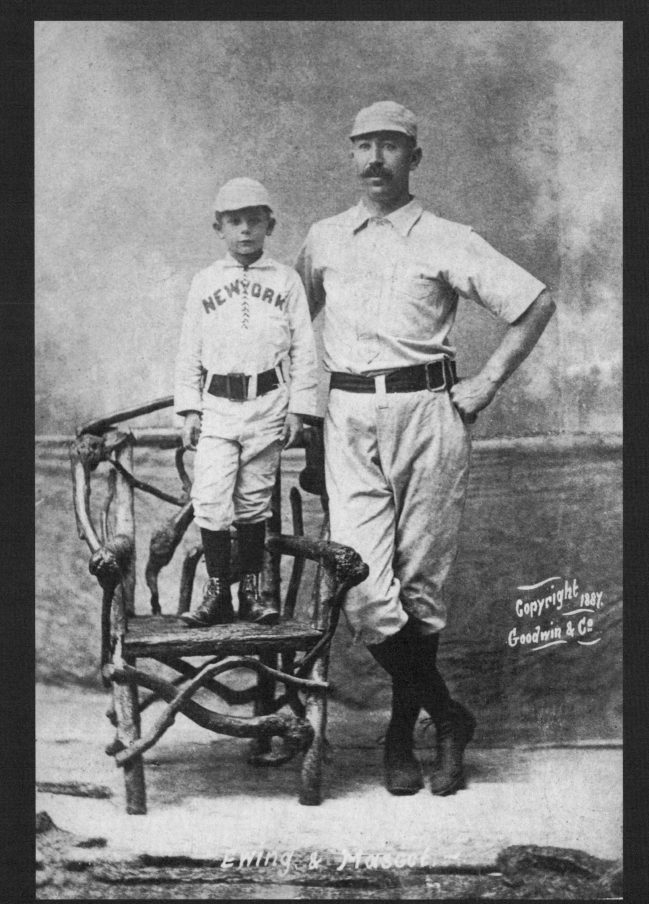

NEW YORK

Copyright 1887.
Goodwin & Co

Ewing & Mascot

"Human mascots were considered good luck charms by many early players, and Ewing was almost always personally involved in their recruitment during his career."

—Author Roy Kerr, *Buck Ewing: A Baseball Biography*, 2012

New York Giants great Buck Ewing stands with Willie Breslin, the team's mascot, in 1887. The most celebrated catcher of his day, Ewing didn't believe in leaving anything to chance when it came to his team's fortunes. Children were often used as mascots both during this era and well into the 20th century, with the kids who brought teams the most luck—and victories— in great demand.

Photographer Joseph F. Carroll

"Dean became a legend to literally thousands of people who didn't know if he threw right-handed or left-handed. And didn't care."

—Dizzy Dean's former broadcast partner Buddy Blattner, 1974

Dizzy Dean, sporting his famous white Stetson hat, broadcasts a baseball game in late September of 1950. A talented pitcher who epitomized the Cardinals' "Gashouse Gang" of the 1930s, Ol' Diz's folksy character helped him fashion a decades-long post-playing career in broadcasting in which he angered English teachers (using "slud" for "slid," for example) and sang the "Wabash Cannonball." Starting on the radio in 1941, he took television by storm in the mid-1950s when his *Game of the Week* broadcasts captured 75 percent of the audience.

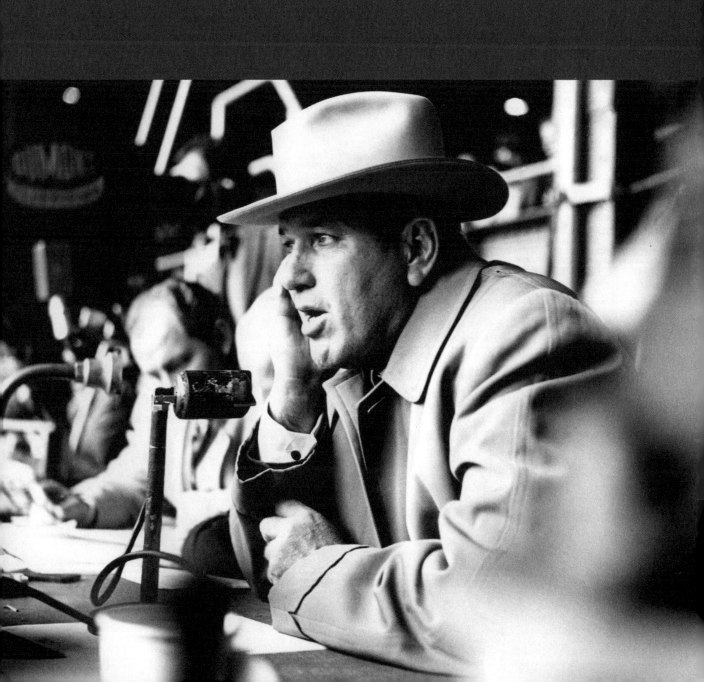

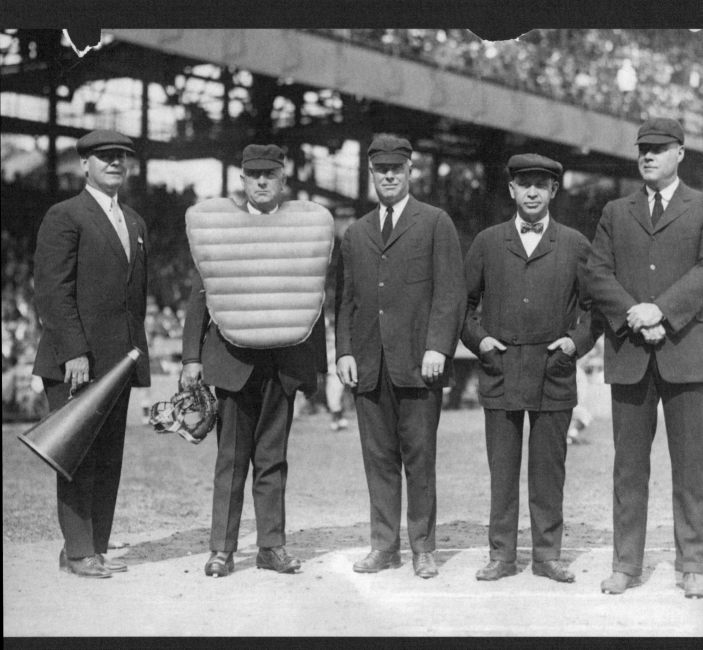

"When you have heard E. Lawrence Phillips hoist his open air baritone from the region of his ankles and bring it up through the whooping apparatus in his neck, you have given ear to a lifelike imitation of a B-flat locomotive whooper whistling in the cut down by the water tower."

—Sports columnist Westbrook Pegler in *The Pittsburgh Daily Post*, October 10, 1925

L ined up prior to Game One of the 1924 World Series at Griffith Stadium are, from left to right, announcer E. Lawrence Phillips (megaphone in hand), and umpires Tom Connolly, Ernie Quigley, Bill Klem, and Bill Dinneen. While the arbiters made the decisions on the field, it was the one-armed, silver-voiced Phillips who acted as the conduit of information to Washington fans. From 1901 through 1928, Phillips daily earned his colorful nickname as "the William Jennings Bryan of the Diamond."

Photographer unidentified

"Buck just makes you feel good. You might be blue, you might be in a slump, but a few minutes with Buck and the world is a wonderful place. Do you know what he is? He's the guiding light."

—Kansas City Royals manager Hal McRae, 1994

Buck O'Neil laughs from the dugout at Chicago's Wrigley Field in late May of 1962. The former Negro American League star player and manager joined Chicago's National League club as a scout in 1955 and seven years later became the first Black coach in what had been the all-white major leagues. His rich and varied life in baseball, especially his character, devotion, and myriad contributions to the game, were the inspiration behind the creation of the Hall of Fame's Buck O'Neil Lifetime Achievement Award in 2008, of which he was the first recipient.

Photograph by Don Sparks ——

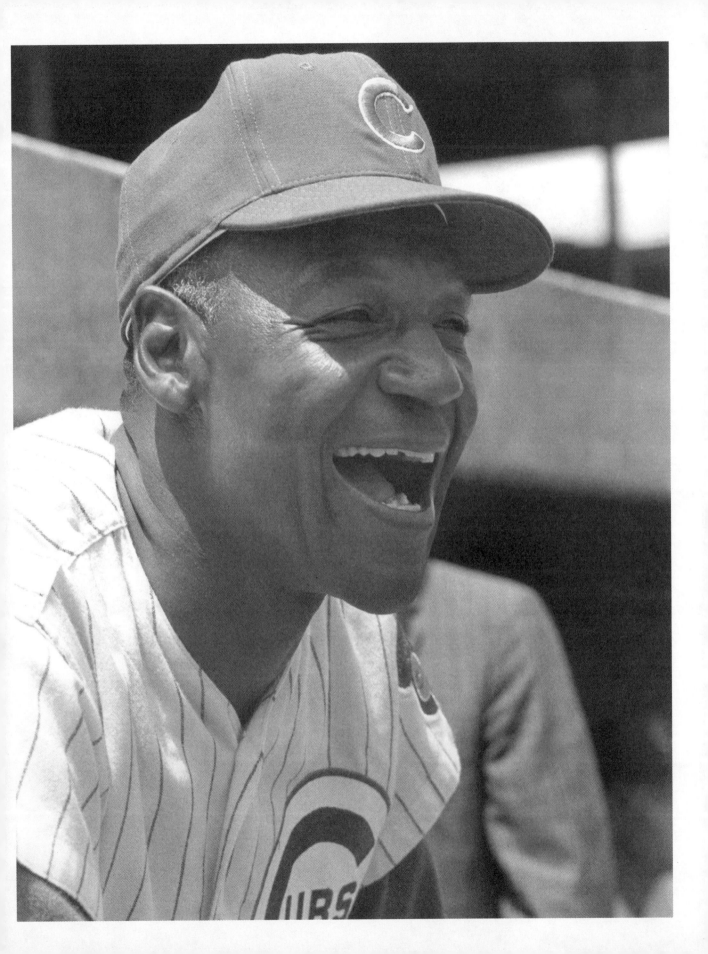

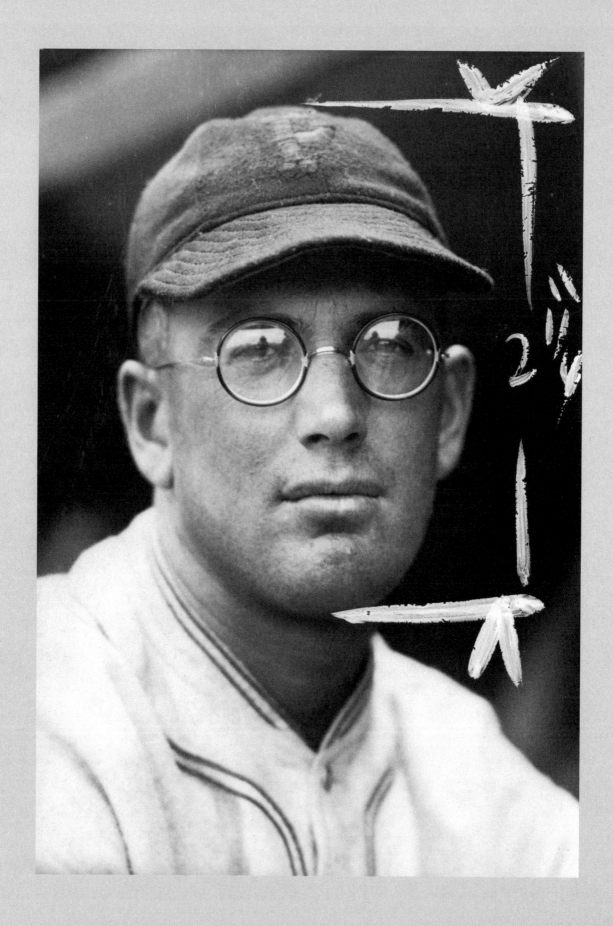

"Lee Meadows is a player who has taught the baseball world that a pitcher with weak eyes may yet win renown in the Major Leagues."

—Author Ward Mason, *Baseball Magazine*, March 1916

Reflected in the spectacles of Pittsburgh's Lee Meadows, photographer Charles Conlon captures an image of the Pirates pitcher, circa 1927. When the 20-year-old made his major league debut in 1915, Meadows became the first ballplayer to wear glasses since Will White in 1886. The righty not only survived the jeers that came his way but became a consistent workhorse, winning 188 games over 15 big league seasons.

Touching Up Photos

Touching up photographs was common practice when preparing an image for newspaper printing. The decisions that were made by editors are still to be seen, years later, in a combination of marks and writing on the photograph itself. Silver, black, or other color markings on an image could indicate cropping marks. These are usually lines, numbers, or arrows, such as the ones seen on this photograph of Lee Meadows, which indicate how an image should be resized. Other typical marks include silver ink used to either highlight the central figure or hide background noise.

Photograph by Charles M. Conlon

"We traveled in a big bus, and many's
the time we never bothered to take
off our uniforms going from one
place to another.... The bus was our
home, dressing room, dining room,
and hotel."

—Former Negro leagues catcher Roy Campanella, 1959

The 1936 Pittsburgh Crawfords kneel in front of the team's bus at their home stadium, Greenlee Field. After spending long hours traveling across the country, Black ballplayers frequently slept on their bus or under the stars if a segregated hotel was unavailable. Despite such difficulties, former player Buck O'Neil often noted, "Waste no tears for me. I didn't come along too early—I was right on time."

Photographer unidentified

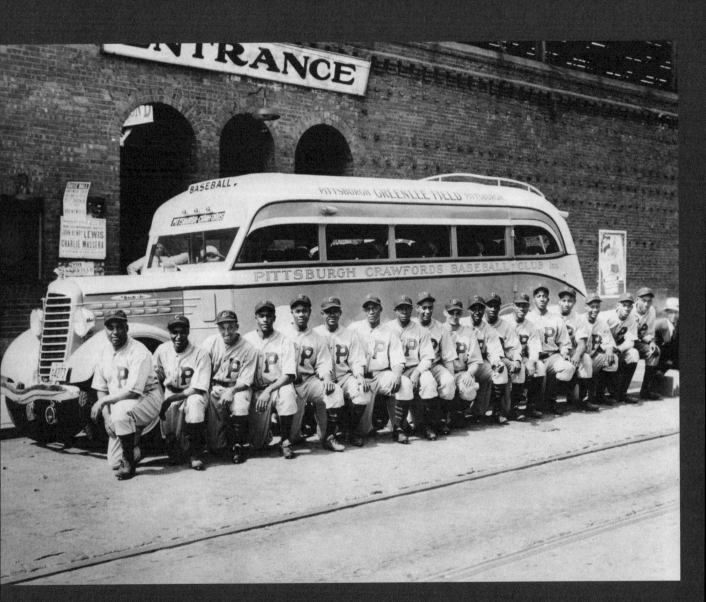

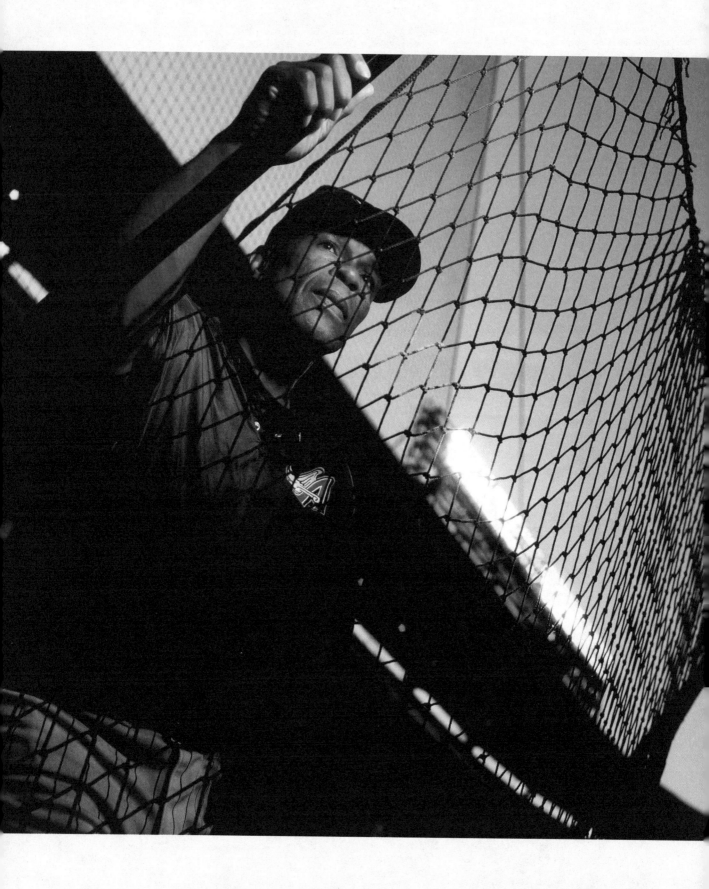

"He has no weakness as a hitter. Pitch him inside, outside, high, low, fast stuff, breaking balls, anything you throw he can handle. He swings with the pitch; that is why he's so great. He has no holes."

—Pitcher Catfish Hunter on Rod Carew, 1977

Anaheim Angels batting coach and hitter extraordinaire Rod Carew stands watchfully at the batting cage in 1999. In eight seasons as a coach with the Angels, the Panama native shared what he had learned during his 19-year major league career—his preparation, his execution, his confidence—with a new generation of stars.

Photograph by José Luis Villegas

"The year has only two seasons— winter and baseball."

—Humorist Arthur "Bugs" Baer, *The Washington (DC) Times*, April 3, 1916

While in New York City for baseball's winter meetings, Ty Cobb and former big league pitcher "Big Ed" Walsh make snowballs on the sidewalk on December 14, 1922. Clearly neither ballplayer could resist taking a moment to scoop up and create a few wintery baseballs, especially Cobb, a native of Georgia who had not seen snow in 10 years.

Photographer unidentified

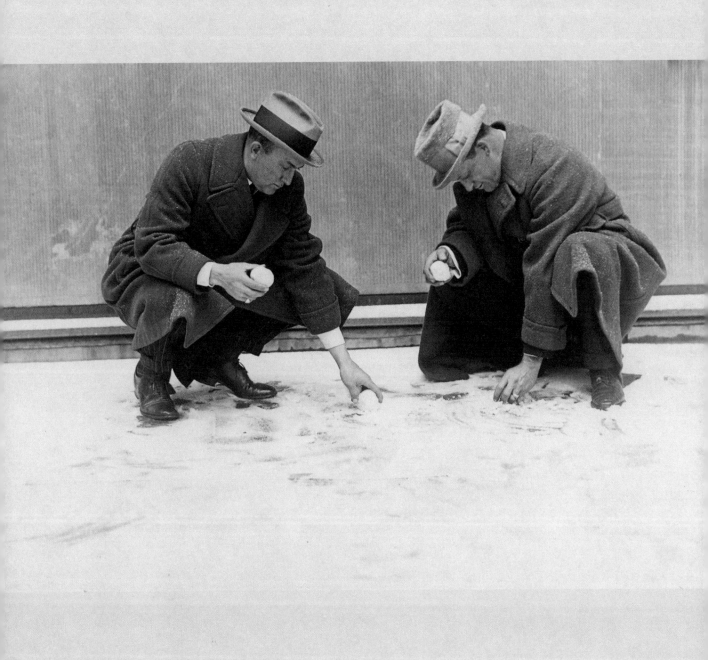

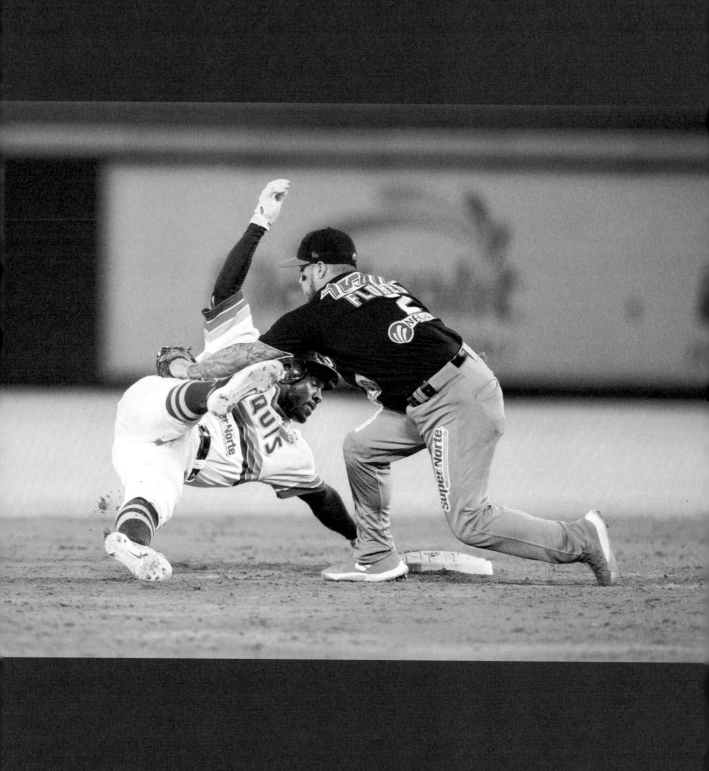

"Baseball is a ballet without music. Drama without words."

—Broadcaster Ernie Harwell, 1955

Ernie Harwell's words ring true across the decades, as seen in this dance at second base where infielder Jorge Flores tags out base runner Cory Wimberly during a Mexican League game at Ciudad Obregón's Estadio Yaquis in December of 2016. Perhaps there is no place where baseball is more like a ballet than second base, where the defense must cut down runners to keep them out of scoring position. The runner, just as urgently, seeks to begin the next play at the keystone sack, where a single might bring him home and add to the inning's drama.

Photograph by Jean Fruth

"Although he may have lacked the color of a Bill Klem, Mr. Connolly was perhaps the perfect umpire."

—*The New York Times*, April 29, 1961

S hot from a low angle circa 1920, Tom Connolly surveys the field, appearing much taller than his five-foot-seven frame would suggest. Small of stature, Connolly was a giant among arbiters of the game. Despite having never seen a baseball game until he arrived in the United States as a young teenager, the Briton made his mark as an umpire, calling both the first American League game in 1901 and the first modern World Series contest two years later.

Photograph by Charles M. Conlon

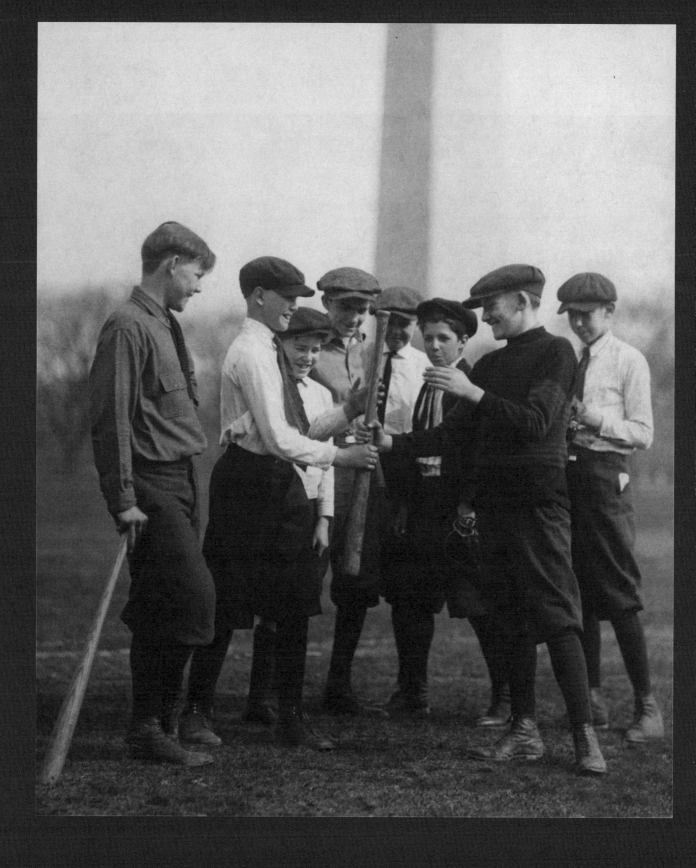

" 'Sides for base!' was screamed out as we broke headlong into the play-ground; and then in a twinkling the two recognized leaders had tossed the bat and were putting hand over hand."

—*The Galaxy*, July 15, 1866

On March 25, 1922, with the Washington Monument in the background, congressional pages on the National Mall watch as team captains use the traditional method of choosing sides for a baseball game. Tossing, then catching a bat vertically, the captains alternated grips up the bat handle. The first pick was awarded to the captain with the final hold who could successfully whirl the bat around his head without dropping it, and then toss it a set distance.

Photographer unidentified

"The Page Fence Giants, who will play here to-morrow, Thursday and Friday, are the star amateurs of the west. They travel in their own private [railroad] car and give a parade on bicycles."

—*The Fort Wayne (Indiana) News*, May 20, 1895

M embers of the Page Fence Giants pose atop rolls of fencing for a team photograph, circa 1895. Following the unspoken "Gentlemen's Agreement" of 1887, which created the color line in professional white baseball, Black players commonly formed their own teams, many of which were funded by local companies. Sponsored by the Page Woven Wire Fence Company of Adrian, Michigan, the barnstorming Page Fence Giants became one of the most successful Black teams of the 19th century, traveling the country in their own private railroad car.

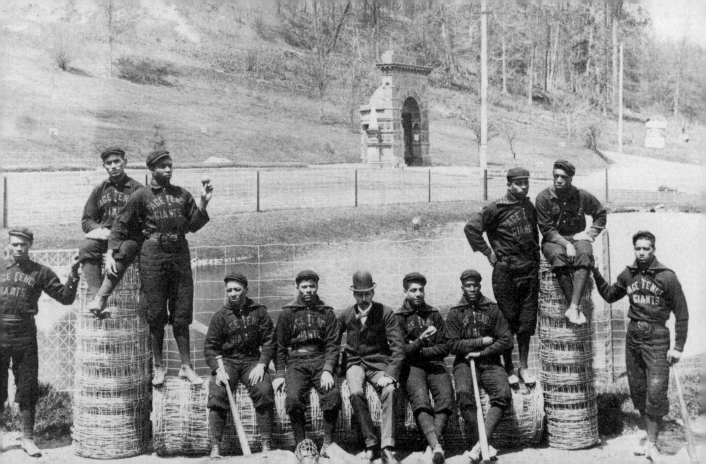

"It's a beautiful place, and it's outdoors.
It almost doesn't seem like Houston.
It seems like we're in someone else's
park right now."

—Houston Astros first baseman Jeff Bagwell, 2000

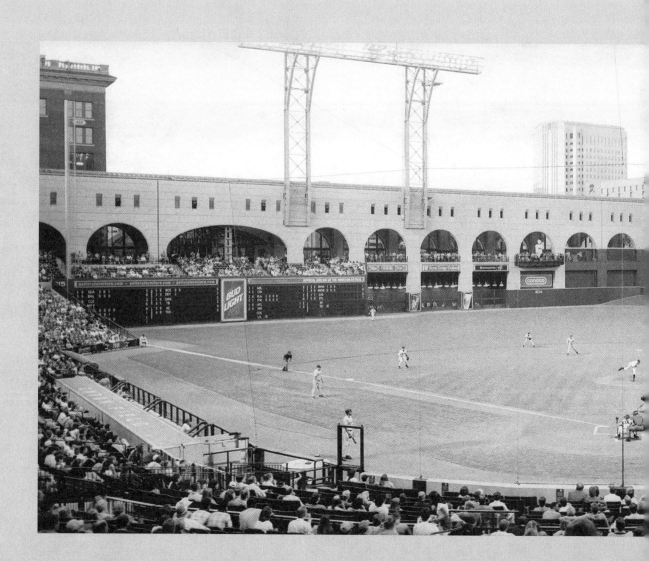

The Houston Astros play host to the Pittsburgh Pirates at Enron Field on September 16, 2000, the new ballpark's first season after the franchise bid farewell to the 35-year-old Astrodome. Now known as Minute Maid Park, the $248 million, retractable-roof stadium on the edge of downtown features a train atop the left field wall and a manually operated out-of-town scoreboard. The center field incline known as "Tal's Hill," the brainchild of former Astros President Tal Smith, was removed after the 2016 season.

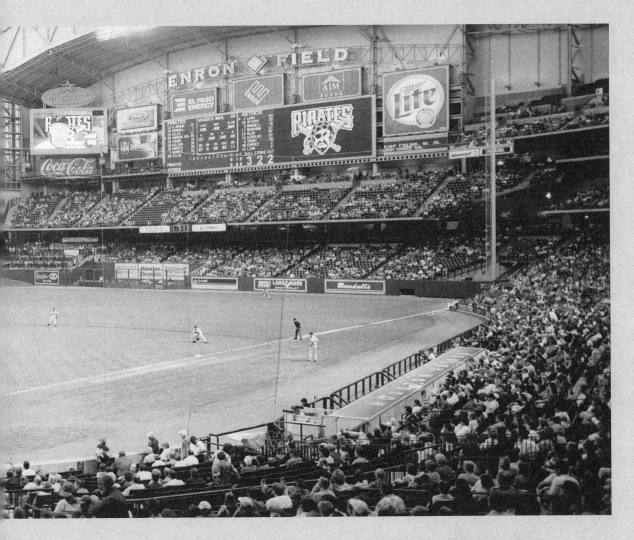

Photograph by James McKinnis

"Legend has it he once was chased around the bases by a pitcher whose game he had ruined with a home run. 'You big bully,' the pitcher cried. . . . 'You ought to be ashamed of yourself going around the country with a telegraph pole for a bat and knocking the bread and butter out of pitchers' mouths.'"

—*The Washington (DC) Evening Star*, August 3, 1932

In an era when small ball ruled the diamond, six-foot-two Dan Brouthers, bat in hand, stands tall as a member of the National League's Buffalo Bisons in 1882, the year he won the first of five batting titles. A dominant force in the game, Brouthers led the National League in slugging percentage for six straight seasons from 1881 to 1886 and finished his 19-year big league career with a stunning .342 batting average.

Sitting for the Photographer

In the 19th century, having one's portrait taken sometimes required posing without moving for up to a half a minute. Photographers of the era were entirely dependent on natural light, equipping their studios with floor-to-ceiling windows, skylights, and large mirrors to reflect sunlight onto their subjects. To assist the subjects in holding still, photographers often provided head rests and metal stands with horizontal braces positioned behind individuals to prevent motion. In this portrait of Dan Brouthers, the base of one such stand is visible just behind his feet.

Photograph by William L. Smith

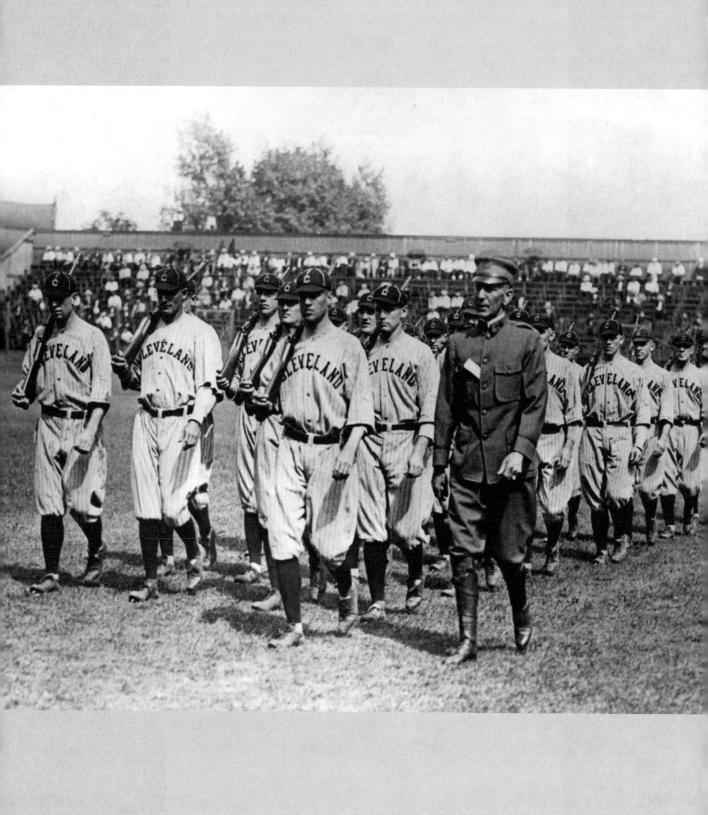

"Every American League club had
an Army officer drilling the players
in the training camps this spring,
and that drill will be continued all
season. Permission has been secured
from Army headquarters to retain
these officers throughout the year,
and each club will be given its full
quota of instruction every day.
The fact that the government has
consented to permit us to retain these
instructors shows how highly the
work is regarded in Army circles."

—American League President Ban Johnson, 1917

The Cleveland Indians practice military drills using regulation Army rifles in 1917 as the United States prepares to enter World War I. Although the seriousness of the coming conflict filled the minds of fans—with the majors for the first time starting a season in a state of war—the military drills performed prior to games by all big league teams aroused a patriotic sentiment. Later that year, the American League offered a $500 prize to its best drilled team.

Photographer unidentified

"There are some things women can't do. The teachings of centuries have established the fact that a woman can't play baseball. None but a perverted and baldheaded advocate of female suffrage would permit the assumption to dally in his mind that a woman could throw a ball underhand or attempt to catch one without shutting both eyes just when she could see biggest."

—*The New York Clipper*, March 20, 1880

With her eyes wide open, Springfield Sallies infielder Renae Youngberg awaits a throw at third base while Chicago Colleens runner Joan Sindelar scampers back to the bag, 1949. Over 600 female athletes played in the All-American Girls Professional Baseball League from 1943 to 1954. Providing a welcome source of entertainment during and after World War II, the high caliber of competition initially surprised baseball fans and the media, but quickly proved that the league was much more than a wartime publicity stunt.

Photographer unidentified

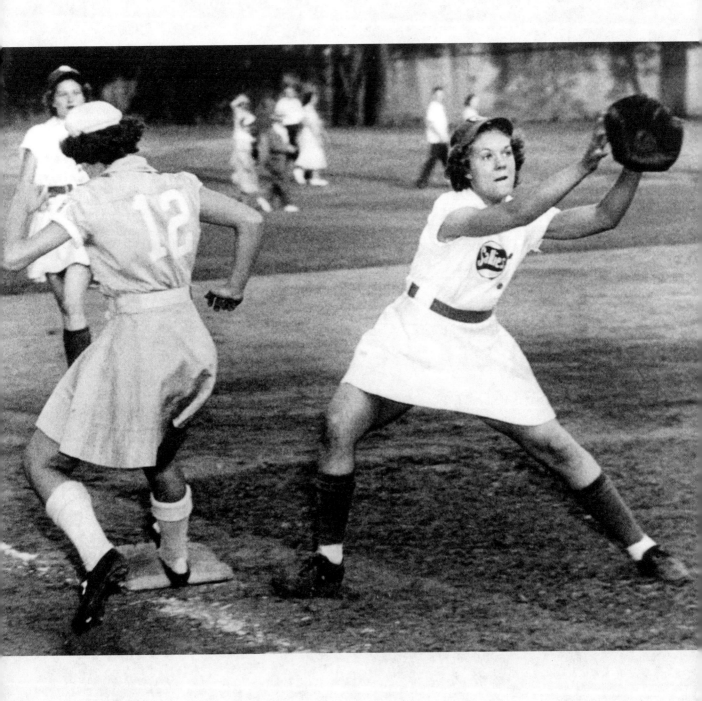

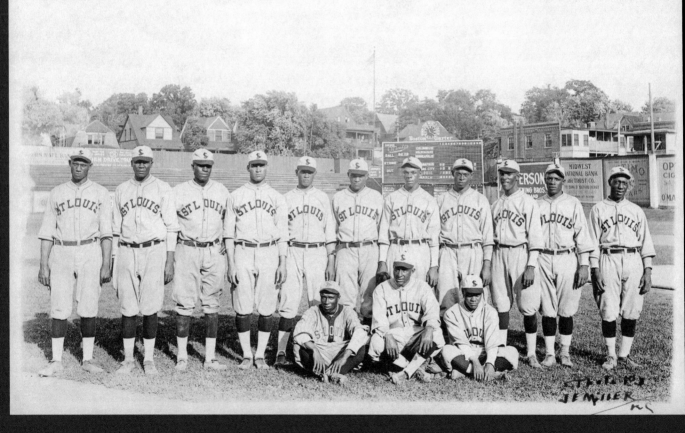

"I don't feel bitter about it.... It's just one of those things. It just didn't happen in my time. So I don't have anything to be bitter about."

—Pitcher Bill Drake (standing at far left) on playing segregated baseball, 1971

The St. Louis Giants pose on the field at Kansas City's Association Park following their June 14, 1920, game against the Monarchs in the inaugural season of the Negro National League. Comprised of eight teams, the new league was the first successful Black baseball circuit. During a time when social norms and Jim Crow laws prevented Blacks from playing on white teams, this and subsequent Negro leagues enabled Black athletes to play the game they loved, while traveling and earning a decent wage.

Researching the Picture

Picture researchers use small details and visual clues in photographs to help answer basic questions about the image. For this team portrait, researchers determined the exact date and location using information on the advertising billboards and the scoreboard. The Midwest National Bank and Trust Company, whose ad appears at the right in the background of the photograph, was traced through regional city directories to reveal the location of the ballpark as Kansas City, Missouri. Likewise, partial scores and team matchups on the scoreboard were cross-checked against known results to provide the exact day the portrait was taken.

Photograph by James E. Miller

"[The warehouse] gave us a reference point that dictated virtually everything else—from the field dimension to the vertical scale of the building to the brick and the steel palate and the seat colors.... The warehouse, more than anything, was like our clue of what to do."

—Janet Marie Smith, Orioles architect for Oriole Park at Camden Yards, 2017

Pedestrians stroll Eutaw Street just outside Baltimore's Oriole Park at Camden Yards in 2002. When the stadium opened ten years earlier, its celebrated design included a thoroughfare lined with shops and restaurants between the old B&O Railroad Warehouse and the ballpark. Early proposals had slated the warehouse for demolition, but historic preservation won out, and what was once thought an eyesore became the park's signature feature. Setting a trend for new parks around the country, Baltimore's gem was the first major league "retro" stadium.

Photograph by Bob Busser

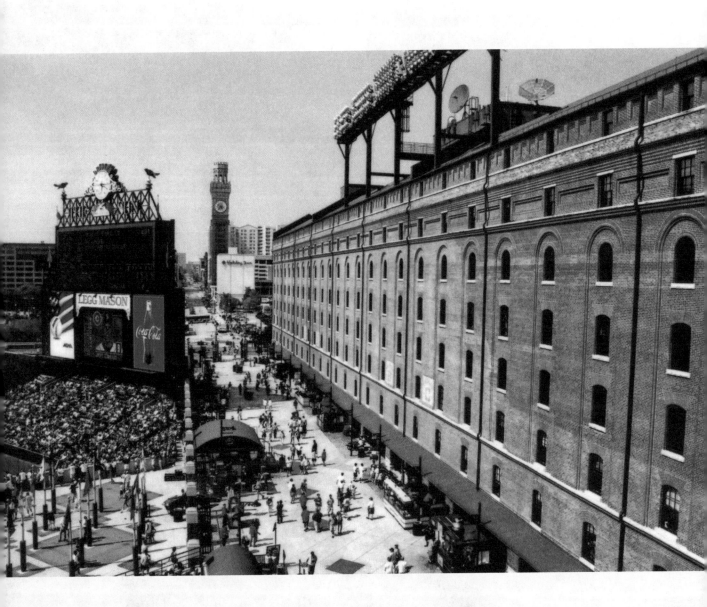

"It has been the custom for years with major league players to drive a few small nails or tacks into the bat where it showed signs of splitting. Although the rules say that the bat shall be entirely of wood, little attention has ever been paid to the custom."

—Umpire Billy Evans, 1922

Phillies outfielder Chuck Klein drives a nail into a well-used Louisville Slugger, circa 1930. Though illegal then (and today), the practice was a common method of keeping bats from splintering. Why go to all the trouble? In the days before every big leaguer had access to a near-endless supply of quality bats, good lumber was sacred.

Photographer unidentified

"Some of the wounded survivors
of the ill-fated warship speak
in glowing terms of the team's former
prowess and believe that some
of the crack nines of the big league
would have had to hustle in a contest
with the sailor laddies who have made
their last home run."

—*The Savannah (Georgia) Morning News*, May 27, 1898

The USS *Maine* baseball team and their goat pose for a picture, circa 1897. In an era when professional baseball was wholly segregated, the *Maine*'s Black pitcher William Lambert (back row, far right) helped the squad win the Navy's 1897 baseball championship. The team never played another game, for the *Maine* famously and mysteriously exploded off the coast of Cuba on February 15, 1898, helping to spark the Spanish-American War. Over 260 men were killed, including everyone in the team photo save John Bloomer (back row, far left) and the ship's four-legged mascot.

Photograph by George C. Mages

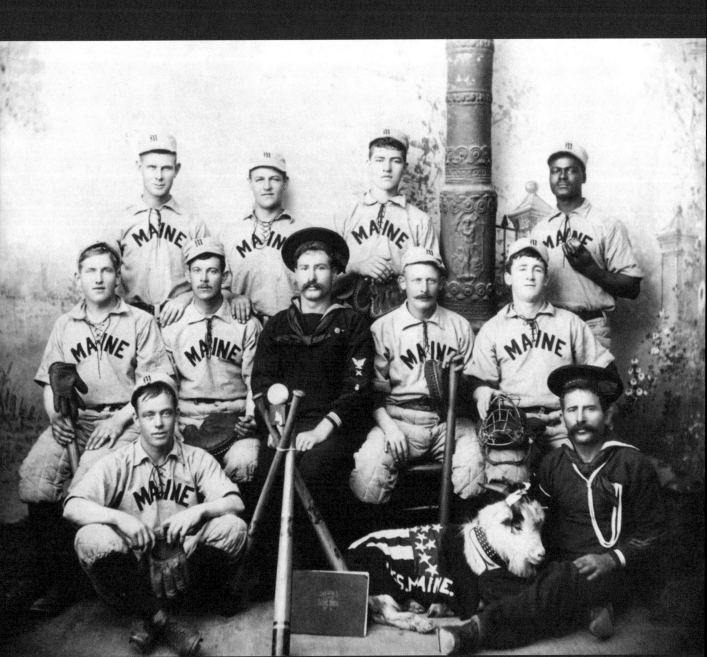

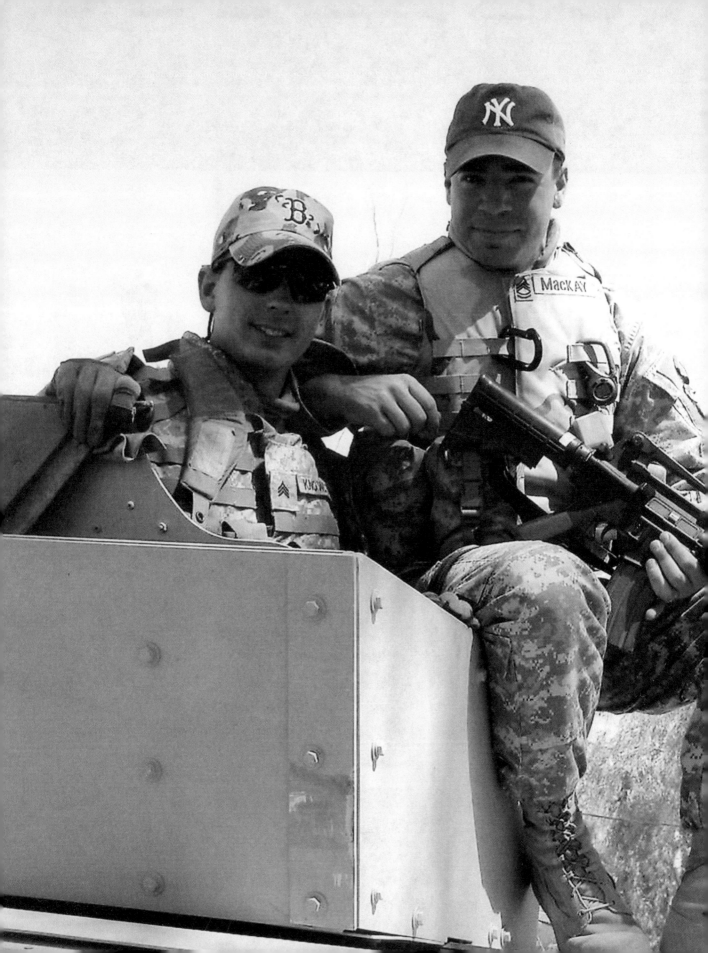

"After what I went through overseas, I never thought of anything I was told to do in baseball as hard work. You get over feeling like that when you spend days on end sleeping in frozen tank tracks in enemy-threatened territory. The Army taught me something about challenges and about work and about what's important and what isn't."

—Warren Spahn in *Warren Spahn: Immortal Southpaw* by Al Silverman, 1961

Sergeants Jason Knowlton (left) and Lee MacKay don caps of their favorite baseball clubs while on combat patrol in Khanaqin, Iraq, in June of 2006. The very symbols on these servicemen's caps, which might divide them at Yankee Stadium or Fenway Park, brought them closer together as Americans, soldiers, and baseball fans. In baseball, as in much of life, context makes all the difference.

Photographer unidentified

"The pride of Boston in its base ball team has been something unique. It was compounded of confidence and admiration, both fully justified by the skill and character of the men comprising it. We have not only felt sure that they could beat all other clubs but that they would do their best."

—*The Boston Daily Advertiser*, July 23, 1875

Members of the Boston Red Stockings pose casually together in 1874. After placing second in their 1871 inaugural season, Boston became baseball's first dynasty by dominating the National Association (baseball's first major league) the next four years. Five of the 11 players pictured are Hall of Famers, including Albert Spalding (standing, second from left), Deacon White (standing, second from right), Jim O'Rourke (seated, far left), and brothers Harry (seated, center) and George Wright (seated on ground, left).

Photograph by James Wallace Black

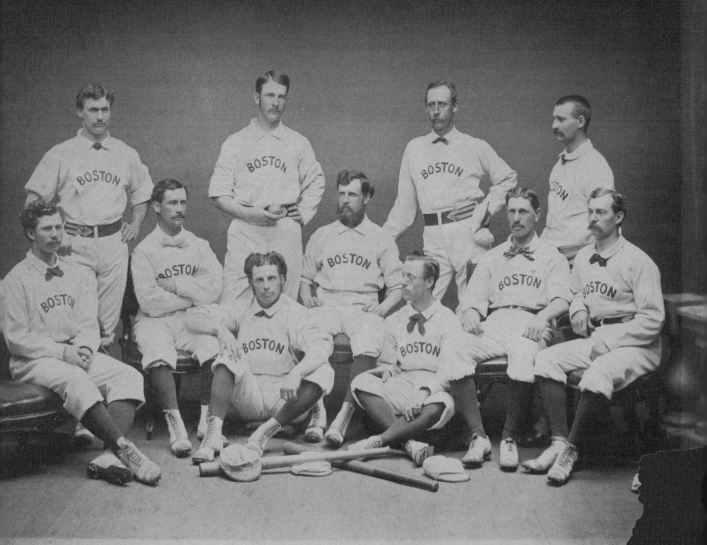

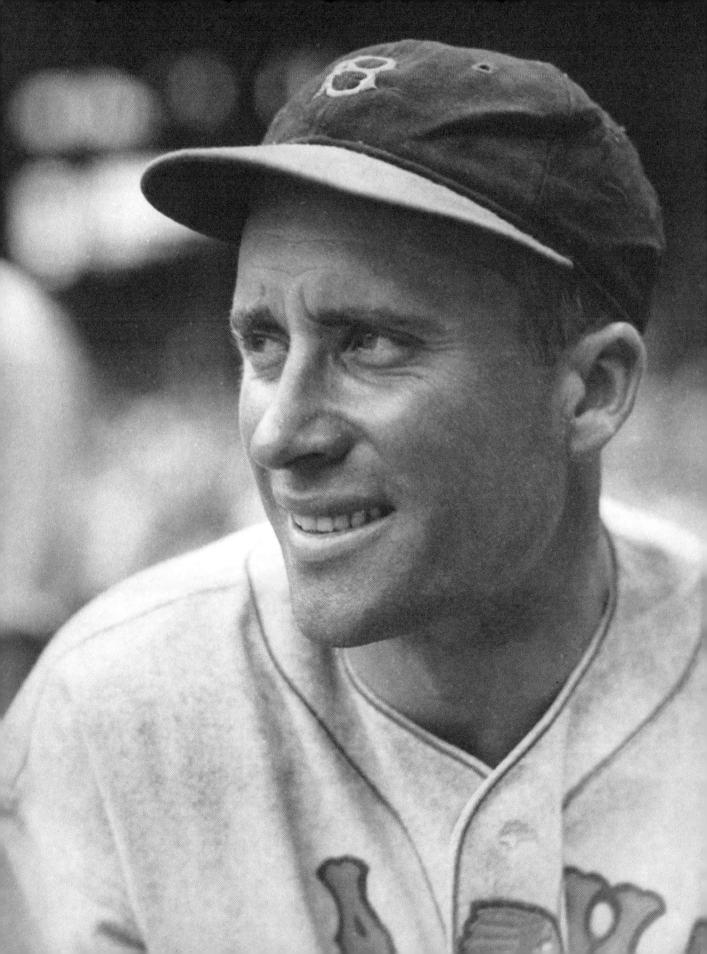

"I never did find out who held the rookie home run record before I came along. All I know is that I hit tape-measure home run jobs in every major league ballpark I played in. I never thought of records. I just liked to hit."

—Wally Berger, 1987

In the mid-1930s, Wally Berger smiles as a member of the Boston Braves, a franchise with which he excelled even though the club often suffered in the standings. The oft-overlooked star exploded on the Beantown scene in 1930 with 38 home runs, a major league rookie mark not eclipsed until 1987. His 119 runs batted in that same season set a National League rookie record that lasted 71 years. In his seven full seasons in Boston, the slugger averaged 28 homers and 103 RBI.

Photograph by Forrest S. Yantis

"Hardly anybody recognizes the most significant moments of their life at the time they happen. I figured there'd be plenty more days."

—Archibald "Moonlight" Graham in *Shoeless Joe* by W.P. Kinsella, 1982

Archibald "Moonlight" Graham sits in the back of a car virtually overflowing with members of the 1905 Scranton Miners. The young doctor, whose story was made famous in the movie *Field of Dreams*, never had the chance to have an at-bat in the big leagues. The real-life Graham played two innings in right field for the New York Giants on June 29, 1905, before being sent down to the minors to finish the season and his all-too-brief major league career.

Photographer unidentified

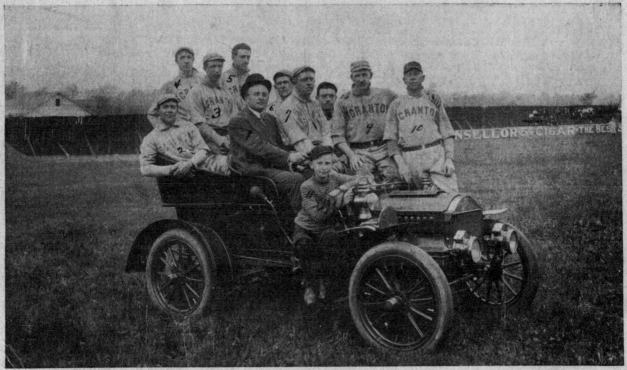

SCRANTON BASE BALL CLUB, 1905.

1. ASHENBACK, Manager
2. ZIEMER, Short-stop
3. HANNIFEN, Pitcher
4. GRAY, Pitcher

5. GRAHAM, Left Field
6. GETTIG, Third Base
7. BETTS, Right Field
8. SCHRALL, Center Field

9. SHORTELL, Second Base
10. MANNERS, First Base
11. EDDY ASHENBACK, Jr.
(Mascot)

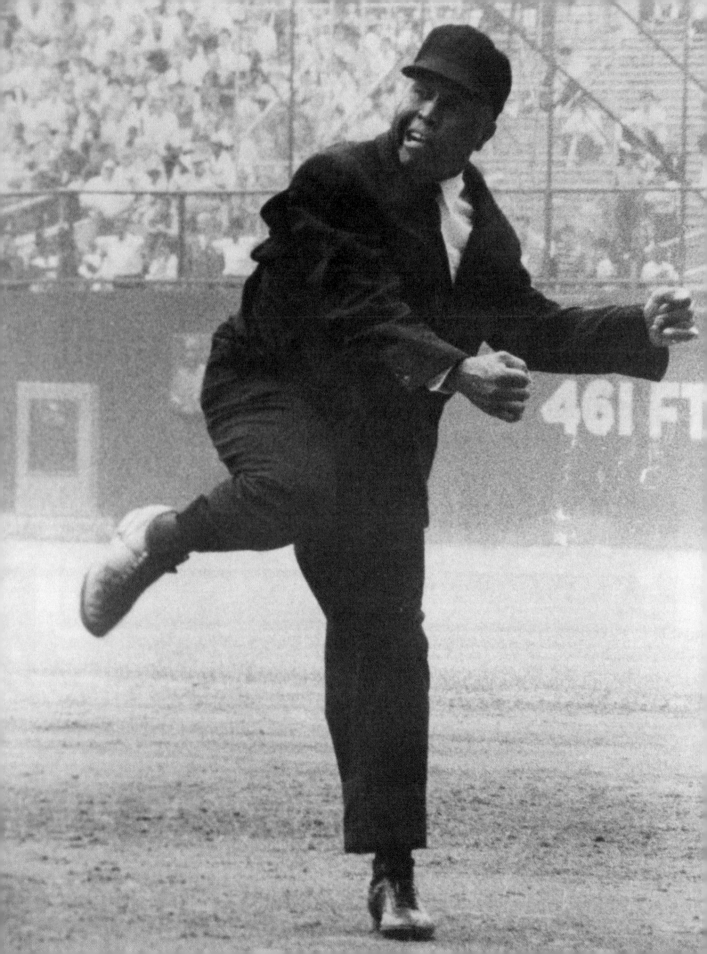

"I never went to an umpiring school because they didn't accept Blacks in those days, so I developed my own style of officiating."

—Emmett Ashford in *The Men in Blue* by Larry Gerlach, 1980

Emmett Ashford emphatically calls a player out during a game at Yankee Stadium on June 16, 1966. Earlier that season, Ashford had made his major league debut, becoming the first Black umpire to integrate the white major leagues. A veteran of 15 minor league seasons, Ashford brought to the majors his signature boisterous style—one that many fans enjoyed, but others felt was "over the top." Still, despite a big league career that lasted just five seasons, his historic achievement and animated demeanor on the diamond left a lasting legacy.

Photographer unidentified

" … I'll still come to spring training.
I love the game and I love the people."

—Broadcaster Ernie Harwell upon his retirement, 2002

Giants shortstop Dave Bancroft takes a swing at the plate during a preseason matchup against the White Sox at San Antonio's League Park, circa 1923. Since the 19th century, spring training has meant the return of the game and the annual rebirth of baseball. It has also provided a boon to the cities and towns that host training camps. Over the years, San Antonio has served as the spring headquarters for at least 10 major league clubs.

Photographer unidentified

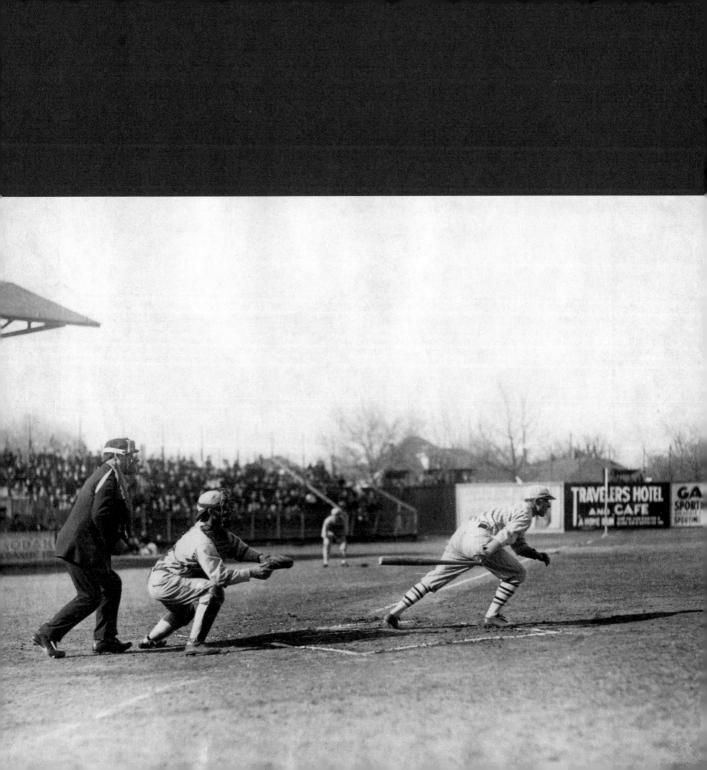

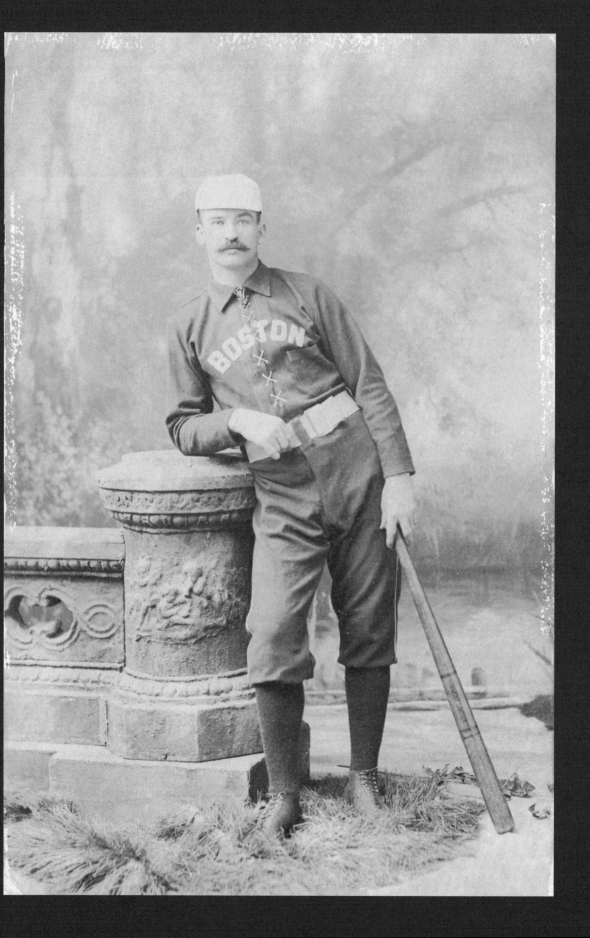

"The $5,000 that Kelly will receive for his coming season's base ball work can be divided into $2,000 salary and $3,000 for his photograph, which the Boston Club directors feel they cannot do without. The picture will be of the usual cabinet size obtainable in galleries for $3 a dozen."

—*The New York Sun*, February 20, 1887

Popular baseball star Mike "King" Kelly poses for a photograph after his February 1887 sale by the Chicago White Stockings to the Boston Beaneaters for the then-record sum of $10,000. As a parting gift to his former charge, Chicago club president Albert Spalding sent Kelly a special uniform identical to that of his old club with two notable exceptions: his jersey read "BOSTON" instead of "CHICAGO," and his stockings were of course red, not white.

"Whatever else it is, the game is wholesome. Its very vital call is its unquestioned integrity, and it gives one the chance to 'smile out loud' under God's clear sky and to take in life-giving breaths of fresh air every time one empties the lungs with a lusty cheer."

—Actress Lillian Russell, 1911

A young woman prepares to bat during an informal game of baseball at Miss Hall's School in Pittsfield, Massachusetts, circa 1919. At the turn of the 20th century, concerns about the increasingly sedentary lifestyle of young Americans led schools to add physical education to their curriculums. Thanks to shifting social norms, as well as educational and health reforms, young women gained opportunities to engage in various outdoor activities such as golf, tennis, archery, and the National Pastime.

Photographer unidentified

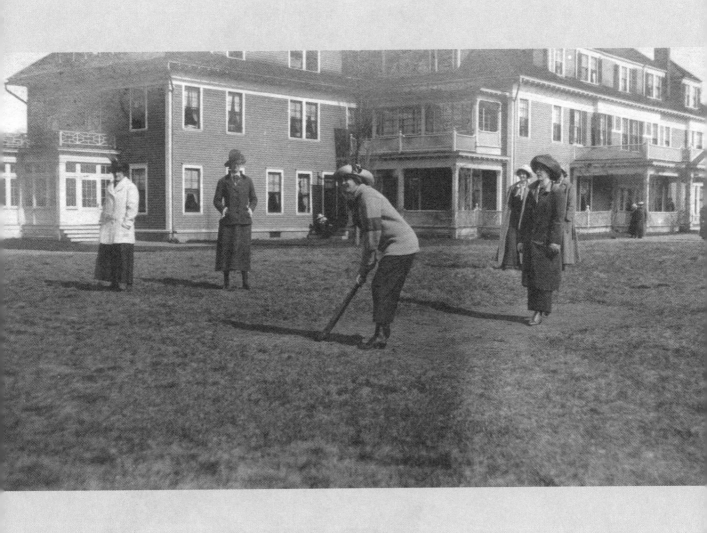

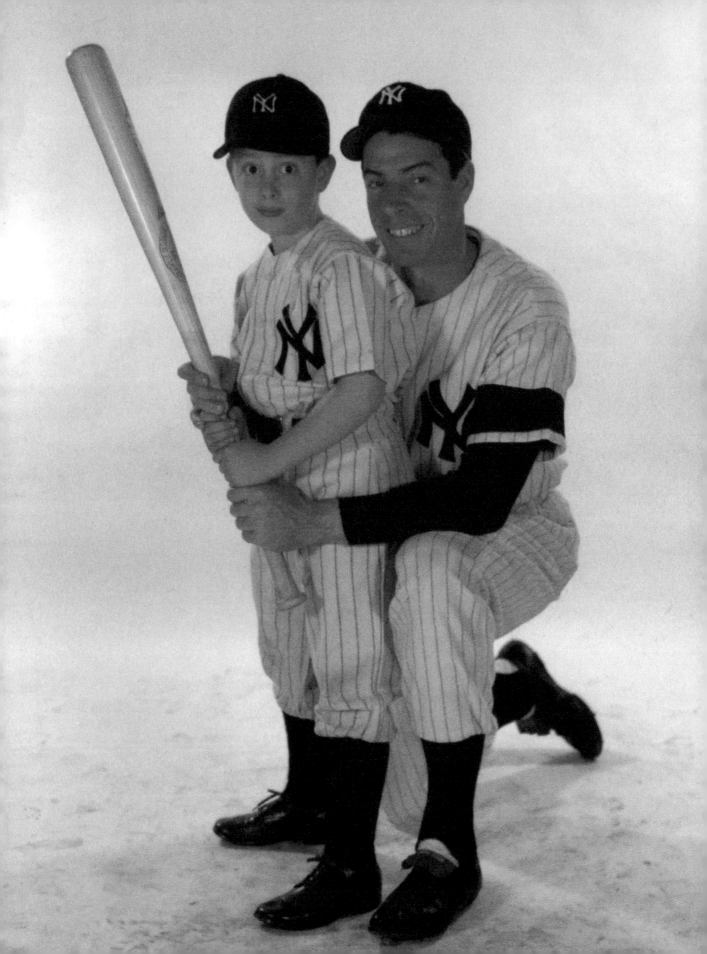

"I love him and just all of the things that are felt, but never said, between people."

—Joe DiMaggio Jr., 1999

Yankees legend Joe DiMaggio and his son Joe Jr. smile for a photo published in the April 26, 1949, issue of *Look* magazine. Born October 23, 1941, after the season in which his father hit in 56 straight games, Joe Jr. was the only son of DiMaggio and actress Dorothy Arnold. As a young boy, Joe Jr. dreamt of following in his father's footsteps. One day, in a room full of reporters and packed with the many playthings lavished upon the young boy, the seven-year-old pleaded to his father, "I don't want toys. I want you to show me how to slide."

Photographer unidentified

"Baseball—because of its sense
of continuity over the space of
America and the time of America—this
is a place where memory gathers."

—Poet Donald Hall, 1992

The generations of memories packed in Fenway Park's blue grandstand
seats are real—no ersatz imported nostalgia is needed (or wanted) here.
Big league baseball's oldest active ballpark, the Boston landmark opened
in April of 1912 and has itself become an American institution. The park has
survived numerous plans to have it razed, outlasted the multi-purpose stadium
era, and today endures as the real thing.

Photograph by Bob Busser

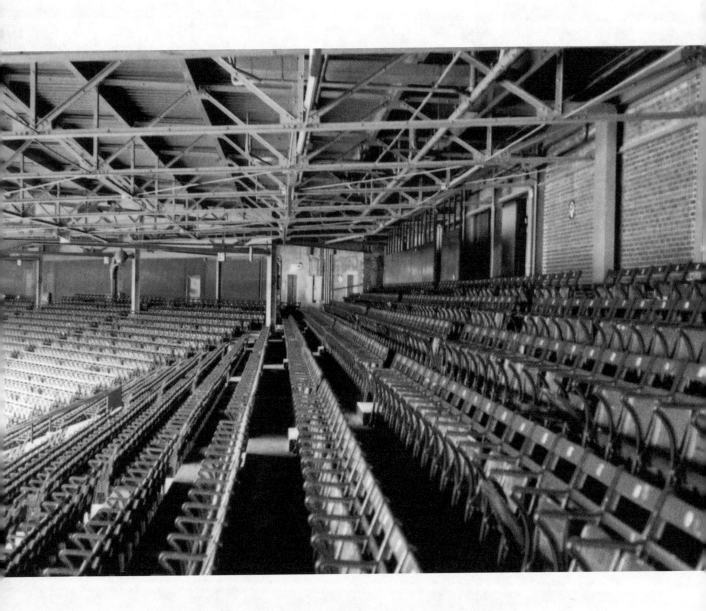

"The bat which [Jackson] clutches in his sinuous fingers with so resolute a grip, is black. When the unknown amateur from a Southern cotton town started to burn up the local circuit, he used a black bat.... His greatest triumphs in the American League have been won with a black bat. Now he will use no other."

—Sportswriter F.C. Lane, 1917

Legendary outfielder "Shoeless" Joe Jackson shows off his lumber outside the dugout at Chicago's Comiskey Park in May of 1916. Like many ballplayers, the White Sox batting star was superstitious and known to name his bats—"Black Betsy" being the most famous. Jackson's involvement in the 1919 Black Sox Scandal put an abrupt end to his stellar career, and today, Jackson is celebrated as a tragic figure in baseball lore.

Photographer unidentified

"I wish every athlete in all of sports, not just baseball, could act like [Tony Pérez]. Never once in his career did I see him throw a helmet. He never once threw a bat. He never once made an alibi."

—Former Cincinnati Reds manager Sparky Anderson, 2000

In late May of 1993, Cincinnati Reds manager Tony Pérez sits contemplatively in the visitors' dugout at Candlestick Park. One day after the Reds completed their series in San Francisco, Cincinnati dismissed the beloved former first baseman who wore a Reds uniform for 16 of his 23 major league seasons. Shocked and disappointed, Pérez did not make any excuses, instead embracing his past and proclaiming, "I'll always be a Red."

Photograph by José Luis Villegas

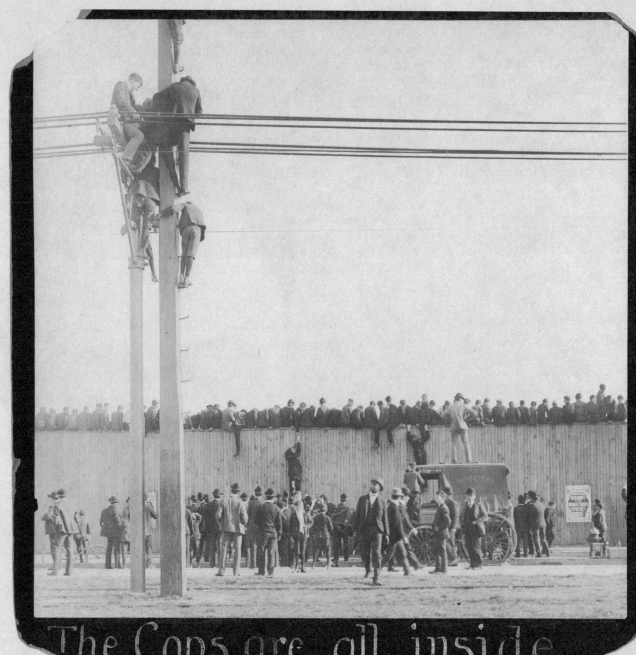

The Cops are all inside

"At a quarter before 2, the fence from bleacher end to bleacher end served as a perch for thousands. The bipeds without feathers on the fence top were packed as closely as prisoners in lock-step formation."

—*The Boston Sunday Globe*, October 4, 1903

Anxious to witness the 1903 World Series and knowing full well that "the cops are all inside," fans clamber up the fences surrounding Boston's Huntington Avenue Grounds. No vantage point was too precarious and no obstacle insurmountable. The excitement of watching their American League champions meet the National League's Pittsburgh Pirates in the first modern World Series rendered Boston fans simply delirious.

Photographer unidentified

"My Cooperstown experience is never complete without walking to Doubleday Field and stepping on that sacred soil. I realize it's now widely accepted that Doubleday Field serves merely as the symbolic birthplace of baseball, but that doesn't diminish its aura for me. Its symbolism is powerful, and as a baseball player, it's still the Promised Land."

—Outfielder Ichiro Suzuki, 2013

Young men play baseball on an open lot, now home to Cooperstown's Doubleday Field, circa 1920. Once a cow pasture, Cooperstown's fabled ball field later secured its prominence as a national treasure by hosting the likes of Babe Ruth, Jackie Robinson, and Hank Aaron, as well as countless amateur ballplayers. Today, the historic landmark, which is situated less than two blocks from the National Baseball Hall of Fame in the upstate New York village, is not only a destination for baseball teams, but baseball fans from around the world.

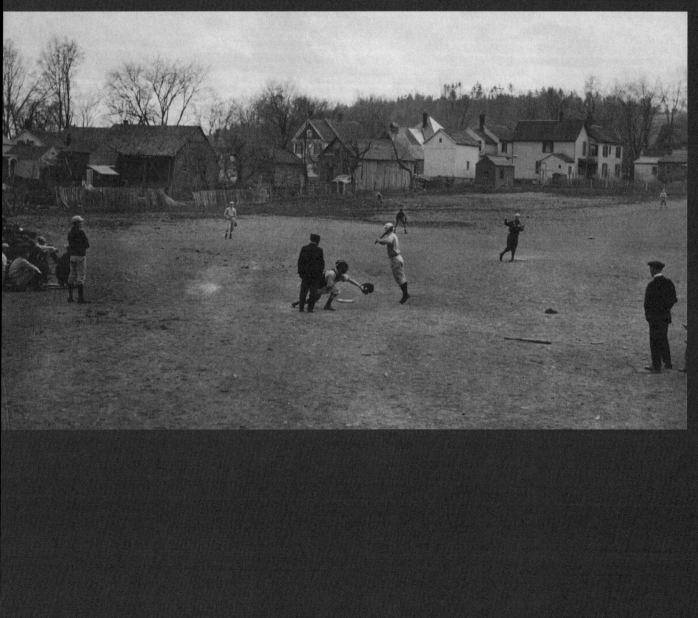

"I am going to try to be an officer.
I don't know how much of a success
I shall make of it. I had determined
from the start to be in this war if it
came to us, and if I am not successful
as an officer I shall enlist as a private,
for I believe there is no greater duty
that I owe for being that which I am—
an American citizen."

—Eddie Grant, 1917

Following stints in Cleveland, Philadelphia, and Cincinnati, Eddie Grant poses in the mid-1910s as a member of the New York Giants, his final major league club. But it was his selflessness, not his ball play, that distinguished the Harvard-educated third baseman. Responding when the US joined its allies to fight in World War I, Grant died fighting in France on October 5, 1918, the first big leaguer to make the supreme sacrifice for his country in the Great War in Europe.

Photograph by Paul Thompson

"When Barney wanted a picture, he got it."

—Longtime Dodgers pitcher Clem Labine, 2006

Amid a scramble of cameramen covering the 1956 World Series at Brooklyn's Ebbets Field, Dodgers official photographer Barney Stein (squatting at far left) maintains a firm grip on his Graflex camera. Stein was also a staff photographer with the *Brooklyn Times Union,* and, as the New York Yankees faced the Brooklyn Dodgers for the sixth time in the previous 10 seasons, it was no wonder that newspapers from all five boroughs made sure every angle was covered by their "photogs."

Photograph by Osvaldo Salas

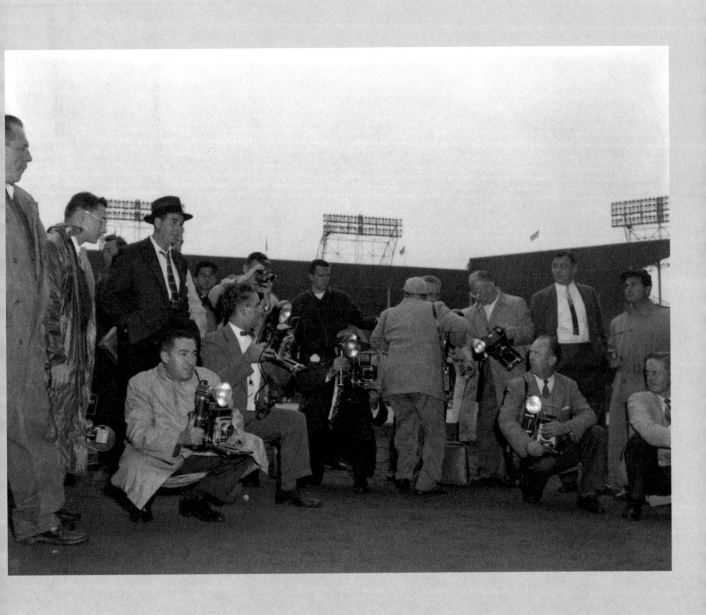

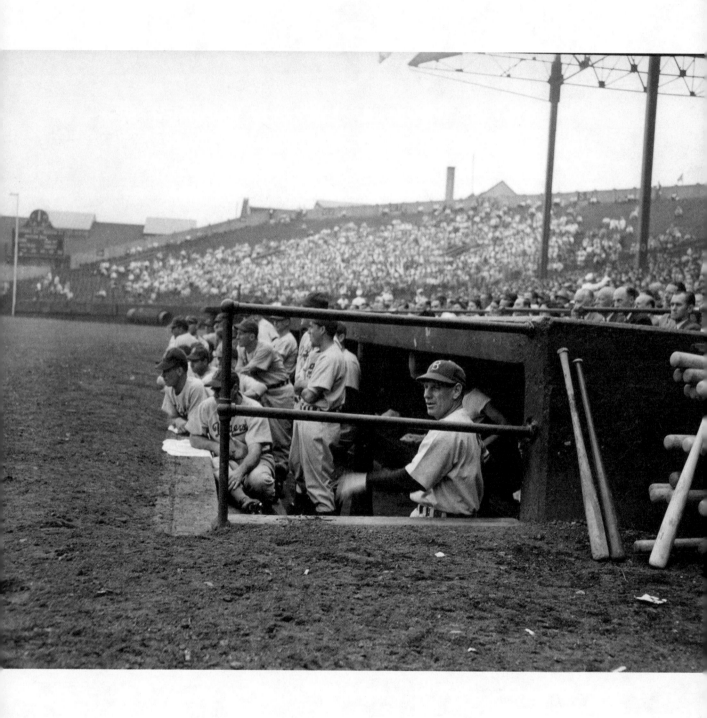

"As long as I've got a chance to beat you, I'm going to take it."

—Leo Durocher, 1975

Dodgers manager Leo Durocher surveys the diamond from the dugout at Boston's Braves Field in 1946. Throughout his managerial career, Durocher, like many managers, stationed himself at the end of the dugout nearest home plate, ensuring that players would have to walk by—and avail themselves of various counsel—en route to their at-bat. It also made for a shorter distance to converse with (that is, bark at) the home plate umpire.

Photographer unidentified

" 'Who wants to buy a dog?' As I shouted, Chris Von Der Ahe, the lucky Dutchman, then in the heyday of his power, came from another room.
He took one look at the dogs and then asked, 'What does he want for them?' 'Three hundred for the two,' I said. 'They go together.' 'Sold,' said Chris."

—Sportswriter Alfred H. Spink, *1000 Sport Stories*, 1921

Flanked by two handsome greyhounds, the St. Louis Browns pose for a team portrait after winning their fourth consecutive American Association championship in 1888. The dogs once belonged to an up-and-coming pitcher named John Healy. When asked to pitch in a local championship game, Healy agreed, but only if someone would take the dogs off his hands. The Browns' eccentric owner, Chris Von Der Ahe, came to the rescue, spontaneously making the purchase and adopting the canines as official mascots of his club.

Photograph by Fitz W. Guerin

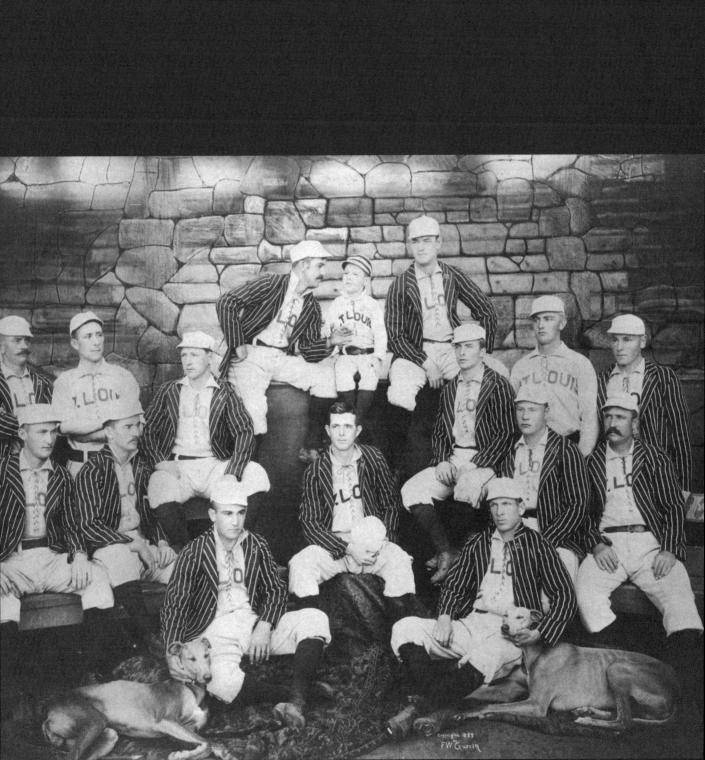

Copyright 1888
F.W. Guerin

Nearly 30,000 fans overwhelm Baltimore's recently completed Terrapin Park as Baltimore and Buffalo meet on April 13, 1914, for the first major league game in the history of the short-lived Federal League. Meanwhile, just across the street, a crowd of just 3,000 attended a preseason exhibition contest between the International League Orioles and the New York Giants. Pitching for the Orioles that day was a 19-year-old local kid named George Herman "Babe" Ruth. In hindsight, 30,000 fans went to the wrong game.

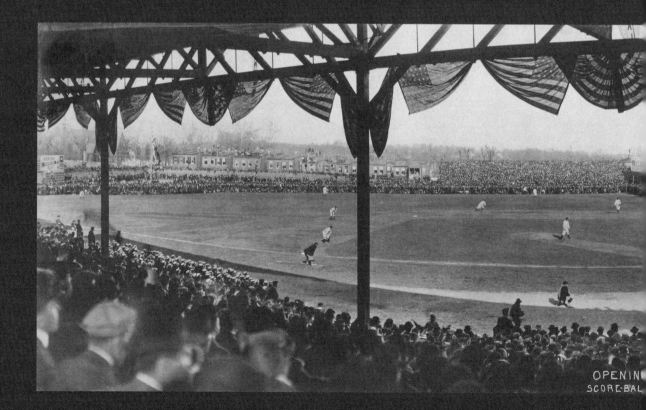

OPENIN
SCORE-BAL

"Hurrah! The season's started—
the opening game's today!

The fans are swarming to the park
to see our heroes play;

The whole darn town is turning out,
to get in on the fun,

And cheer the team that has the flag
already good as won."

—Sportswriter Grantland Rice, March 1907

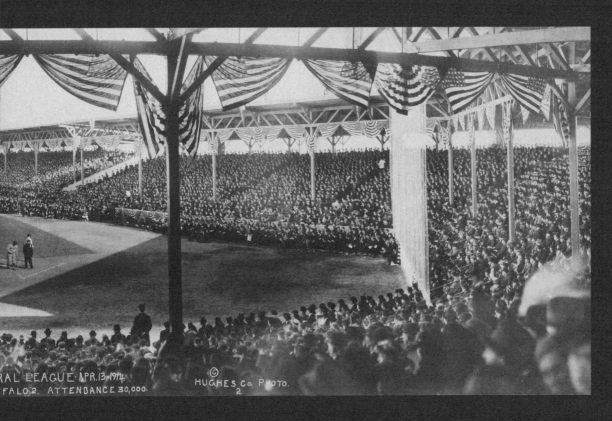

RAL LEAGUE· APR.13·1914
FALO 2. ATTENDANCE 30,000. HUGHES Co. PHOTO.
2.

Photograph by the Hughes Company

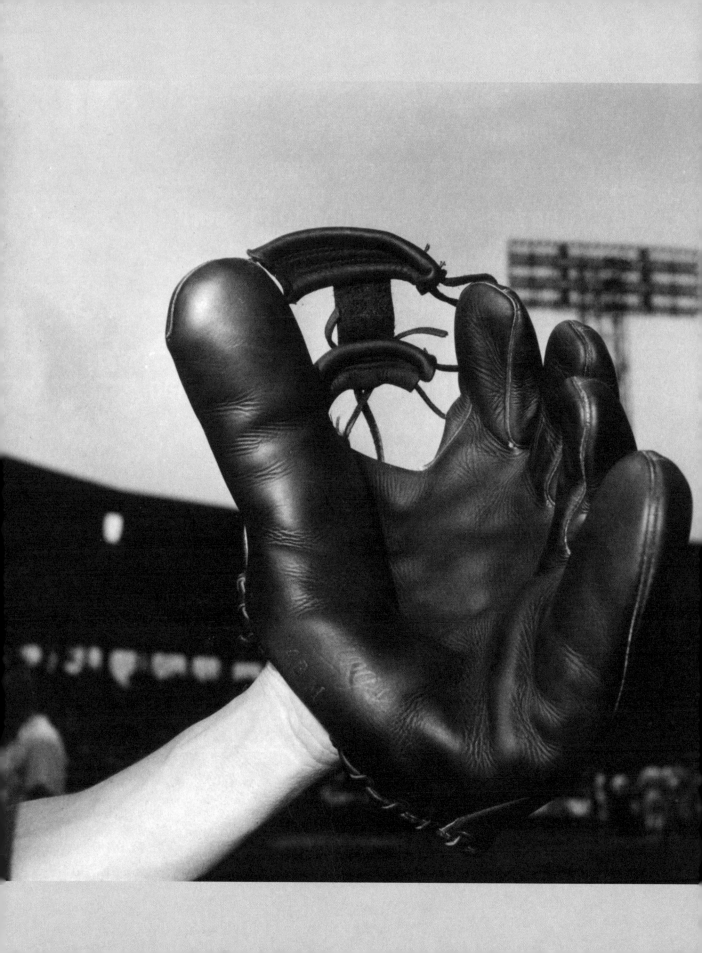

"It's your glove, your baseball glove. It's got a soul, a memory all its own, and a future that never fades, because it has never let go of the grasp the past has on you and so many others."

—Journalist Mike Barnicle, *The Daily Beast* website, March 30, 2014

Center fielder Dom DiMaggio shows off his well-worn glove, circa 1948. The Rawlings professional model served the Boston Red Sox star well, as he was generally considered to be one of the best outfielders of his era. Still, from a modern-day point of view, one is left wondering how any play could be made with such a leather contraption. The answer? Use two hands... just as you still should today.

Photograph by Frank Bauman

"Outstanding. Similar to Jeter only bigger and better. Better at 17 now than all the superstars in baseball were when they were seniors in [high school] … Generates a special feeling when watching him play … Premium prospect with potential to be an impact player."

—Report by Seattle Mariners scout Roger Jongewaard, 1993

Young Seattle Mariners shortstop Álex Rodríguez pauses for a moment in 1996, his first full year in the majors. This was the season he became a superstar, the season he became "A-Rod," the season he topped the American League in runs, doubles, batting average, and total bases, and the season he captured the first of his 14 All-Star berths and 10 Silver Slugger Awards. And it was also the season when all the potential that had caught the eye of scout Roger Jongewaard came to fruition.

Photograph by José Luis Villegas

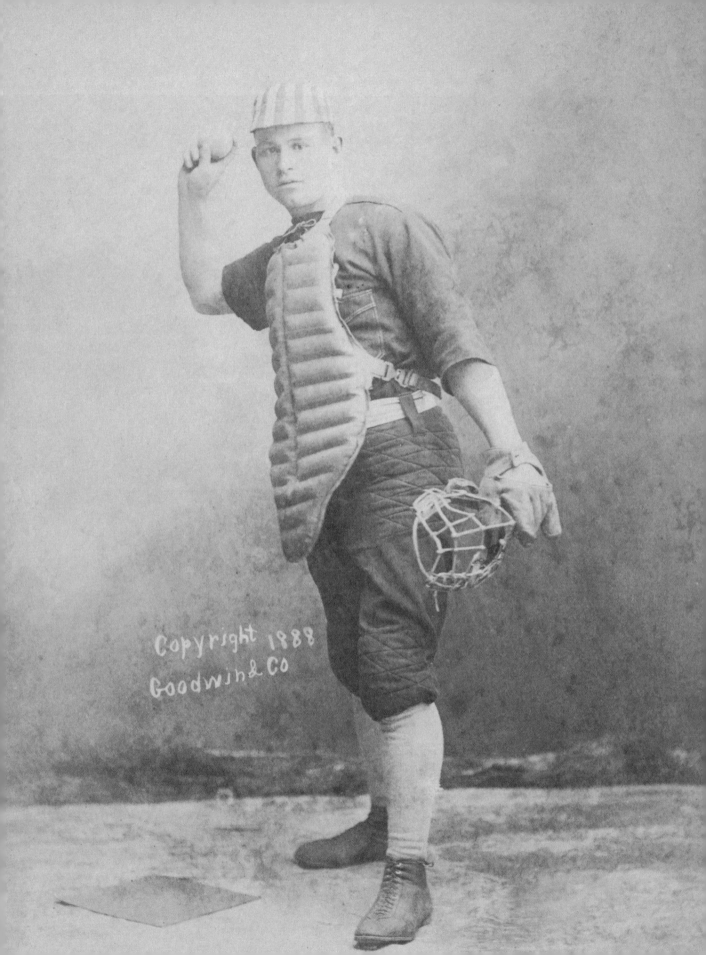

Copyright 1888
Goodwin & Co

"As catchers are hidden from us by mask and armor, so their skills are hidden. The best-caught game is the one least noticed."

—Author David Falkner, *Nine Sides of the Diamond*, 1992

Billy Earle of the Western Association's St. Paul (Minnesota) Apostles strikes a catcher's pose in 1888. While catchers in the 19th century began with nothing but a mouth guard and mangled hands due to the lack of gloves, the evolution of baseball's protective equipment eventually included masks, mitts, chest protectors, and shin guards. The introduction of such gear was often met with derision from fans and opponents, but for those behind the plate, the paraphernalia helped them survive collisions, foul tips, and wild pitches.

Photographer unidentified

"There was only one Matty—only one.
For Christy Mathewson of the
New York Giants was something
more than one of the game's greatest
pitchers. [He] brought class and
character to baseball beyond all
others. For a combined mixture
of brains, courage, and skill,
he stood alone."

—Sportswriter Grantland Rice, *The New York Sun*,
February 13, 1934

Confident, relaxed, and refined, the incomparable Christy Mathewson
stands alone on the field at New York's iconic Polo Grounds in 1911.
At the time, "Matty" and the Polo Grounds *were* the Giants. The season of 1911
was the ninth of a dozen straight campaigns in which Mathewson notched
over 20 victories, and it marked the first of three straight pennants captured
by his club.

Photograph by Charles M. Conlon

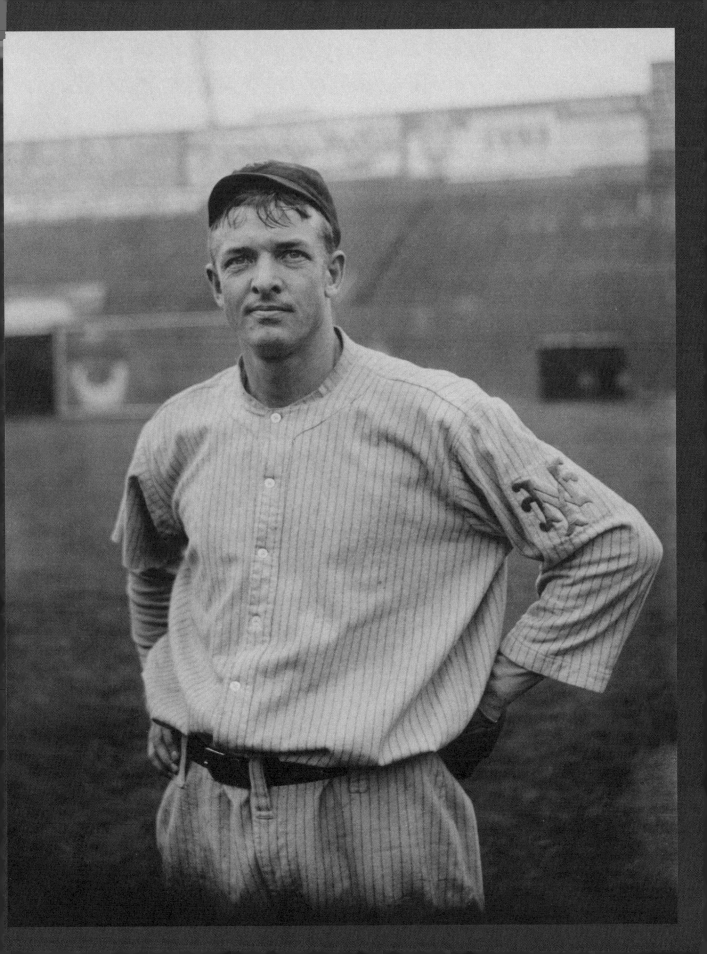

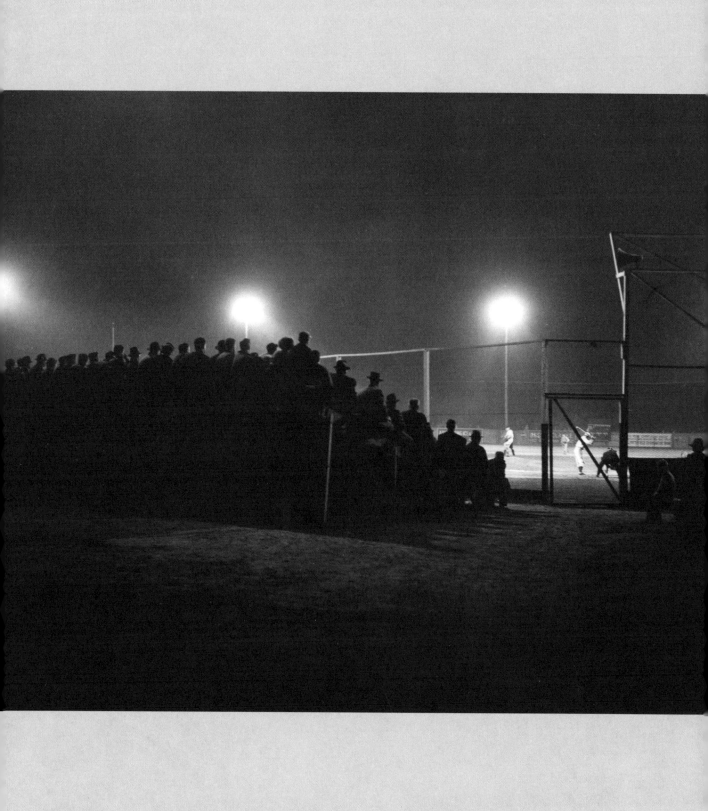

"A ballpark at night is more like a church than a church."

—Author W.P. Kinsella, *Shoeless Joe*, 1982

The stands are filled to the brim for a 1946 game under the lights at Elm Park in Oneonta, New York. Today known as Damaschke Field, the quaint ballpark is a quintessential example of America's love for grassroots baseball. Whether comprised of imported professionals or local amateurs, clubs that play at fields like Damaschke thrive on a devotion to baseball that is unique to small-town America.

Photograph by Hy Peskin

" ... By carefully selecting the depth
of field and making it narrow, I could
create a sense of movement and
reality that was in fact not there."

—Photographer David Levinthal, 1998

As photographed by David Levinthal, this figurine of Ichiro Suzuki perfectly captures the hitting legend's iconic swing. The artist recognized and highlighted his subject's distinctive features, and by experimenting with focus and lighting, imbued a simple baseball toy with life. Using an extremely large-format Polaroid camera, Levinthal fulfilled his vision in a giant 20-by-24-inch print, rich in color and stunning in detail.

Photograph by David Levinthal

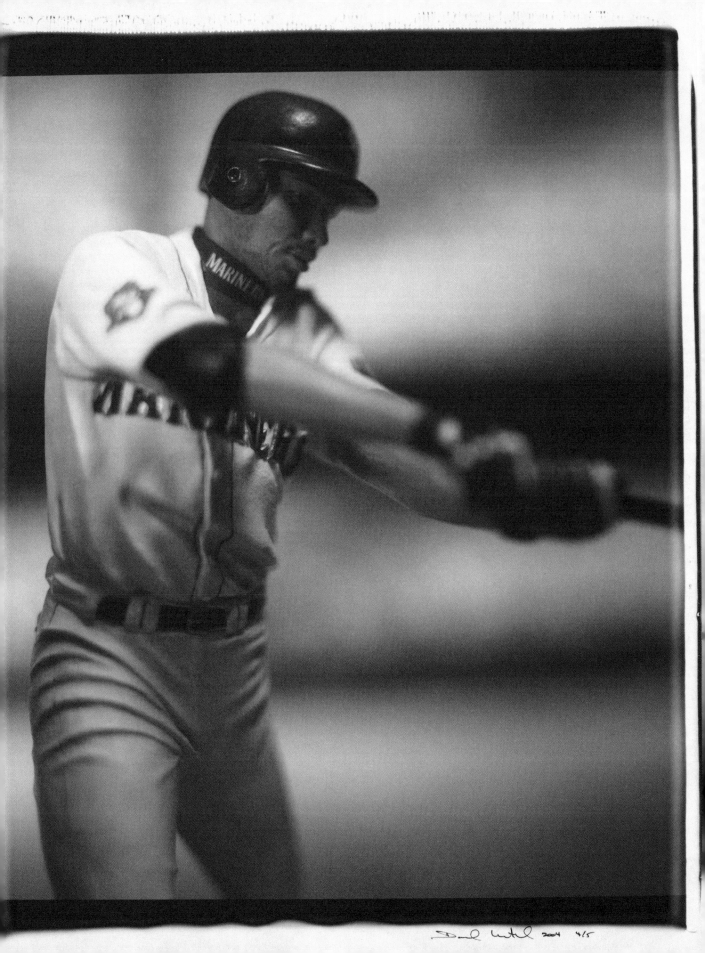

David White 2004 4/5

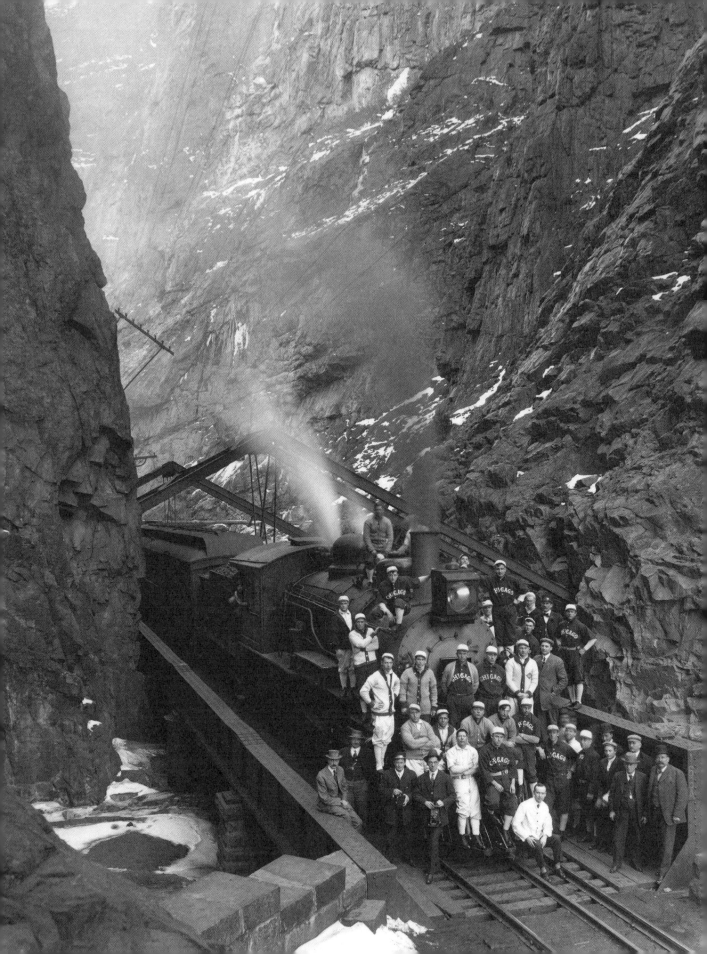

"It resulted in a far greater camaraderie than you have in ball clubs today, because you spent so much time together.... We ate together in the dining car, played cards together, slept together in the Pullman cars, and talked baseball by the hour."

—Infielder Don Gutteridge in 1991, on traveling by train in the 1930s and '40s

En route to spring training in San Francisco, the Chicago White Sox gather in front of (and atop!) their train on the Royal Gorge Hanging Bridge, February 27, 1910. Completed in 1879, the bridge built along the Arkansas River in Fremont County, Colorado, became a popular location for trains to stop, allowing visitors to examine the engineering feat and have their picture taken. Indeed, just a few years before the Sox took advantage of the photo op, President Theodore Roosevelt did just the same.

Photograph by George L. Beam

"The objects of this Association are ... to foster the most creditable qualities of baseball writing and reporting."

—Baseball Writers' Association of America constitution

A cadre of the top New York City sportswriters pose at the Polo Grounds during the 1912 World Series. At a time when three of the 16 big league teams called New York home, there were more than a dozen local daily newspapers chronicling their ball-playing exploits. "The Knights of the Keyboard" pictured are (standing, left to right) John Wheeler and John B. Foster, (seated in chairs) Sam Crane, Fred Lieb, Damon Runyon, Bozeman Bulger, Sid Mercer, Grantland Rice, and Walter Trumbull. On the ground are an unidentified boy and concessionaire Harry M. Stevens.

Photograph by Pach Brothers

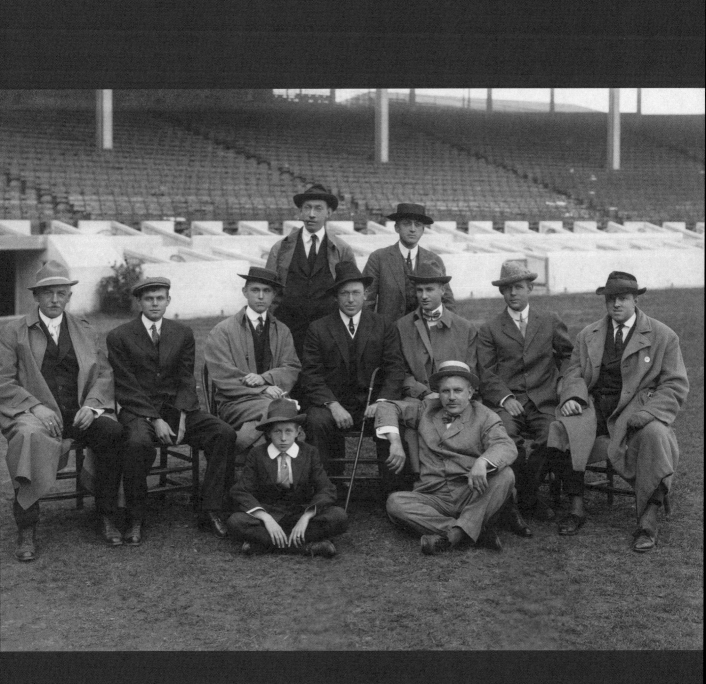

"The game begins with sons and fathers, fathers and sons. The theme is older than the English novel, older than 'Hamlet,' old at least as the Torah. You play baseball with love, and you play baseball to win, and you play baseball with terror, but always against that backdrop—fathers and sons."

—Author Roger Kahn, *A Season in the Sun*, 1977

Staring through a catcher's mask, young Lew Fonseca Jr., son and namesake of the White Sox player-manager, dons a chest protector and a pair of shin guards in the early 1930s at Chicago's Comiskey Park. The father-son bond (and that of mothers and daughters as well) undoubtedly goes back to baseball's beginnings, and it continues to thrive today, whether it's playing catch in the front yard, attending a game together, or debating the travails of a favorite team.

Degradation of Photographs

Photography began as a grand science experiment. Mix a few chemicals and see what happens. Keep experimenting and try to make it safer, faster, lighter. As a result, many of the compounds used to create photographs and negatives are unstable and easily degrade over time. The medium, the binder, the emulsion, and the silver or dye used all affect the volatility of the photo. Common problems include flammability, vinegar syndrome, mold, shrinkage, and fading, or in the case of gelatin dry glass plate negatives, such as the one used to create the image featuring Lew Fonseca Jr., cracked or broken glass supports, flaking emulsion, and oxidative deterioration.

Photographer unidentified

"The Philadelphia Giants are the champion colored baseball team of the world. Their record last year [1905] was 144 victories and four tie games out of 172 games played during the season."

—*The Minneapolis Journal*, April 5, 1906

Members of the Philadelphia Giants gather around white sportswriter and team owner Walter Schlichter for a studio shot in 1909. Later mislabeled as the 1906 club, this photo of the squad is missing key players from their earlier powerhouse teams, including Hall of Famers Andrew "Rube" Foster, Pete Hill, and club cofounder Sol White. Still, these 1909 Giants could boast of another Hall of Fame legend, one of the greatest players to ever grace the diamond, John Henry "Pop" Lloyd (standing, second from right).

Photographer unidentified

Season 1906

"The war won't be over for Boston fans until [Ted Williams] again wears his Red Sox uniform."

—Sportswriter Harold Kaese, *The Boston Globe*, August 21, 1945

Facing the Yankees at Fenway Park in 1942, Boston's Ted Williams displays his unmistakable batting form: the dramatic follow-through, long stride, and vicious cut that made No. 9 perhaps the most feared batter of his day. When the season ended, Williams had won his first Triple Crown, but with World War II raging, he joined the military and used his focus and drive to become an exceptional pilot and flight instructor.

Photograph by Bob Sandberg

"The greatest crowd that has
assembled at a ball game this year ...
flocked to the plateau overlooking
the Hudson to see 'Big Six' carry the
team through with flying colors.
Matty measured up to the job
majestically and served the Phillies
a delicious portion of goose eggs
on a gold platter."

—*The New York Times*, May 28, 1911

After Christy Mathewson's 2-0 victory over the visiting Phillies, a throng some 25,000 strong swarms over the field as they exit New York's Hilltop Park on May 27, 1911. The park overflowed with jubilant fans that day, with every seat occupied and thousands forced to sit on the grass in front of the grandstands, bleachers, and outfield walls. The ballpark was briefly home to the Giants that spring while the Polo Grounds were being rebuilt following a devastating mid-April fire.

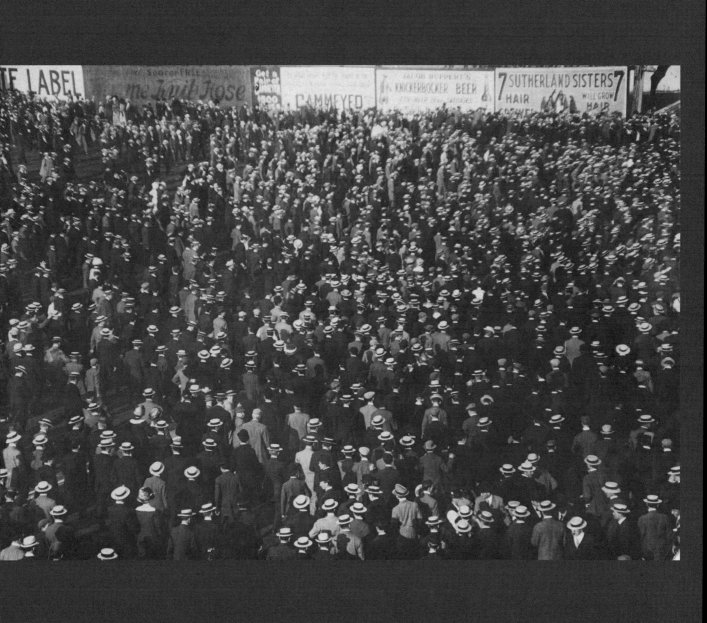

"He's still the only man in the big leagues who can stretch a double into a single."

—Sportswriter Joe Gootter, *The Paterson (New Jersey) Evening News*, May 11, 1943

Cincinnati Reds catcher Ernie Lombardi stands for a portrait, circa 1937. It is a shame that Lombardi is more often remembered for his prominent nose (he was nicknamed "Schnozz") and his lack of footspeed than for his ability with the bat, which was nothing short of spectacular. A rugged six-foot-three and 230 pounds, Lombardi won National League batting titles in 1938 and 1942 despite infielders playing virtually in the outfield due to the time he took to reach first base.

Photograph by Forrest S. Yantis

"We get out of life what we put into it. The same could be said about baseball."

—Bert Blyleven, 2011

Confident and slightly bemused, Bert Blyleven demonstrates how he pitches out of the stretch at Oakland-Alameda County Coliseum, June 29, 1977. The son of immigrant parents who married while their native Netherlands was under Nazi occupation, Blyleven and his family came to the US in the late 1950s seeking a better life. With 287 victories, 3,701 strikeouts, and a successful post-playing career as a baseball broadcaster, Blyleven put much into his life and earned what he got out of it.

Lighting the Scene

Photographer Doug McWilliams is known for his brilliant use of light. To make his subjects stand out from the background, McWilliams carefully balances two different light sources: the sun and a strobe. Here he captured Rangers pitcher Bert Blyleven in the late afternoon before a twi-night doubleheader with the lowering sun creating the dappled light and shadows across his back. At the same time, McWilliams used a strobe (a flash unit on the camera), illuminating Blyleven from the front and preventing his face from disappearing in shadow.

Photograph by Doug McWilliams

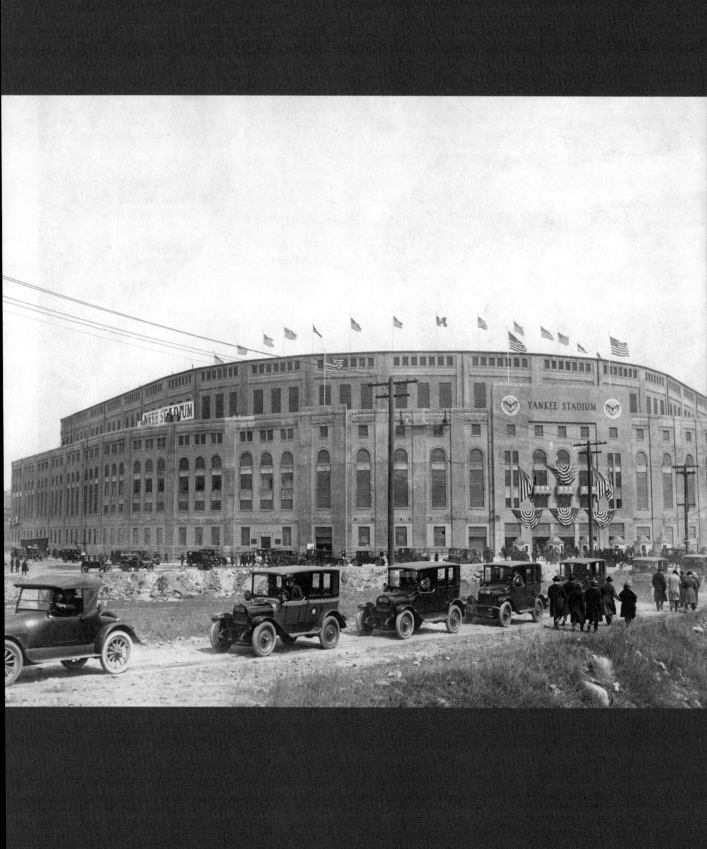

"Governors, generals, colonels, politicians, and baseball officials gathered together solemnly yesterday to dedicate the biggest stadium in baseball, but it was a ballplayer who did the real dedicating. In the third inning, with two teammates on the baselines, Babe Ruth smashed a savage home run into the right field bleachers, and that was the real baptism of the new Yankee Stadium. That also won the game for the Yankees, and all the ceremony which had gone before was only a trifling preliminary."

—*The New York Times*, April 19, 1923

With automobiles and fans congregating around its exterior, a bunting-draped and flag-festooned Yankee Stadium hosts its first game on a brisk spring afternoon, April 18, 1923. After Governor Alfred E. Smith threw out the first ball, Yankees slugger Babe Ruth, as if on cue, provided the dramatics for the estimated 74,200 home fans, blasting a three-run home run to secure a 4-1 victory over the visiting Boston Red Sox.

Photographer unidentified

"A genuine pitching wonder has risen
up to lead the Cleveland League team
to glory. His name was plain Mr. Young
at the beginning of the season,
but now it is 'Cyclone' Young."

—*The Baltimore Sun*, August 13, 1890

Denton True "Cy" Young warms up at New York's Hilltop Park during his final big league season in 1911. At the time, the veteran pitcher had already won more than 500 games and thrown more than 7,000 big league innings, records that remain unchallenged to this day. Legend has it that the Ohio farm boy earned his colorful nickname thanks to a fastball so powerful that it knocked down fences like a cyclone.

Photography by Charles M. Conlon

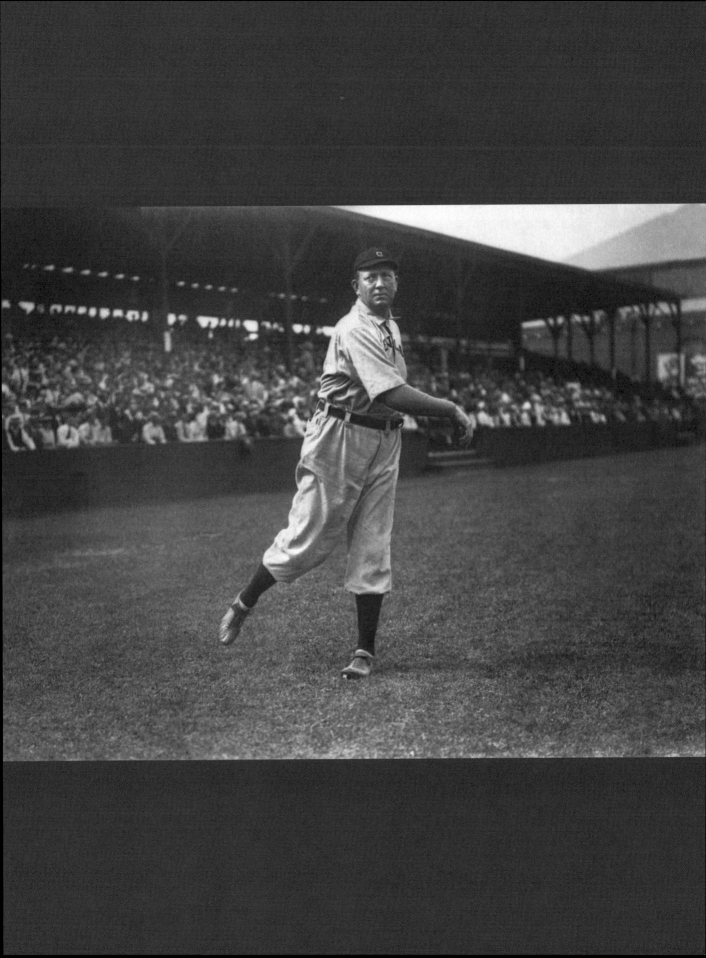

"It was so fluid, so elegant, you almost became mesmerized by it."

—Phillies pitching coach Rich Dubee on Roy Halladay's delivery, 2019

Toronto Blue Jays minor league prospect Roy Halladay pitches during the annual Hall of Fame Game at Cooperstown's Doubleday Field, July 27, 1998. After holding the Baltimore Orioles to three runs over six innings, it was clear that Halladay was ready for prime time, and he made his big league debut less than two months later. After 16 years in the majors, "Doc" Halladay retired with a stellar .659 winning percentage, a pair of Cy Young Awards, and eight All-Star Game appearances.

Photograph by Milo Stewart Jr.

"The older they get, the better they were when they were younger."

—Pitcher Johnny Sain on Old-Timers' Games in *Ball Four* by Jim Bouton, 1970

Umpire Al Schacht, a former pitcher who later gained lasting fame as a baseball clown, flamboyantly tosses Leo Durocher (left) from the annual Old-Timers' Game held at Yankee Stadium on August 25, 1956. Over 55,000 fans were in attendance to watch stars from the game's past, including Joe DiMaggio, Lefty Gomez, Wally Pipp, and catcher-turned-spy Moe Berg (wearing No. 21). Though expelled by Schacht, Durocher lived up to his "Lippy" nickname and managed to talk his way back into the game.

Photographer unidentified

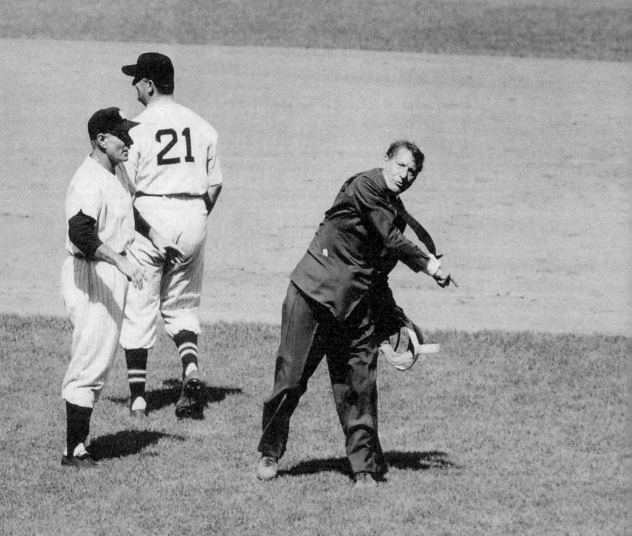

"Thousands of determined 'fans'… waited all last night and the night before, stretching their attenuated lines from the Polo Grounds fifteen blocks to 140th Street, a mile and a half, in order to get a ticket for the big games."

—*The New-York Tribune*, October 8, 1912

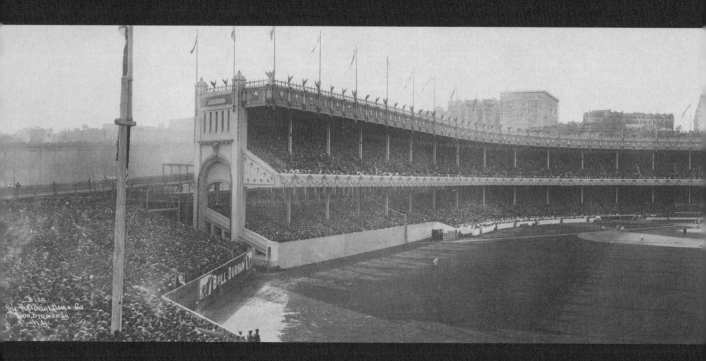

Fans overflow the Polo Grounds for the 1912 World Series between the hometown New York Giants (at bat) and the Boston Red Sox. The famed park, with its majestic décor of colorful concrete friezes and gilded eagles crowning the roofline, was not always so ornate. A more modest structure had succumbed to fire the previous season, and it was not until October of 1911 that the stunning new Polo Grounds were fully completed.

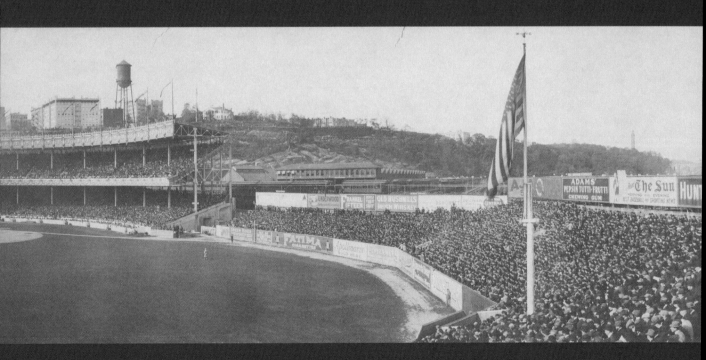

Photograph by Pictorial News Company

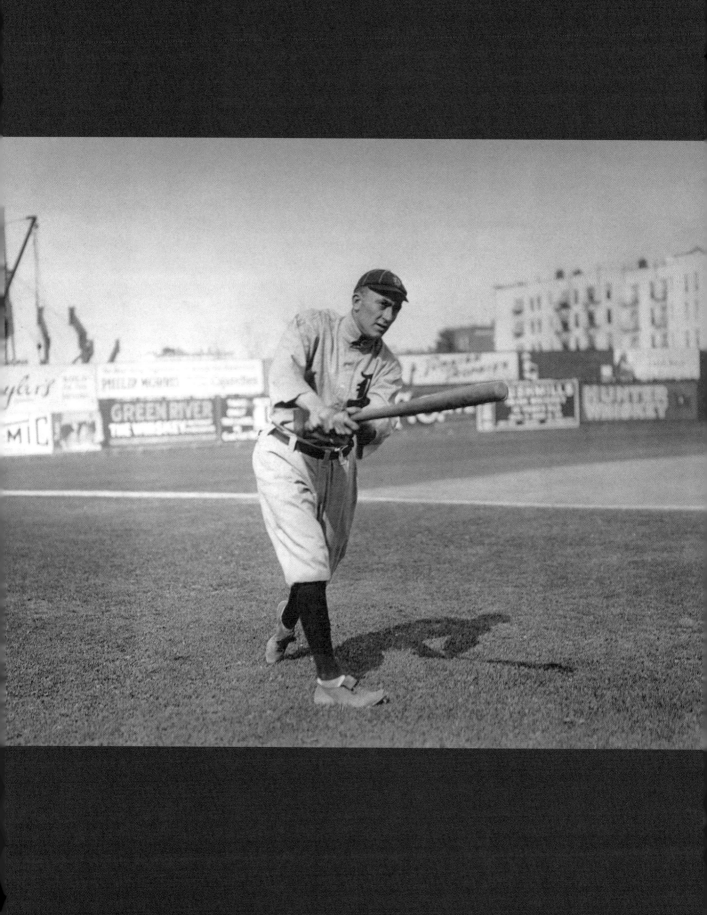

"The cruelty of Cobb's style fascinated the multitudes, but it also alienated them.... Ty Cobb was the best. That seems to be all he wanted."

—*New York Journal-American* sportswriter Jimmy Cannon in *The Miami (Florida) Herald*, July 21, 1961

Arguably the game's most successful hitter, Ty Cobb swings a bat along the third base line at New York's Hilltop Park in 1910. That season saw him bat a stellar .382, a remarkable figure until one considers that the next two years saw him post marks of .419 and .409! Even while posing for a picture, Ty Cobb flashes the unmistakable intensity that drove him to the heights of success, while simultaneously distancing him from teammates and fans alike.

"American League umpires may not call the low strike, but they look sharper than their National League brothers when they come bouncing out of the field in their maroon sports jackets."

—Sports columnist John Hall, *The Los Angeles Times*, June 18, 1973

P rior to a game at Oakland-Alameda County Coliseum in 1974, four umpires—these "men in blue" sporting maroon blazers—meet at home plate with Texas Rangers manager Billy Martin and Oakland Athletics third baseman Sal Bando, lineup cards in hand. Introduced by the American League in 1973, the maroon jacket was worn by Junior Circuit arbiters through 1979. The next season, umps in both major leagues were wearing navy blue blazers, charcoal gray slacks, and dark blue caps.

Photograph by Doug McWilliams

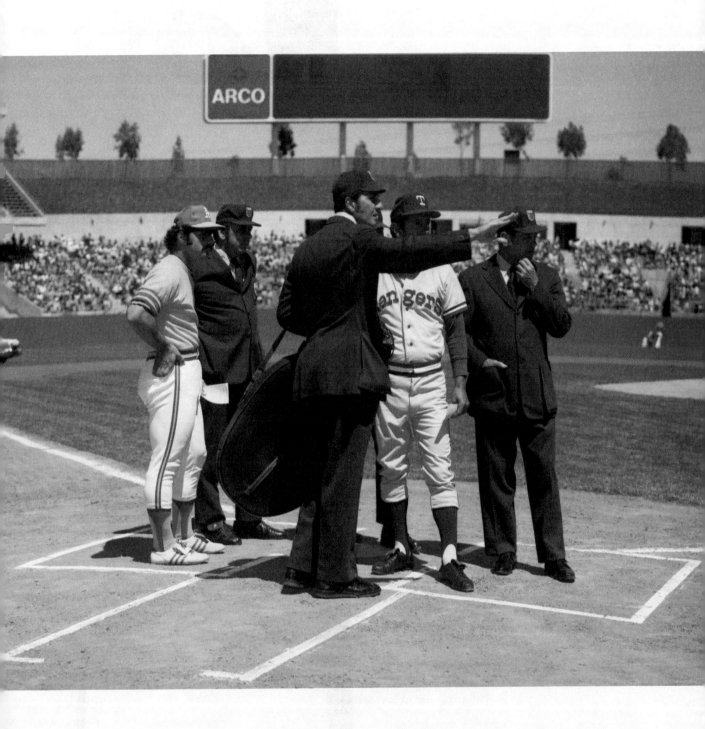

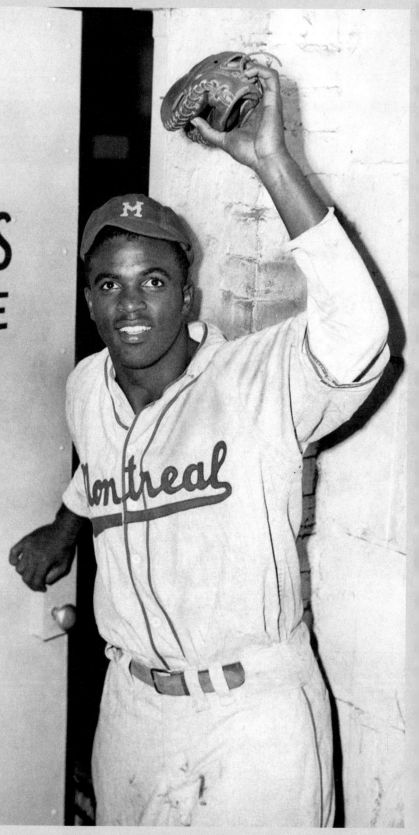

"That 'Keep Out' sign on the Brooklyn Dodgers clubhouse no longer applies to Mr. Robinson."

—*The Columbus (Ohio) Evening Dispatch,* April 11, 1947

After Brooklyn purchased his contract from the minor league Montreal Royals, Jackie Robinson opens the Dodgers clubhouse door on April 10, 1947. When he took the field for the Dodgers five days later, Robinson integrated the white major leagues, becoming the first Black player to do so since the 1880s. In his rookie season, Robinson tallied 175 hits with 12 home runs, 125 runs scored, and 29 stolen bases, in addition to winning the first-ever Rookie of the Year Award, an honor which now bears his name.

Photograph by William C. Greene

"At two thirty, when the men came out for a limbering-up throw around, thousands had flocked from all fields and covered everything excepting the pitcher's box and a small area around the home place [sic]. Not a ghost of a desire to see the game started was apparent."

—*The Boston Sunday Globe*, October 4, 1903

At Boston's Huntington Avenue Grounds (official capacity: 9,000), some 20,000 or more fans successively ring the infield, fill the stands, wrap the outfield, and mount the fences prior to Game Three of the 1903 World Series. When the field was finally cleared, play began, and the masses witnessed their hometown club's fall to the Pittsburgh Pirates, 4-2. But Boston would win four of the next five games, thus capturing the World Championship.

Photographer unidentified

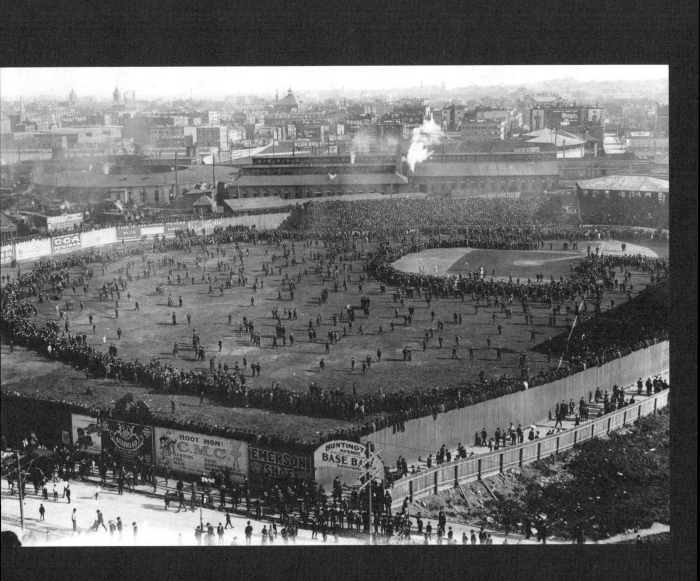

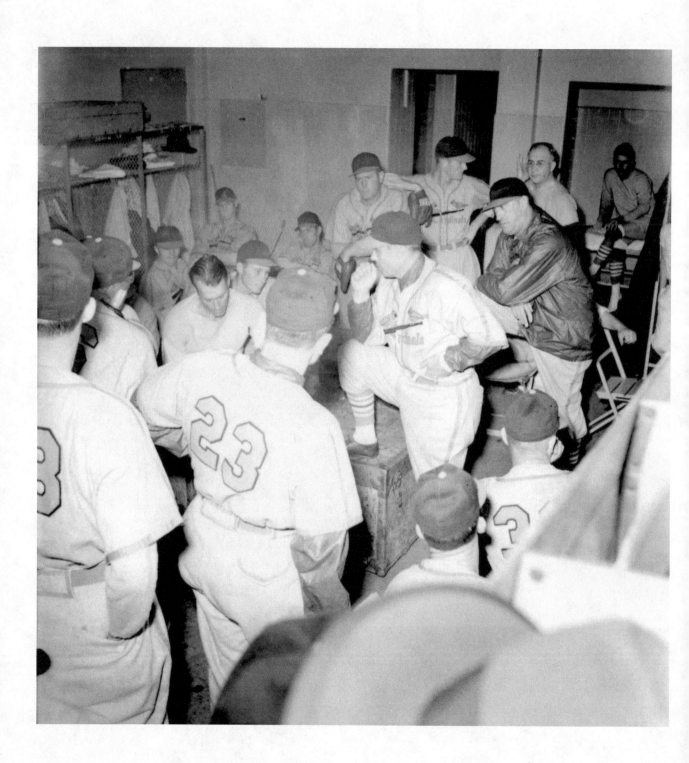

"Communication is different in the clubhouse than it is in a boardroom. The heartbeat that exists in the clubhouse … you don't find that same type of heartbeat in the front office. There is a cloak of intensity in the clubhouse that doesn't exist here."

—Red Sox General Manager Theo Epstein, 2011

St. Louis Cardinals manager Ray Blades addresses his team in Sportsman's Park's clubhouse in 1940. Clubhouses date back to the mid-19th century as a meeting place for the social clubs that played baseball. Later, they moved to the ballpark as a place to change clothes, shower, or shoot the breeze. Today the clubhouse is also a place to seek medical treatment, conduct interviews, and relax before and after the game, all the while adhering to the dictum, "What happens in the clubhouse, stays in the clubhouse."

Photograph by Frank Bauman

"Previous to the commencement of the game, the two nines, with their managers and Umpire [Billy] McLean, arranged themselves in a semi-circle just beyond the diamond and were 'photoed.'"

—*The Providence (Rhode Island) Evening Press*, October 1, 1879

Providence's Messer Street Grounds is a majestic backdrop for the hometown National League pennant-winning Greys (at right) as they pose with the 1878 champion Boston Red Stockings on September 30, 1879. Captured in this early on-field photo are pioneers of the game, future Hall of Famers John Ward (standing third from right), Jim O'Rourke (standing fifth from right), George Wright (on the ground, second from right), and George's older brother Harry (seated with cane in hand). Note the chalk-outlined "pitcher's box" at the center of the diamond, a feature that predates the pitcher's mound and explains the still-used phrase "knocked out of the box."

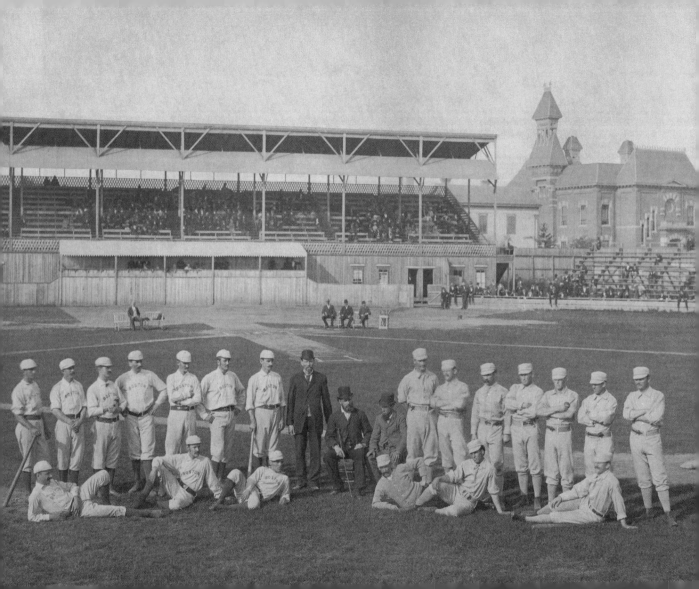

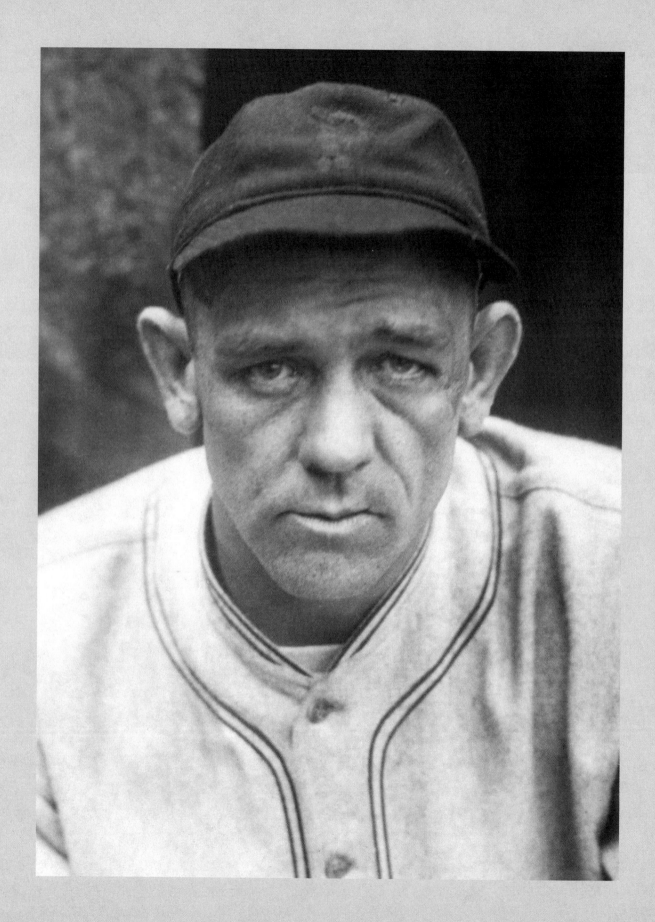

"Joseph Harris, first baseman of the Cleveland Indians, is lying in a military hospital in the small town of Tonnere, France, with a fractured skull, three broken ribs, and severe bruises on his legs, a victim of an unfortunate automobile accident. It is doubtful if he will ever be able to play ball again."

—*The Washington (DC) Evening Star*, May 22, 1919

Joe Harris, the 36-year-old first baseman and left fielder for the 1927 pennant-winning Pittsburgh Pirates, looks like he has seen it all. He has. A decade earlier, after establishing himself with Cleveland, World War I intervened. During the war, he was shot at, shelled, gassed, and suffered nearly career-ending injuries in an ambulance accident. Undaunted, he returned to star for the Boston Red Sox, Washington Senators, Pirates, and Brooklyn Dodgers, ending his 10-season big league career with a .317 batting average.

Photograph by Charles M. Conlon

> "Mr. [Hugh] Chalmers decided
> that he would offer a trophy on ...
> the basis of the greatest all around
> value of a player to his team
> in the pennant race."
>
> —*The Hartford Daily Courant*, September 21, 1911

On October 9, 1914, minutes before the start of Game One of the World Series, Philadelphia Athletics second baseman Eddie Collins is presented with a Chalmers automobile at Philadelphia's Shibe Park. As his teammates and the opposing Boston Braves viewed the festivities, Collins earned this early version of today's Most Valuable Player Award on the strength of his .344 batting average, a league-leading 122 runs scored, and his always stellar defense.

Photograph by Paul Thompson

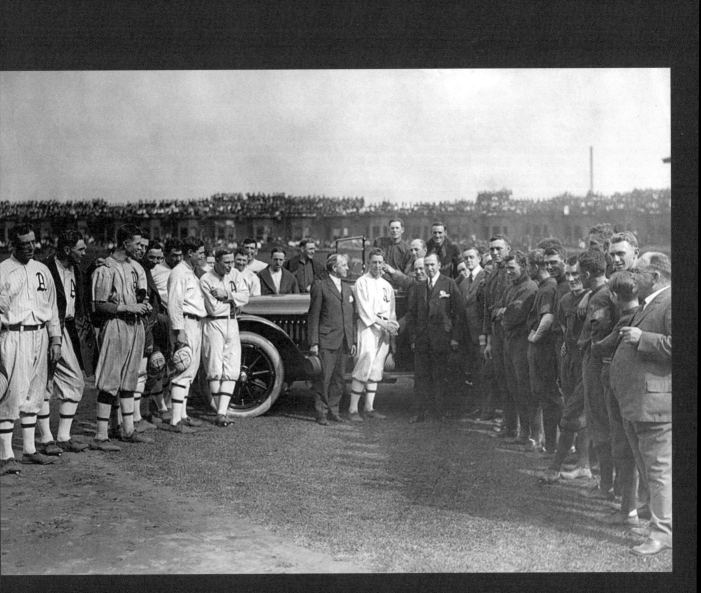

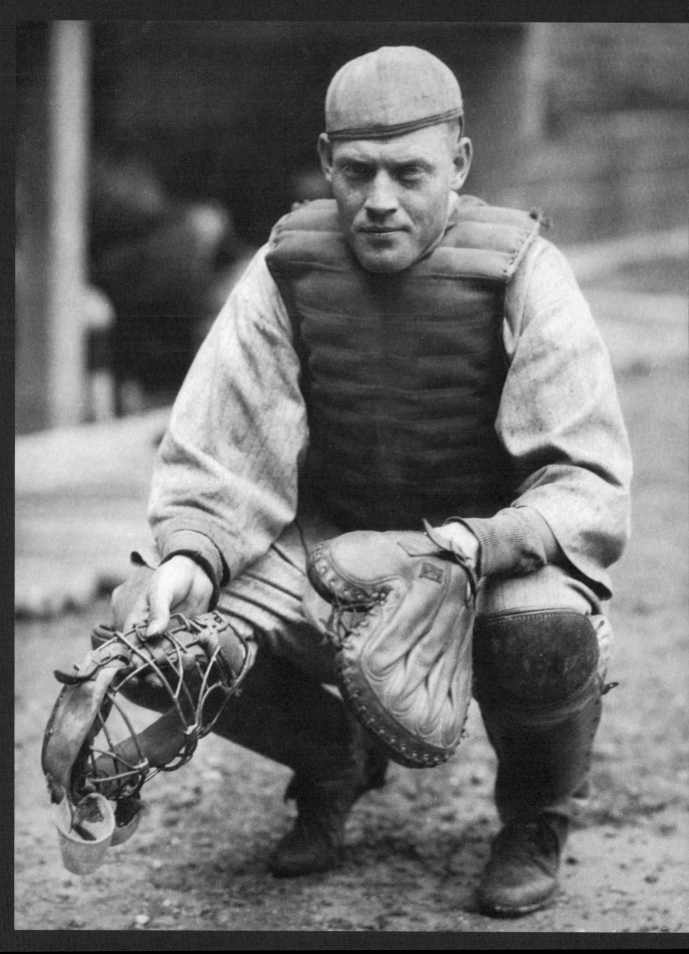

"The catcher ... is the psychologist and historian for the staff—or else his signals will give the opposition hits. The value of his headpiece is shown by the ironmongery worn to protect it."

—Historian Jacques Barzun, *God's Country and Mine*, 1954

Cincinnati's Ivey Wingo casually displays the catcher's so-called "tools of ignorance," his mask, chest protector, shin guards, and heavily padded mitt, circa 1919. Despite retiring with the National League record for most games caught in a career (1,233), the Georgia native and his wonderfully unique name have been lost to all but the most ardent fans of baseball history. Where memories fade, photographs cling to the past and help revive the stories of old.

Photograph by Charles M. Conlon

"Now Alma is sure that cookie had something to do with Babe's home run."

—The New York Times, October 16, 1923

Clutching a sugar cookie in his mouth, Babe Ruth buys a bag of homemade Girl Scout cookies from 15-year-old Alma Swahlin before Game Six of the 1923 World Series at the Polo Grounds. The Bambino holds a flyer for Girl Scout Week, which aimed to raise $439,703 in a national fundraiser. Ruth not only contributed to the Girl Scouts that day, but he also homered to help the Yankees defeat the Giants 6-4 in the October 15 tilt.

Photographer unidentified

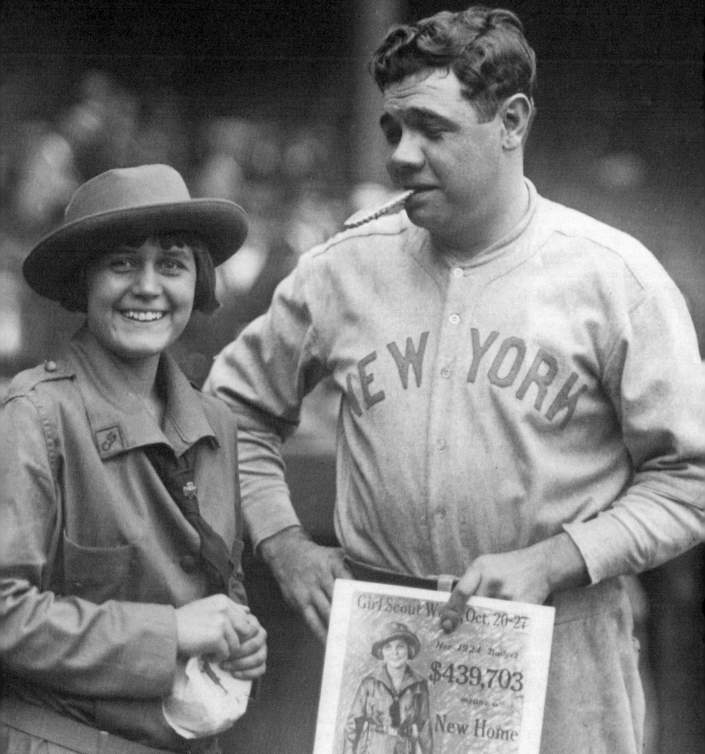

Girl Scout We... Oct. 20-27

Her 1924 Budget

$439,703

means a

New Home

"The most peculiar thing about the Japanese team was that it was not peculiar. Except for the slant in his eyes and the deep gutteral [sic] accent of his rooting, the Japanese player is as much like an American player as one pea is like another in the pod."

—Sportswriter Randall Henderson, *The Los Angeles Times*, April 20, 1911

Minori Sohara of the Japanese Base Ball Association stands ready to bat as catcher Seiji Inoue of the Sanshu club awaits the pitch in a game played in Los Angeles, circa 1913. In the face of rampant racism, the Japanese-American community embraced the American game, helping the Issei (first-generation Japanese immigrants) assimilate into American culture during the early 1900s.

Photographer unidentified

"Ten thousand fans sat spellbound through the contest. There was little cheering. Nerves were at too tight a tension for whoops and yells. There was an outburst when Cleveland's run was scored, and Walsh's great pitching drew an occasional round of hearty applause, but mostly the people sat with hands tightly clinched and bated breath."

—Sportswriter Norman Rose, *The Des Moines (Iowa) Daily News*, October 5, 1908

Chicago's "Big Ed" Walsh (left) and Cleveland's Addie Joss share small talk before their historic pitching duel on October 2, 1908, at Cleveland's League Park. With five games left in the season and both clubs racing for the pennant, Walsh struck out 15 and allowed only a single unearned run. But somehow, Joss was even better. Needing just 74 pitches, the Ohio native did not allow a solitary White Sox batter to reach first base as he tossed a 1-0 perfect game.

Photograph by Louis Van Oeyen

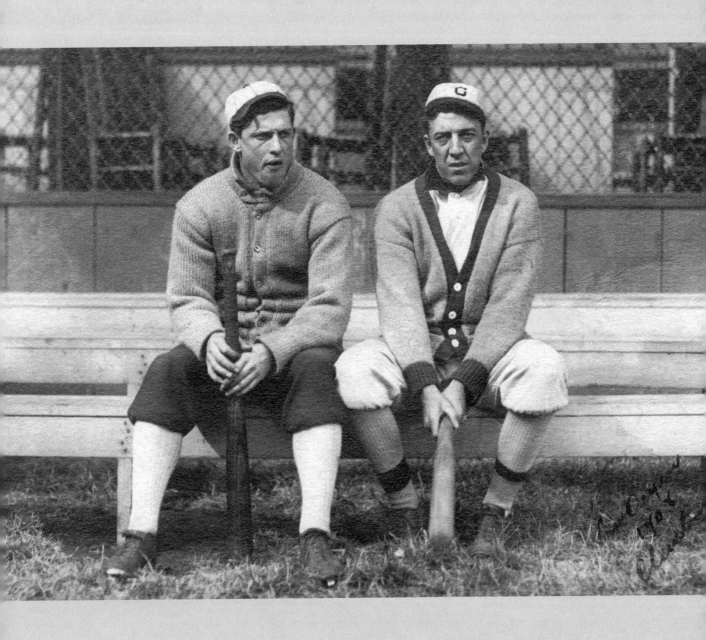

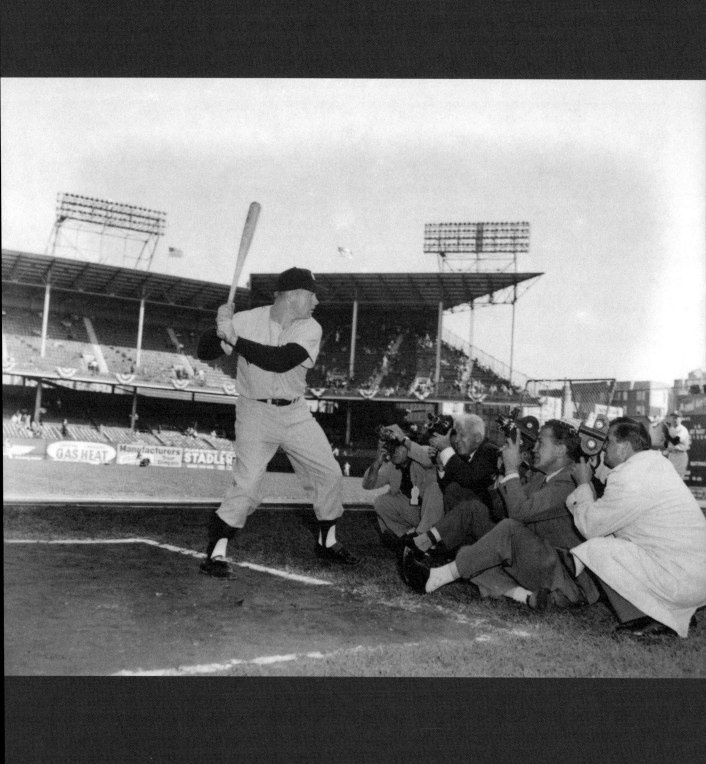

"Mickey Mantle was the kind
of ballplayer—the kind of person—
that people were attracted to."

—Bobby Richardson, 1995

A t Brooklyn's Ebbets Field prior to a World Series game in 1956, all cameras
are focused on Mickey Mantle...and why not? The 24-year-old Yankees star
ascended to the top of the baseball world that season by winning the American
League's Triple Crown. He went on to hit three of his record 18 Fall Classic
home runs that fall, helping the Yankees win their seventh title in ten seasons
and avenging their World Series loss to the Dodgers the previous October.

Photograph by Osvaldo Salas

"The greatest of all, the game
which seems to breathe the restless
spirit of American life, that calls
for quick action and quicker thinking,
that seems characteristic of a great
nation itself, is baseball."

—Photographer Charles M. Conlon, 1913

G iants batter Beals Becker tops the ball to Cardinals third baseman
Mike Mowrey at New York's Hilltop Park, May 13, 1911. This play,
a run-of-the-mill third-to-first groundout, has happened countless times in big
league history. And these players, though big leaguers one and all, are of little
note today. Yet the photograph is an unheralded classic, with the everyday
beauty of the game frozen for all time.

Photograph by Charles M. Conlon

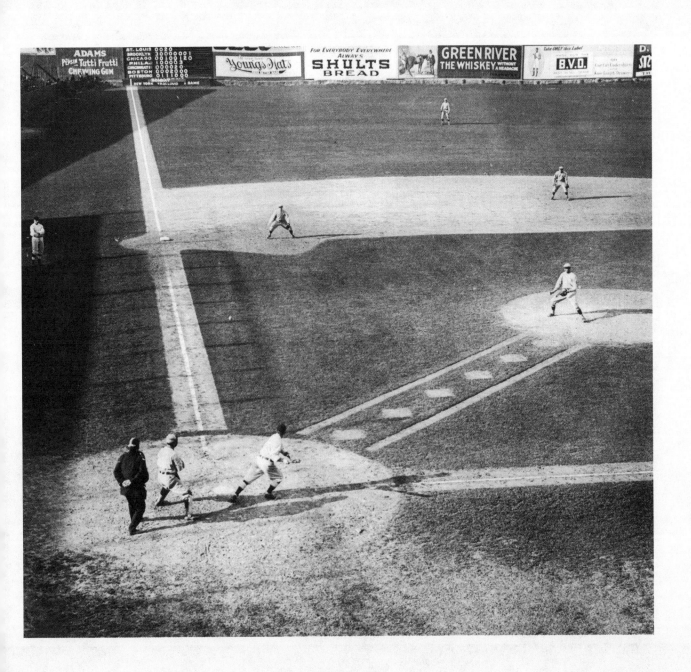

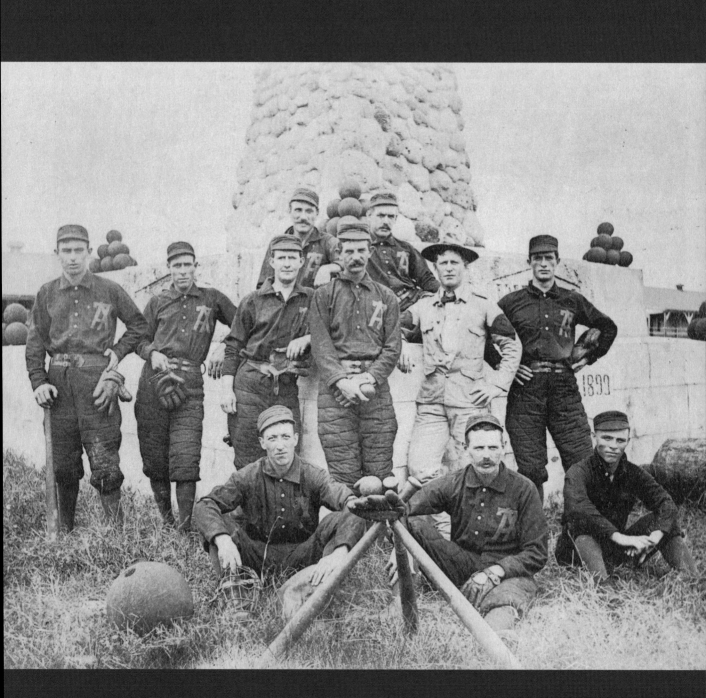

"The men take pride in having a good regimental team so they can go down and trim the town people. A good baseball team is a constant source of amusement to the garrison, as well as an impetus and a reward to those players who have come up through the school of the company team to the 'big team.' "

—Second Lieutenant Frederick B. Terrell of the 19th Infantry, 1910

The 7th Cavalry Troop A baseball team poses in front of the 161st Indiana Monument soon after its completion in 1899. The monument, the first memorial to be erected for fallen American soldiers on foreign soil, stood at the Camp Columbia Barracks in Cuba, a country already obsessed with baseball. Indeed, the same year that the monument was built, the "All Cubans" became the first baseball club from the island to tour the United States.

Photographer unidentified

" [Carlton Fisk] was standing in the midst of a baseball player's dream world. The cameras were whirring, and the white television lights filled the room, and people were being interviewed on a small wooden platform. Champagne and eggs and shaving cream were being used in varied, unique ways."

—Columnist Leigh Montville, *The Boston Globe*, October 8, 1975

R ed Sox catcher Carlton Fisk fields questions from members of the media in the clubhouse following Boston's American League Championship Series victory over the Oakland A's on October 7, 1975. Two weeks later, Fisk repeated the scene after Game Six of the World Series, when his celebrated 12th-inning home run sent the Fall Classic into a seventh and final game against the eventual World Champion Cincinnati Reds.

Photograph by Doug McWilliams

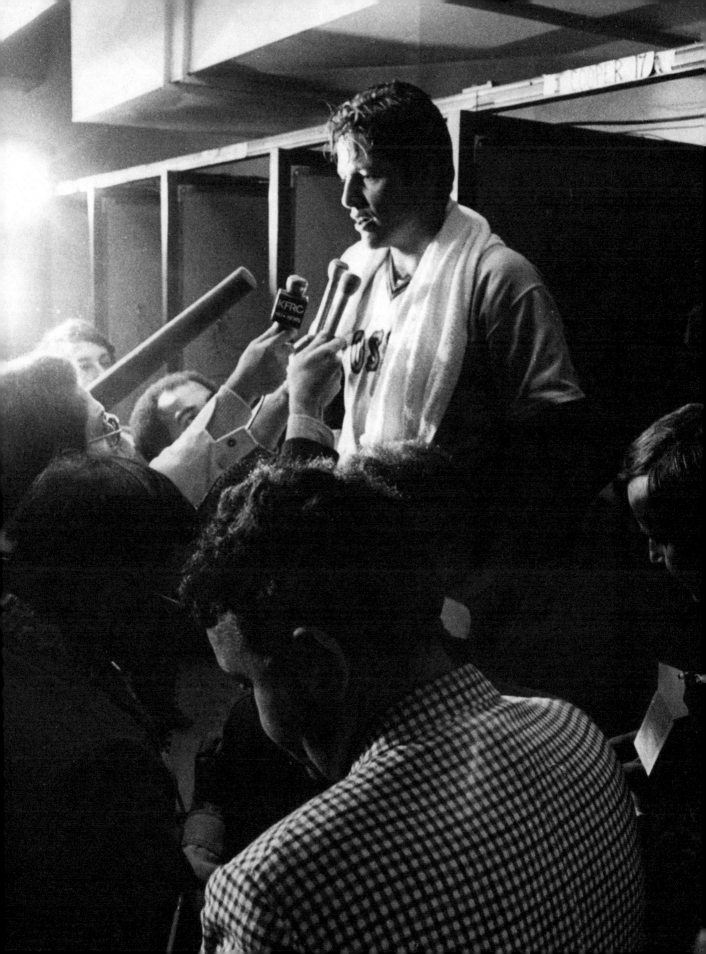

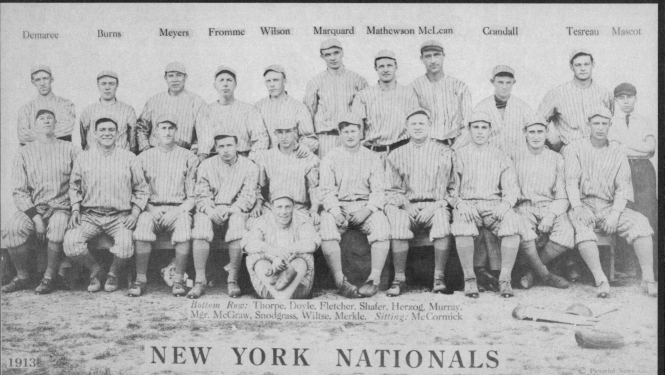

Demaree Burns Meyers Fromme Wilson Marquard Mathewson McLean Crandall Tesreau Mascot

Bottom Row: Thorpe, Doyle, Fletcher, Shafer, Herzog, Murray, Mgr. McGraw, Snodgrass, Wiltse, Merkle. *Sitting:* McCormick

1913

NEW YORK NATIONALS

© Pictorial News Co.

"On receipt of 40 'FATIMA' Cigarette coupons, we will send you an enlarged copy (size 13 × 21) of this picture (without advertising) or of any other picture in this series (National League and American League teams)."

—Advertisement for a tobacco premium, 1913

The 1913 New York Giants pose during spring training...or so it would seem. The picture used for a special collectible made available that year by Fatima Cigarettes underwent some early-20th-century Photoshopping. For example, Doc Crandall's head was pasted on Josh Devore's body, Art Fromme "replaced" coach Wilbert Robinson, and in a disturbing bit of whitewashing, Moose McCormick was pasted over the team's Black trainer Ed Mackall, whose hat and head remain partially visible just to the left of McCormick's.

"The past is never dead.
It's not even past."

—William Faulkner, *Requiem for a Nun*, 1951

Playing under the supervision of an early-1950s Plymouth doing double-duty as a backstop, youths engage in a streetball game in 2016 amidst Old Havana's unique blend of yesterday, today, and tomorrow. A lack of equipment, space, or adult oversight is no hindrance to a ballgame, and many big leaguers have honed their skills and love for the game in such humble environs.

Photograph by Jean Fruth

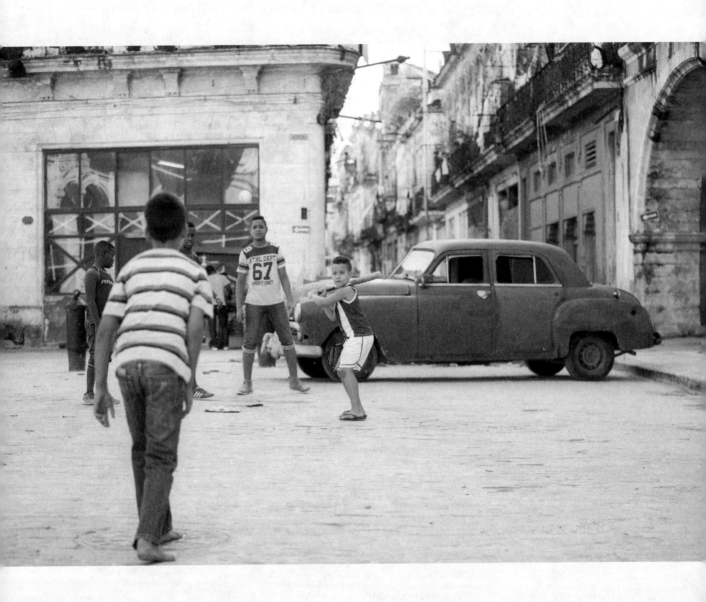

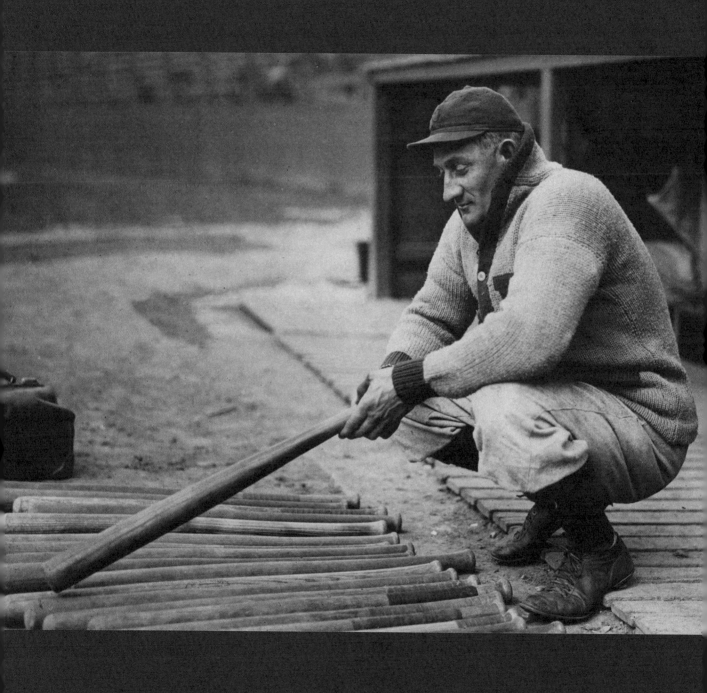

"There never was a perfect bat,
but, some years ago, I handled one
that was almost perfection."

—Honus Wagner, 1911

Honus Wagner selects a bat as he crouches in front of the Pirates dugout, circa 1916. A few years earlier, in an article titled "The Mysterious Bat," sportswriter William Phelon detailed Wagner's recollection of a bat that was "brimful of hits." While playing for Louisville in 1898, Wagner and his teammates borrowed a local boy's homemade bat and proceeded to hit numerous long balls. At the game's conclusion, Wagner hoped to buy the bat, but the boy and his extraordinary bat had vanished.

Photographer unidentified

"Charlie always said to me, 'Hammer, I can't promise that you're going to be a professional ballplayer, but I can say you'll make a positive contribution to your race, and you're a credit to your race.' And he said, 'You're going to be somebody of importance.' "

—MC Hammer, 1990

A teenaged Stanley Burrell (later known as MC Hammer) decked out in an Oakland Athletics uniform, gazes upon the Oakland-Alameda County Coliseum ballfield, circa 1978. A decade away from exploding on the music scene with "U Can't Touch This," the future rap star was dancing in the stadium parking lot when discovered and hired as a batboy by A's owner Charlie Finley. Nicknamed "Hammer" due to his resemblance to "Hammerin' Hank" Aaron, he wore No. 44 as an homage to the legendary slugger.

Photograph by Doug McWilliams

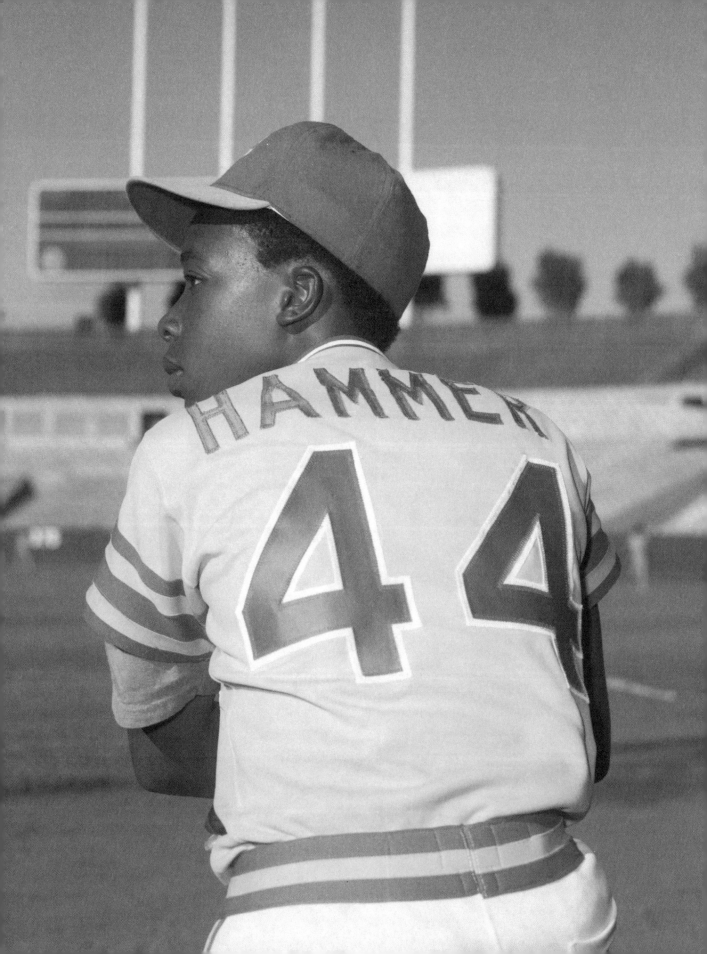

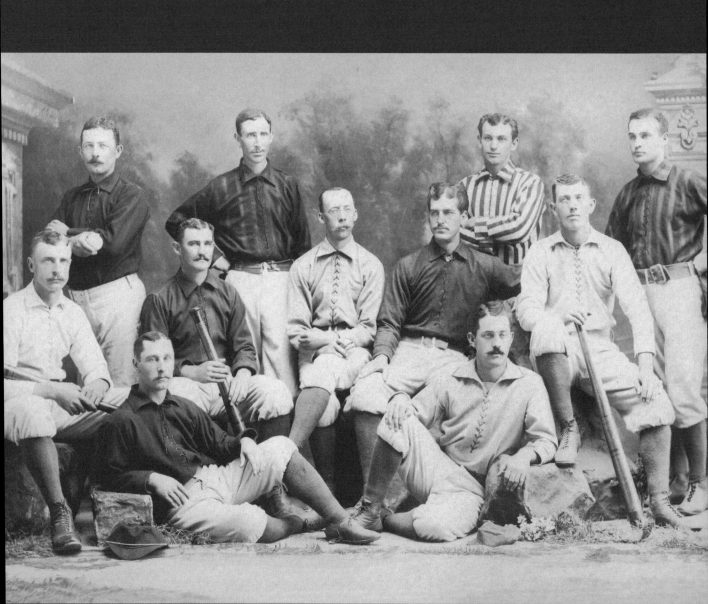

"[The uniforms] … will give a rainbow hue to the diamond and make the spectators wish they were color blind."

—*The Detroit Free Press*, December 11, 1881

The outfits of Cincinnati's 1882 American Association championship club dazzle the eyes with their potpourri of colors and patterns. Prior to the season, baseball adopted a new rule calling for multicolored uniforms to denote each player's fielding position: first basemen wore scarlet-and-white-striped shirts, pitchers were assigned jerseys of light blue, etc. Only the color of the stockings differentiated one club from another. Derided as "clown costumes," confusion reigned, and the experiment was mercifully dropped a few months into the season.

" ... Baseball, with its graceful intermittences of action, its immense and tranquil field sparsely settled with poised men in white, its dispassionate mathematics, seems to me best suited to accommodate, and be ornamented by, a loner. It is an essentially lonely game."

—Author John Updike, "Hub Fans Bid Kid Adieu"
in *The New Yorker*, October 22, 1960

Gazing out onto the field from the dugout steps at Yankee Stadium, Philadelphia Athletics hurler Bob Trice takes a quiet moment for himself before the game begins, 1954. Baseball's pregame activities, whether they be strategy sessions, stretching exercises, or fielding and batting practice, are indeed valuable. But time alone, time to reflect on recent feats or miseries, and time to be inactive also helps prepare players for the upcoming nine (or more) innings of baseball.

Photograph by Osvaldo Salas

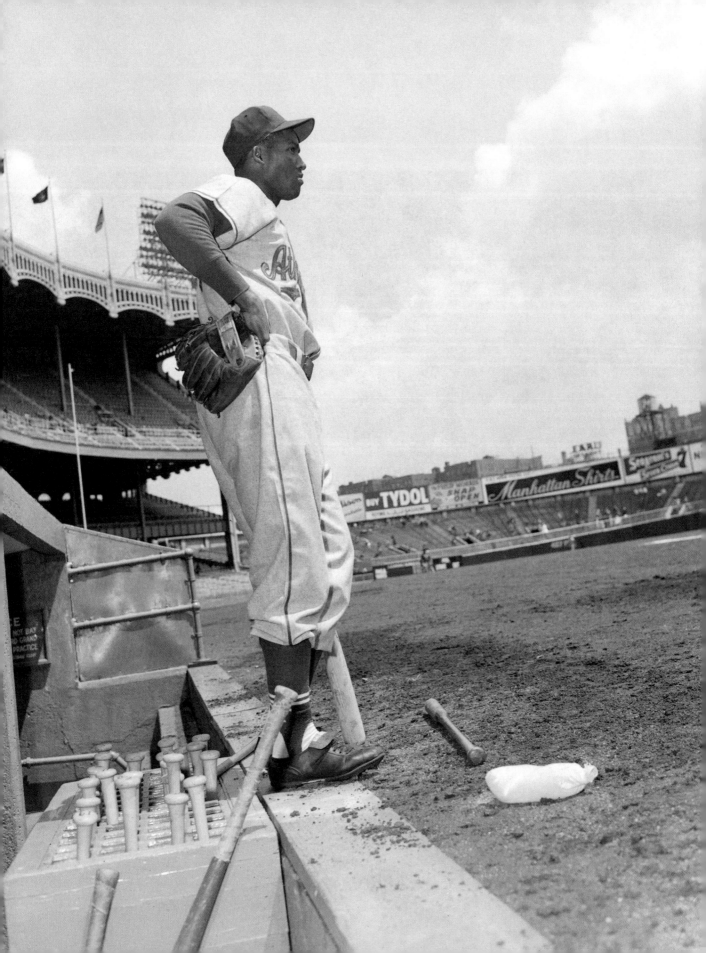

BIG
BEN
BLU
1924

"The 'Big Ben Blues.' This is not a popular song hit, as the words imply, but the name given the baseball team recently organized by the Big Ben overall factory."

—*The Middlesboro (KY) Daily News*, May 10, 1924

Gathered together on the front steps of the company's office building in Middlesboro, Kentucky, the newly formed Big Ben Blues factory team sport their unique denim uniforms in 1924. A nod to the company's main product of overalls, the blue jerseys and pants were also trimmed with green to echo the color of the factory building's wainscoting. Typical of company-sponsored teams of the era, the club was comprised of men and boys who worked in the factory and played after their shifts.

Photographer unidentified

"Carl J. Horner, the famous official photographer of the major leagues … intends to continue the photographing of base ball players as a specialty, and will take the pictures of the new players as fast as the various teams reach Boston."

—*Sporting Life*, April 8, 1905

George "Admiral" Schlei, a young catcher for the Cincinnati Reds, sits for the Boston-based photographer Carl Horner, circa 1905. Horner catered to the public as well as the press by offering images of major league players for 35 cents each. His most famous portrait, that of Honus Wagner, was later used as the basis for the Hall of Fame shortstop's scarce and much sought-after T206 baseball card, the game's most legendary collectible.

Photograph by Carl J. Horner

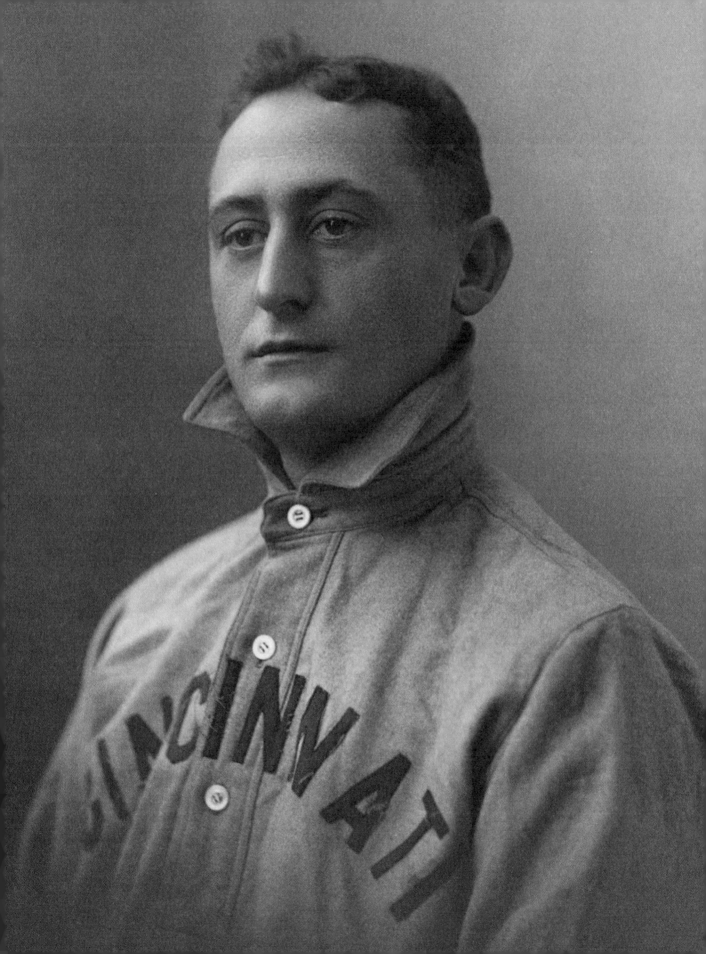

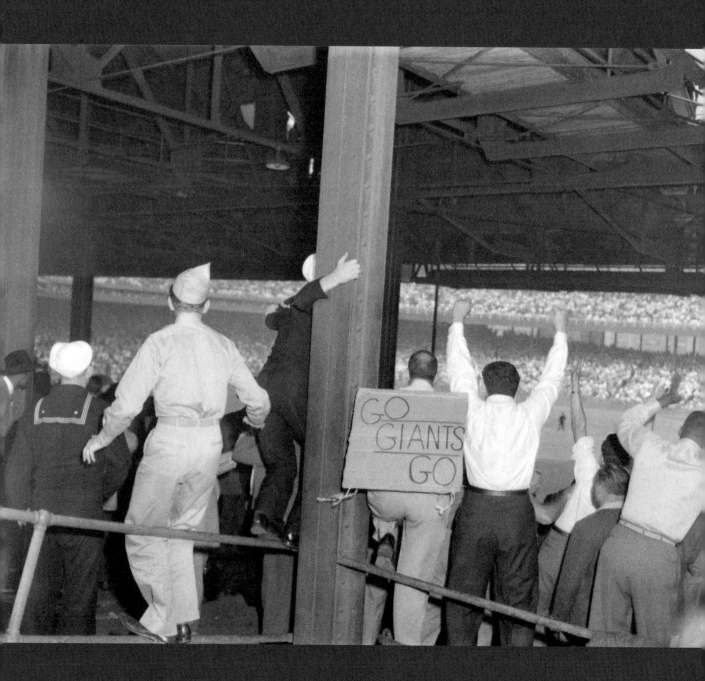

"What is both surprising and delightful is that the spectators are allowed and even expected to join in the vocal part of [the game]. I do not see why this feature should not be introduced into cricket.... The spectators could let themselves go utterly, rivalling each other in every art of the satirist and every apostrophe of the hero-worshipper."

—Irish Playwright George Bernard Shaw, 1924

A passionate melting pot of humanity, New York Giants fans of most every color, occupation, and state of attire erupt at the action on the field at the Polo Grounds in the early 1950s. Variously known over the decades as cranks, rooters, and bugs, these devotees of the game are the ones who truly own baseball. Amongst its most ardent practitioners are celebrated fanatics such as Brooklyn's Hilda Chester, Baltimore's "Wild Bill" Hagy, and the Bleacher Bums of Wrigley Field.

Photograph by Osvaldo Salas

osing for a group photo in 1866, several members of the National Base Ball Club of Albany, New York, display silk ribbons on their jerseys. Early amateur clubs, such as the Nationals, were both social and competitive, drawing membership from upwardly mobile, middle-class society. The Albany club's young sportsmen would go on to become prominent merchants, bankers, real estate moguls, and philanthropists in their community.

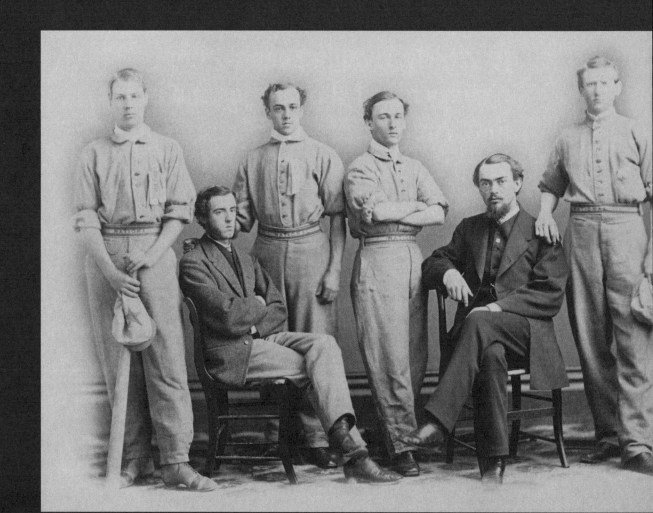

"One or two of the customs of the old game were unique. Such for instance was the habit of the better class of clubs of exchanging, just before each match, silk badges imprinted with the club name. The players wore these accumulated trophies pinned upon the breast, sometimes with startling color effects...."

—Yale alumnus Clarence Deming (Class of 1872), 1902

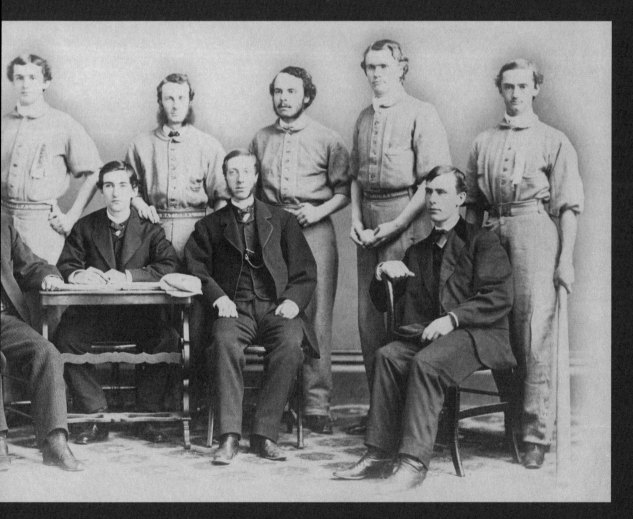

Photograph by Haines & Wickes

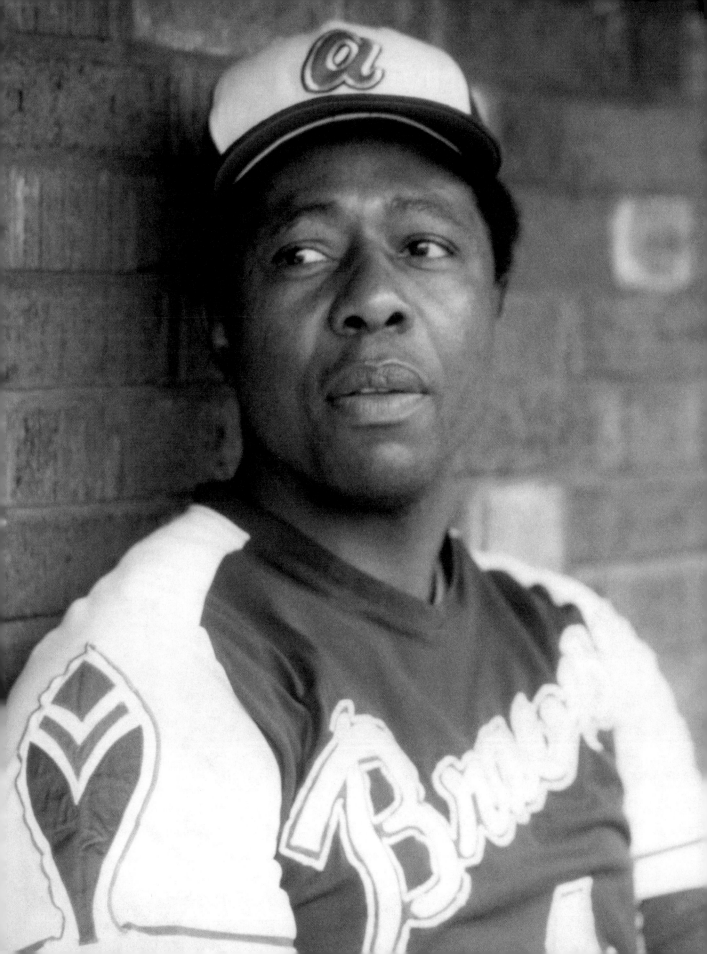

"I didn't want them to forget Babe Ruth, but I also didn't want them to forget Hank Aaron."

—Hank Aaron, 2017

Atlanta Braves great Hank Aaron relaxes in the dugout at Chicago's Wrigley Field, circa 1973. Chasing the sport's most sacred record—Babe Ruth's 714 home runs—throughout the early 1970s, Aaron endured pressures that would have crippled most athletes. But "Hammerin' Hank" met every challenge, and when he hit No. 715 in 1974, he was baseball's unquestioned home run king. While his 755 long balls have been surpassed, Aaron's unrelenting consistency is still the standard by which all players are judged.

Photograph by Don Sparks

"It is clear that Major League Baseball and the union both see the value of access [for the media] and have said as much. For baseball, there is a historic connection between the game and the people who tell its story that has allowed both industries to thrive, grow, excel."

—Sportswriter Derrick Goold, 2016

Baseball writer Fred Lieb talks to Yankees manager Miller Huggins, circa 1925. The longstanding and mutually beneficial relationship between the media and the sport—whether made through an interview in the clubhouse or a Zoom video conference—has helped grow the game. With access consistently referred to as the lifeblood of good journalism, and with baseball being a day-to-day sport, building relationships with players, managers, and coaches has always been crucial to the media's success.

Photograph by Charles M. Conlon

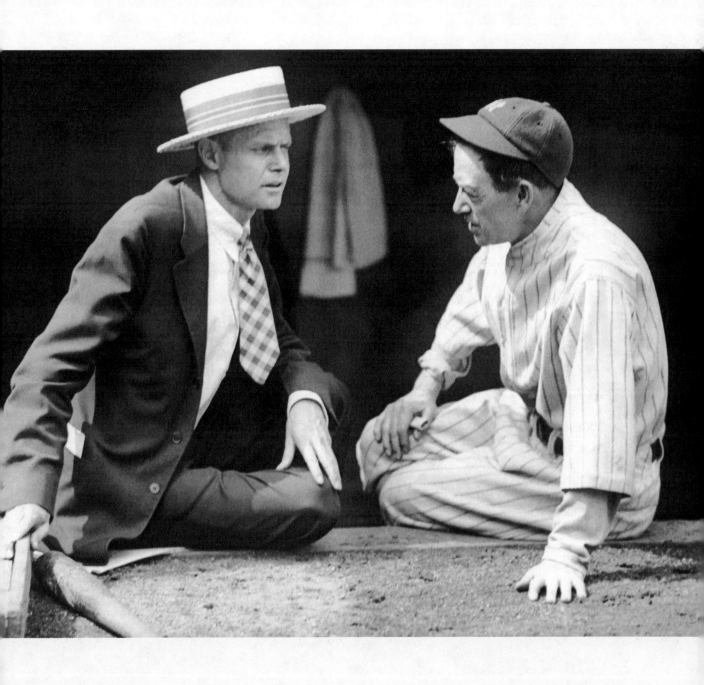

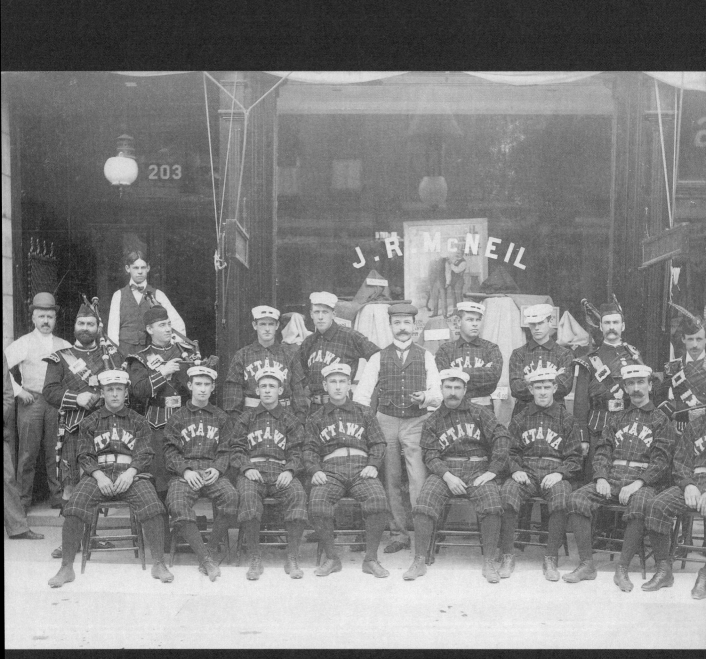

"Baseball Monday was ushered in with a grand flourish of bagpipes, the home team wearing for the first time their new uniforms presented to them by Mr. McNeil, the tailor. The gathering of the Clans took place at the Grand Union Hotel from whence a march started, first to Mr. McNeil's, where they were photographed, and thence to the Metropolitan grounds."

—*The Ottawa (Ontario) Citizen*, August 2, 1898

The Eastern League Ottawa baseball club poses in front of J.R. McNeil's tailor shop in downtown Ottawa, Ontario, August 1, 1898. After the club's midseason relocation from Rochester, New York, Scottish tailor and baseball fan James McNeil welcomed the players by outfitting them with one-of-a-kind tartan uniforms. The pattern they wore (the same as seen on the tailor's vest) is none other than the green, blue, and red design of the McNeil family tartan.

"I was really just a spoke in the wheel of the success that we had some 25 years ago."

—Jackie Robinson, discussing the integration of baseball, 1972

In 1946, Dodgers General Manager Branch Rickey (left) and National League President Ford Frick stare out at Ebbets Field, with not a person of color on the diamond. A year later, the pair worked to rectify that injustice when they brought Jackie Robinson to the majors. Rickey signed the former UCLA star athlete in the fall of 1945 and assigned him to the Dodgers in 1947. With Frick clearing the way for Robinson to be named to the Brooklyn roster, history was made.

Photographer unidentified

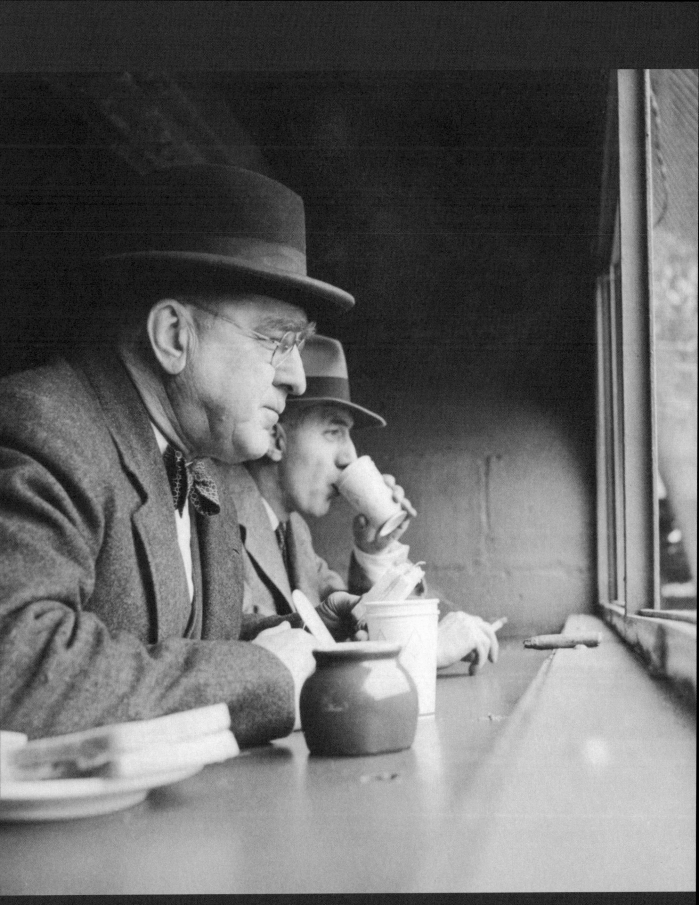

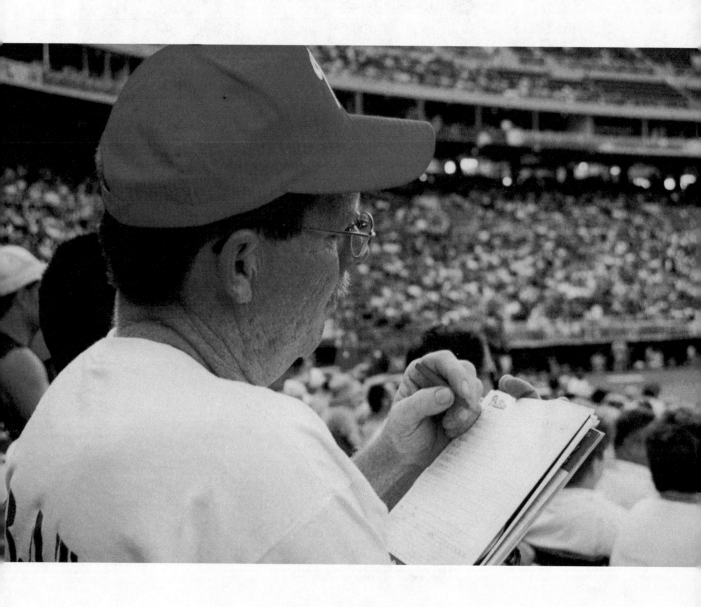

"You can keep score in sports such as basketball, bowling, or golf, but it amounts to little more than marking down numbers.... Scorekeeping in baseball, however, is an art form, individual expression that makes you feel you are part of the game. It personally and precisely records every moment of the game, allowing you to replay and relive it forever."

—Sportswriter Jim Caple, *ESPN* website, August 29, 2013

A fan goes "old school" and diligently keeps score at Philadelphia's Veterans Stadium in July of 2001. By recording the play-by-play with a time-honored set of codes, symbols, and unique annotations, a scorekeeper not only documents what happens during the game—he or she becomes *part* of the game. An old scorecard is like a window to the past that allows one to revisit a special ballpark experience.

Photograph by Milo Stewart Jr.

"He had about him the touch of royalty."

—Baseball Commissioner Bowie Kuhn on Roberto Clemente, 1973

Roberto Clemente looks back for a sign from the third base coach as he prepares to bat against the Chicago Cubs at Wrigley Field on August 21, 1963. Lavished with affection by some and showered with racist criticism by others, Roberto Clemente endured intense scrutiny from the press during his playing career. The four-time National League batting champion was labeled everything from ignorant to arrogant, but those who knew him best saw an incomparable baseball talent and a proud and generous Puerto Rican man.

Photograph by Don Sparks

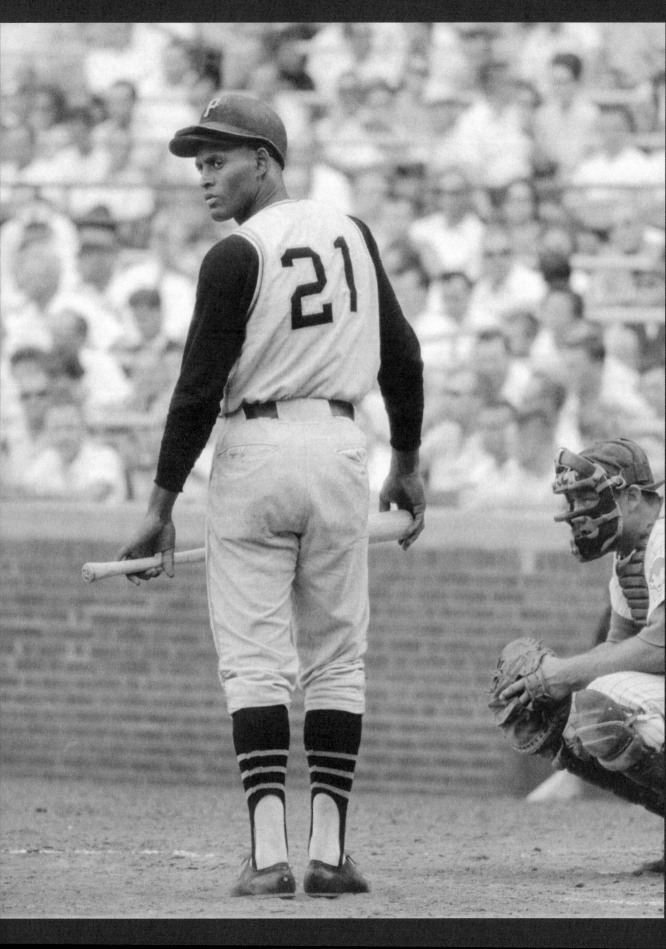

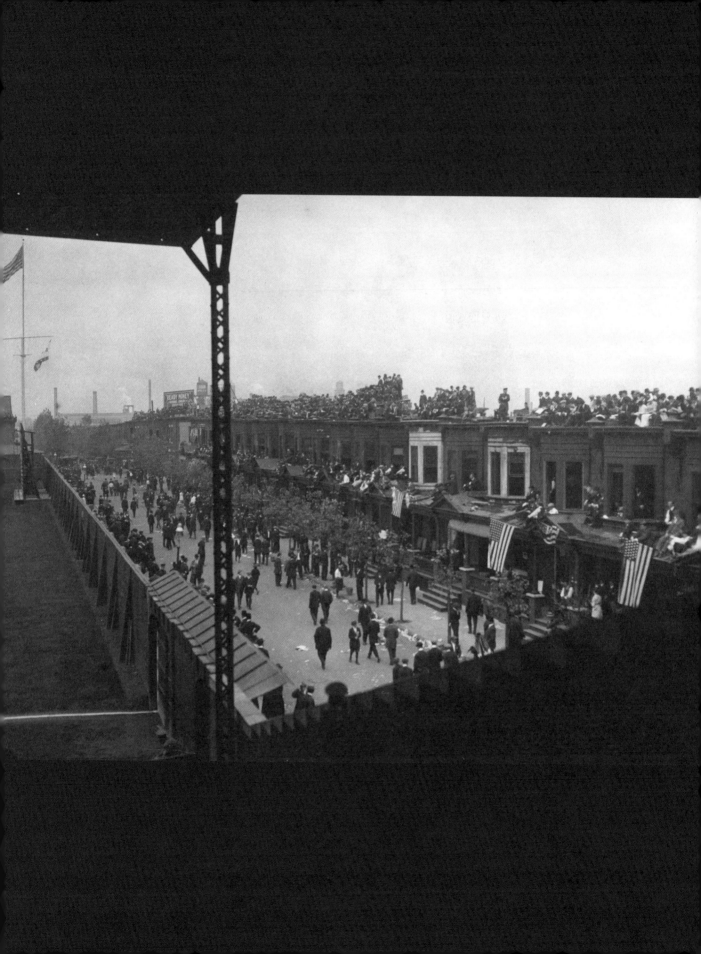

"The 20,000 spectators, who paid admission to the grounds, and the 5,000 more, who populated the housetops and porch roofs on Somerset and 20th streets, witnessed one of the greatest twirling battles ever staged in a World's Series."

—*The Philadelphia Inquirer*, October 9, 1913

With Philadelphia's Shibe Park sold out for Game Two of the 1913 World Series, fans roost atop houses on North 20th Street, just beyond the park's right field wall. From their vantage point outside the grounds, Philadelphia fans witnessed a 10-inning masterpiece, with New York Giants pitcher Christy Mathewson emerging victorious over the Athletics' Eddie Plank, as both future Hall of Famers went the distance.

Photograph by Charles M. Conlon

"The danger in writing about Jim Thorpe is that the chronicler finds himself losing all restraint in an unavoidable tangle of superlatives. Yet there is almost no other way to describe the man and still do justice to him."

—Sportswriter Arthur Daley, *The New York Times*, March 31, 1953

O n April 10, 1913, two months after signing his first big league contract, Jim Thorpe solemnly stares ahead as his New York Giants open the season at the Polo Grounds. The Native American athlete twice captured gold in the 1912 Olympic Games but was stripped of his medals when it was discovered that he had previously played minor league baseball and thus was not an amateur. Seventy years later, the International Olympic Committee posthumously reinstated his Olympic titles.

Photographer unidentified

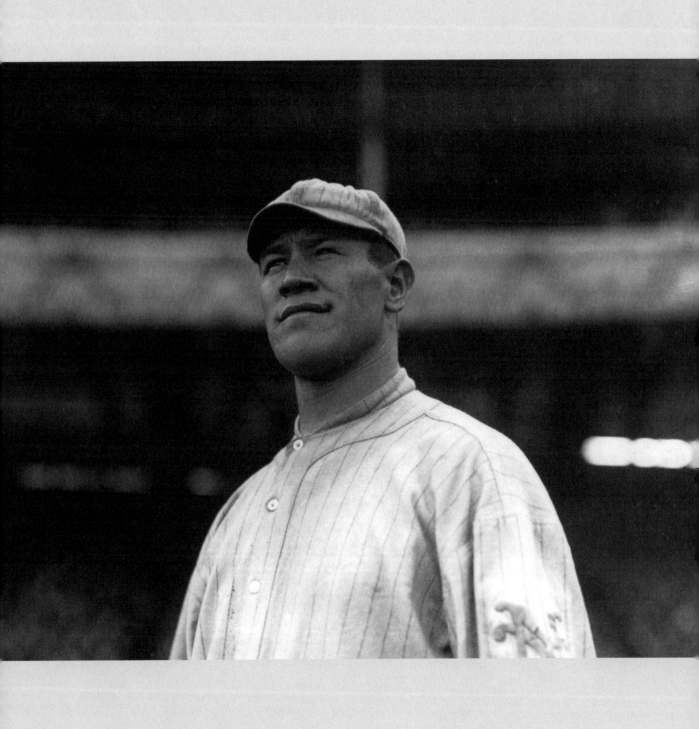

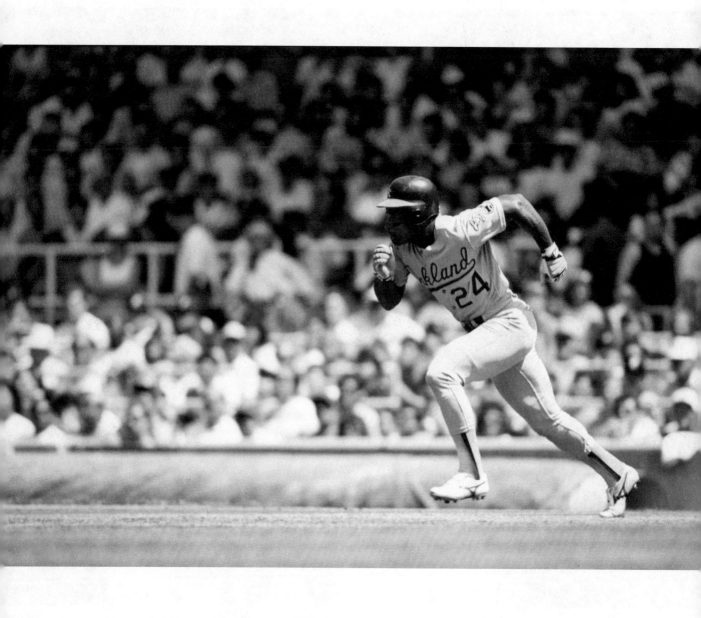

"You have to keep running. I always believed I was going to be safe."

—Rickey Henderson, 2006

As he had done thousands upon thousands of times during his 25-year major league career, Rickey Henderson shows off his explosive base running, circa 1990. No player swiped more bags than Rickey; the superstar amassed 1,406 stolen bases. Since bases are set 90 feet apart, Henderson ran nearly 24 miles on steals alone, almost completing a marathon sliding headfirst after every 13 steps.

Freezing the Action

Changes in camera technology have transformed baseball photography over time. Faster cameras and more powerful lenses have allowed photographers to move out of their studios, onto the playing field, and ultimately into special boxes and pits. Ron Vesely of the Chicago White Sox and other contemporary action photographers use digital cameras with extremely fast shutter speeds and very sensitive light sensors to freeze the action, capturing the intensity of a moment in the smallest fraction of a second.

Photograph by Ron Vesely

to spend time on a major league diamond, watch the top players in the game, and learn how to play ball from a bona fide expert. While some manage to follow in their father's footsteps, others, such as Rube Jr., forego a life in baseball.

Photographer unidentified

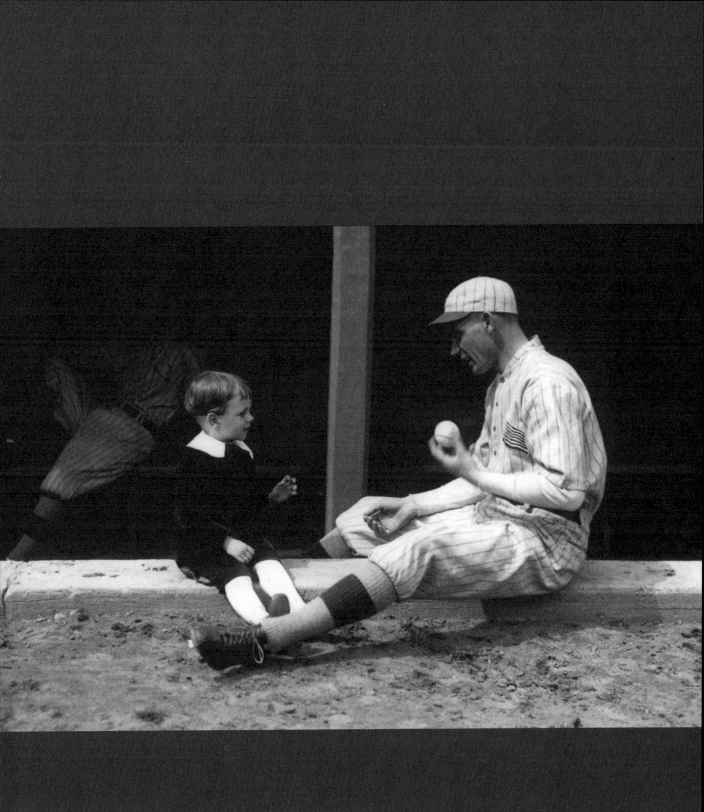

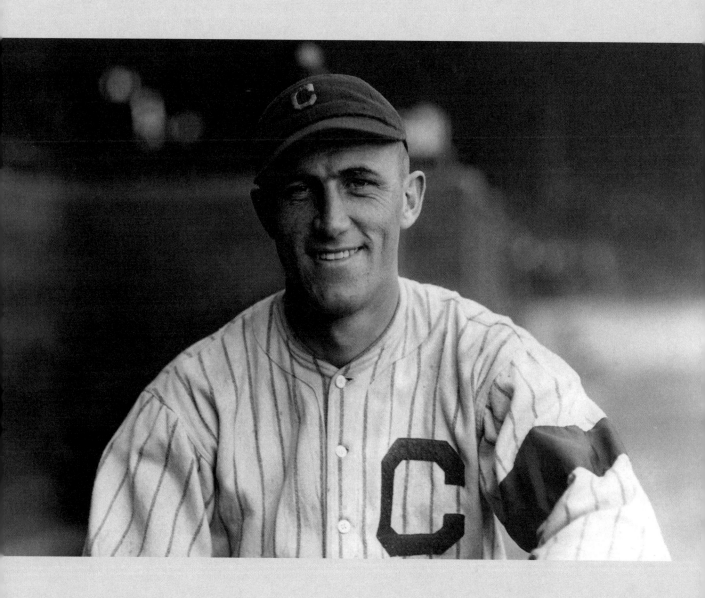

"Then, as I approached the dugout, it began to dawn on them what they had just seen, and the cheering started and quickly got louder and louder and louder. By the time I got to the bench it was bedlam, straw hats flying onto the field, people yelling themselves hoarse, my teammates pounding me on the back."

—Bill Wambsganss, 1920

Bill Wambsganss smiles, looking every bit the hero, in 1920. That October, the Cleveland second baseman gained a measure of baseball fame by achieving the rarest of plays on the biggest of stages. During the fifth inning of Game Five of the World Series, with no outs and Dodgers runners on first and second, "Wamby" snared the batter's line drive, touched second base for the second out, and tagged the runner from first to record the only unassisted triple play in Fall Classic history.

Photograph by Louis Van Oeyen

**"I have discovered in 20 years
of moving around a ballpark that the
knowledge of the game is usually
in inverse proportion to the price
of the seats."**

—Bill Veeck, 1962

Typically shunning a necktie, Bill Veeck, owner of the American
Association's Milwaukee Brewers, sits with fans in the stands at
Borchert Field in 1943. Always focused on the fan experience, it was Veeck
who later hired the three-foot-seven Eddie Gaedel to bat for his St. Louis
Browns, let fans manage the club on "Grandstand Manager Night," and
unveiled Comiskey Park's spectacular exploding scoreboard. As noted
on his Hall of Fame plaque, Veeck was "a champion of the little guy."

Photographer unidentified

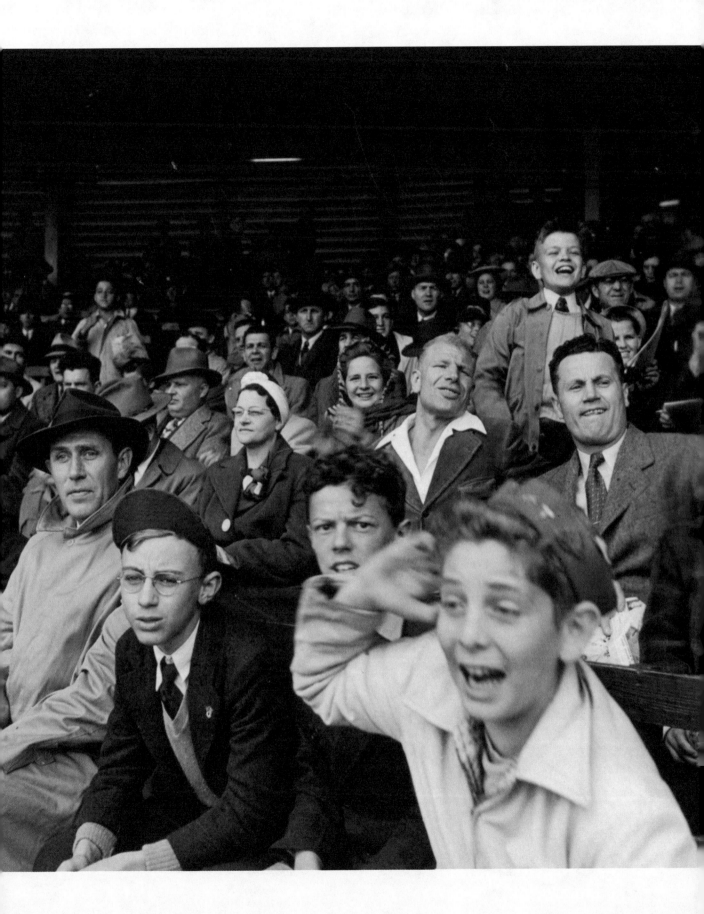

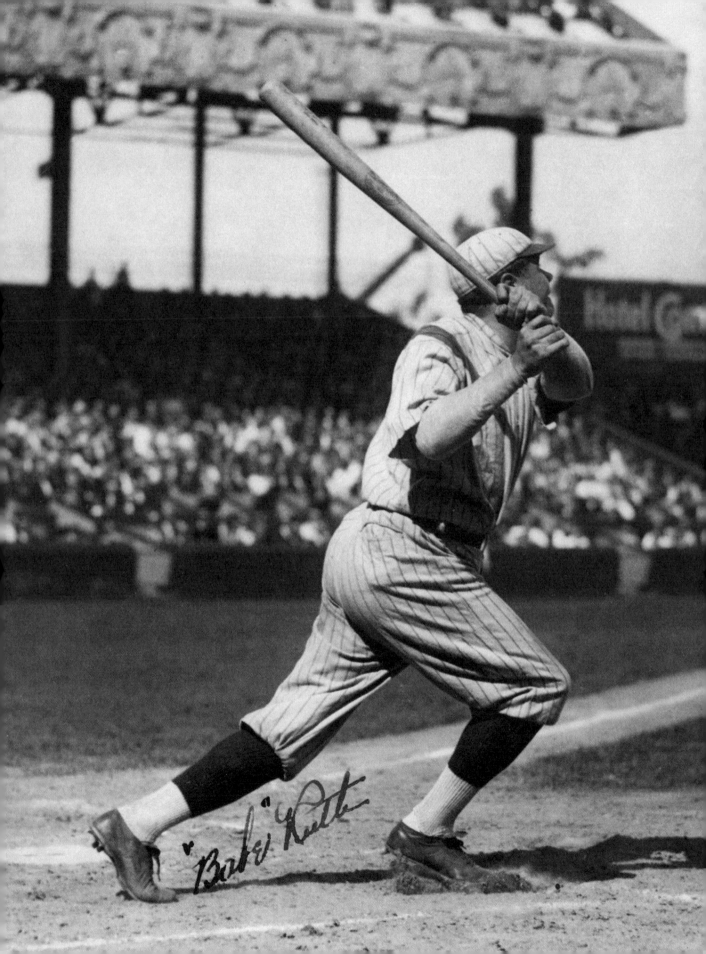

"I pick a good one and sock it. I get back to the dugout and they ask me what it was I hit, and I tell 'em I don't know except it looked good."

—Babe Ruth, 1928

On June 14, 1921, Babe Ruth blasts a home run an estimated 470 feet to center field at New York's Polo Grounds. Combining scale, light, and texture in a stunning composition, the photographer captured the unmistakably Ruthian follow-through to perfection. The repetitive slope of the grandstand seats, the Babe's bat, and his thigh intersect in stark contrast with the vertical beams of the stadium. The strong parallel lines and Ruth's upward gaze intensify the dynamic scene.

Photographer unidentified

" 'I'm the best bunter I've ever seen,'
Ashburn told us. That was Whitey.
He believed he was the best bunter,
and he probably was."

—Former Phillies player John Kruk, 1997

During spring training in 1952, Phillies center fielder Richie Ashburn drops down a perfect bunt along the third base foul line at Clearwater Athletic Field. Ashburn—quite possibly the fastest player in the National League at the time—was a master of the craft, recording double-digit totals for sacrifice bunts each year from 1950 to 1954. And from 1951 to 1958, "Whitey" (so nicknamed because of his shining blond hair) led the league four times in singles, hundreds of which were of the infield variety.

Photograph by Arthur Rothstein

Spalding American Base Ball Party. Chicago vs. all America.
at the Sphinx Feby 9 - 1889.

P. Sebah

"After visiting the big Pyramids and the Sphinx, and having our pictures taken in connection with these wonders of the world, we passed down to the hard sands of the desert where a diamond had been laid out, and where, in the presence of fully a thousand people ... we began the first and only game of ball that the great sentinels of the desert ever looked down upon."

—Former player Adrian "Cap" Anson, 1900

Visiting Egypt in the midst of their around-the-world ball-playing exhibition, tour organizers and baseball players climb the Sphinx for a group photograph on February 9, 1889. The ambitious tour, organized by sporting goods magnate and former pitcher Albert Spalding, was equal parts missionary expedition, goodwill journey, and sales junket, serving to spread the gospel of baseball over five continents in six months.

Photograph by Jean Pascal Sébah

"I think people believe what I say.
I have a long way to go. But I am going
to learn. I'm a long way from my peak
level as an announcer."

—Tony Conigliaro, 1980

Former big league slugger Tony Conigliaro, working for San Francisco
television station KRON, interviews New York Yankees star
Reggie Jackson at Oakland-Alameda County Coliseum before a game in 1980.
Joe Garagiola, Bob Uecker, Tony Kubek, Phil Rizzuto, Dizzy Dean, Ralph Kiner,
and Tim McCarver are just a few of those who have reinvented themselves and
successfully made the baseball-player-turned-broadcaster transition.
Indeed, for many, it is often forgotten that they once roamed the diamond.

Photograph by Doug McWilliams

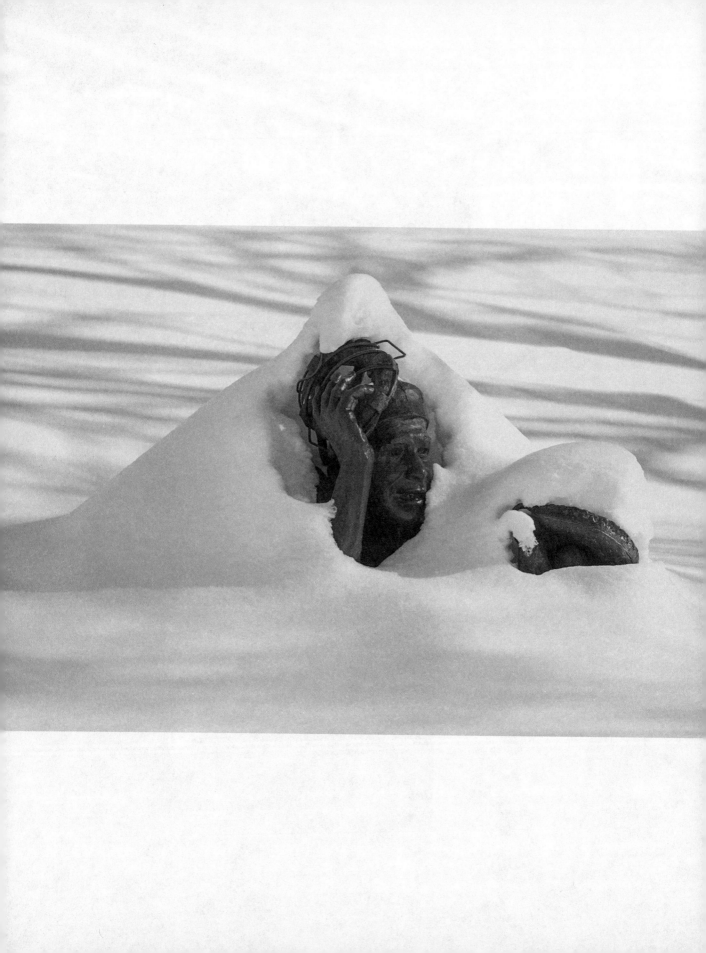

"You have to be a man to be a big league ballplayer, but you have to have a lot of little boy in you, too."

—Roy Campanella, 1955

In the sculpture garden of the National Baseball Hall of Fame and Museum squats a bronze, life-sized figure of Brooklyn's great catcher Roy Campanella, seen here in 2003. Every spring, artist Stanley Bleifeld's sculpture of Campy "reports for duty," emerging from the deep winter snows of upstate New York and announcing the arrival of a new baseball season.

Photograph by Milo Stewart Jr.

"After the New-Yorks had practiced a few minutes a photographer came on the grounds with his camera.... He was compelled to take several plates, and the delay was annoying to the spectators, and they gave evidence of their feelings by shouting at the gentleman who had charge of the camera. 'Three strikes, photographer's out,' yelled one impatient fellow."

—*The New York Times*, April 30, 1886

On April 29, 1886, Boston and New York's National League clubs pose together for an opening day photograph at the Polo Grounds. Conspicuous among the grouping, dressed in his Sunday best (it was Thursday) and with his broad mustache neatly waxed, sat New York manager Jim Mutrie. Known sarcastically as "Truthful James," it was Mutrie who would later falsely claim to have dubbed his club the "Giants" that very season, when in fact it was the sporting press that had first used the nickname the prior year.

Photograph by Frederick L. Howe

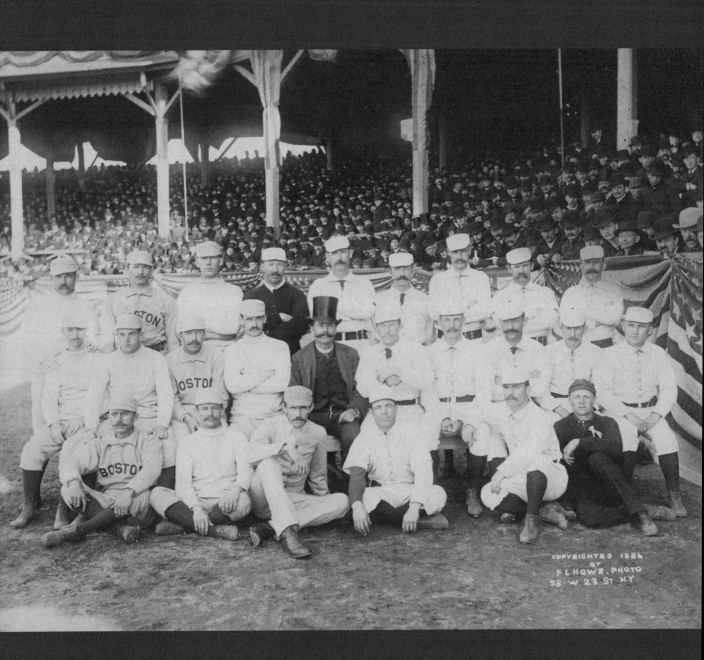

COPYRIGHTED 1886
BY
F.L. HOWE. PHOTO
58 W 23 ST N.Y

"You don't have to be seven feet tall; you don't have to be a certain size to play."

—Shortstop Derek Jeter, 2007

Diminutive New York Giants pitcher Dinty Gearin (five-foot-four) and lanky catcher Hank Gowdy (six-foot-two) still manage to see eye to eye at the Polo Grounds in 1924. In baseball, it has long been the combination of exceptional athletic ability and incomparable skills—not height or weight—that determines a player's success. Just ask Houston's five-foot-six José Altuve, who edged six-foot-seven Aaron Judge of the Yankees to capture the 2017 American League Most Valuable Player Award.

Photograph by Charles M. Conlon

"Always give an autograph when somebody asks you. You never can tell. In baseball anything can happen."

—Dodgers manager Tommy Lasorda in *Five Seasons: A Baseball Companion* by Roger Angell, 1977

L eaning back against the dugout wall at Brooklyn's Ebbets Field, Jackie Robinson adds his name to a Dodgers team-signed baseball, circa 1954. Autographing balls is a longstanding tradition in baseball, helping make and sustain a personal connection between players and fans. Still, the drudgery of signing dozens upon dozens of balls can be difficult to endure. At times, it was not uncommon for relief to come in the form of clubhouse employees doing the actual signing for big name players.

Photograph by Osvaldo Salas

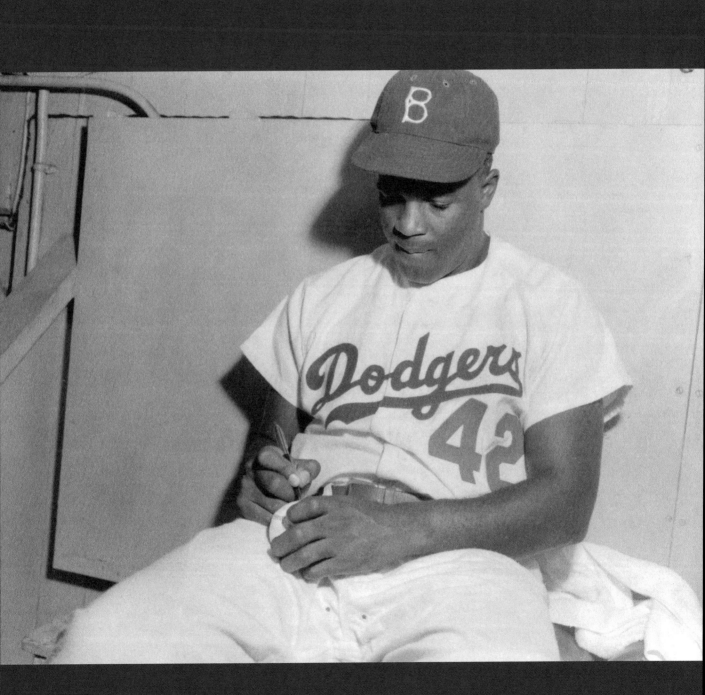

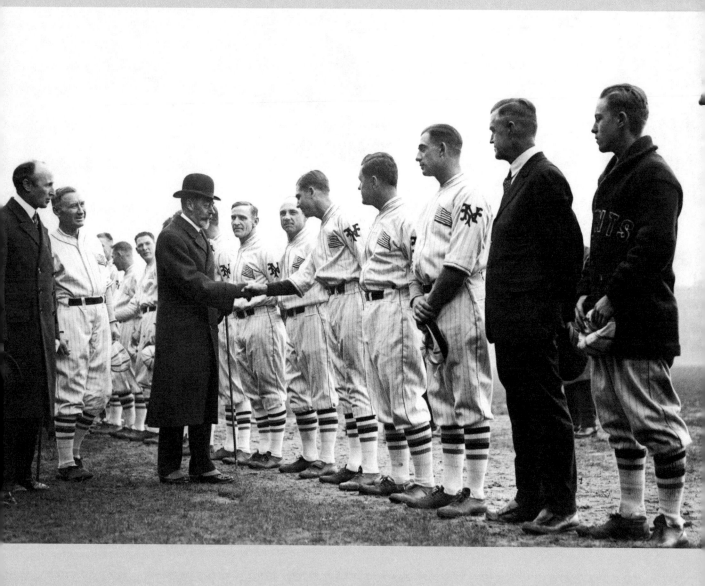

"The royal guests saw a game that was a hard-hitting affair, with frequent smashes into the bleachers which surrounded the grounds."

—*The Toronto Globe*, November 7, 1924

Making his way down the New York Giants lineup, King George V of England shakes hands with shortstop Travis Jackson before the club faces off against the Chicago White Sox at Stamford Bridge grounds on November 6, 1924. The king, along with Queen Mary, the Prince of Wales, and Prince Henry, watched from a box directly behind home plate as the Giants defeated the White Sox, 8-5, in a game played during the clubs' European Tour that fall.

Photographer unidentified

With war raging in Europe and just weeks before crossing the Atlantic for France, Camp Lee's 319th Regiment baseball team poses with the semi-pro Graybers at a Red Cross benefit game near Pittsburgh on April 28, 1918. Several months later, the regiment saw action in the Battle of the Argonne Forest, part of the largest and deadliest offensive that ultimately brought World War I to an end.

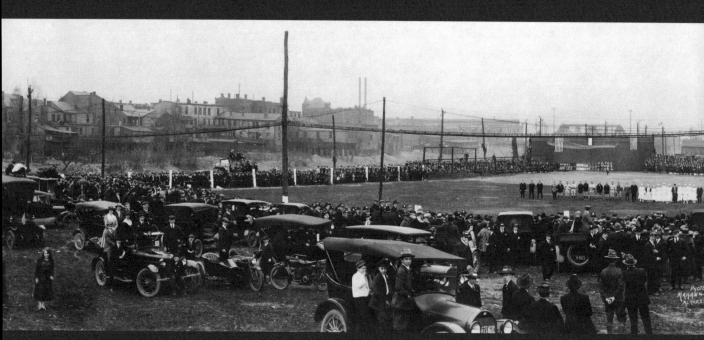

pulled hard for the Camp Lee boys to win, but their cheering and encouragement were to no avail, as Baron Knetzer, former pitcher for the Pittsburg [sic] Federal league team, had plenty of smoke on the ball, and excellent control, which proved the undoing of the boys who are soon to go 'over there.' "

—*The Pittsburgh Press*, April 29, 1918

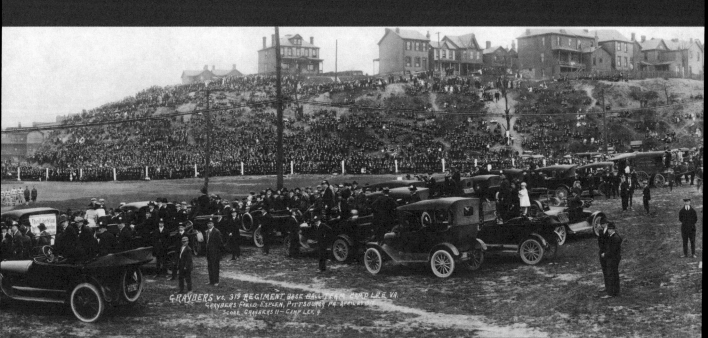

GRAYBERS vs. 319 REGIMENT BASE BALL TEAM CAMP LEE VA.
GRAYBERS FIELD ESPLEN, PITTSBURGH PA APRIL 27 1918
SCORE GRAYBERS 11 — CAMP LEE 4

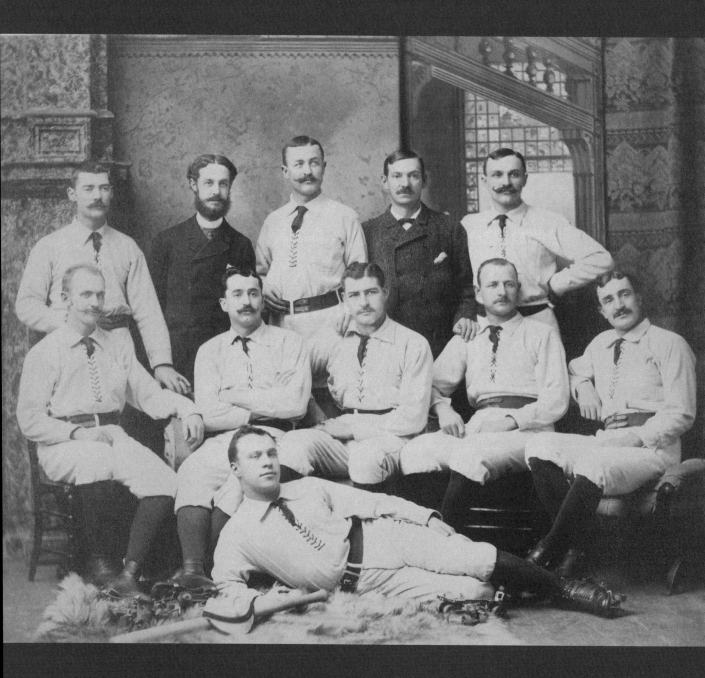

"Men fall when they throw the ball, fall when they make a catch or a pick-up, and fall when they want to stop on a base. Base ball on roller skates is therefore a game of falls."

—*Sporting Life*, November 4, 1885

Members of the Princess League Base Ball Club, billed as the "first professional team on rollers," gather together in 1885. Baseball on roller skates may sound absurd, but in the mid-1880s, the unlikely combination was a popular offseason pastime. Featuring several men who played (regular) baseball for the National League's Detroit Wolverines, including Hall of Famer Ned Hanlon (middle row, second from left), this club took its name from the recently opened Princess Rink in Detroit, Michigan.

Photographer unidentified

"The foot ball has been put aside and base ball is taking its place.... A good start has been made toward getting equipments [sic], and every pleasant Monday afternoon finds the two nines testing each other's powers on the base ball field."

—The Southern Workman and Hampton School Record,
January 1899

Black and Native American members of Hampton Normal Institute's intercollegiate baseball team proudly display their oversized championship pennant, circa 1911. Founded in 1868, the school (now known as Hampton University in Hampton, Virginia) was a traditionally Black institution, but accepted Native Americans, giving rise to both segregated and integrated activities for the students.

Photograph by Christopher E. Cheyne

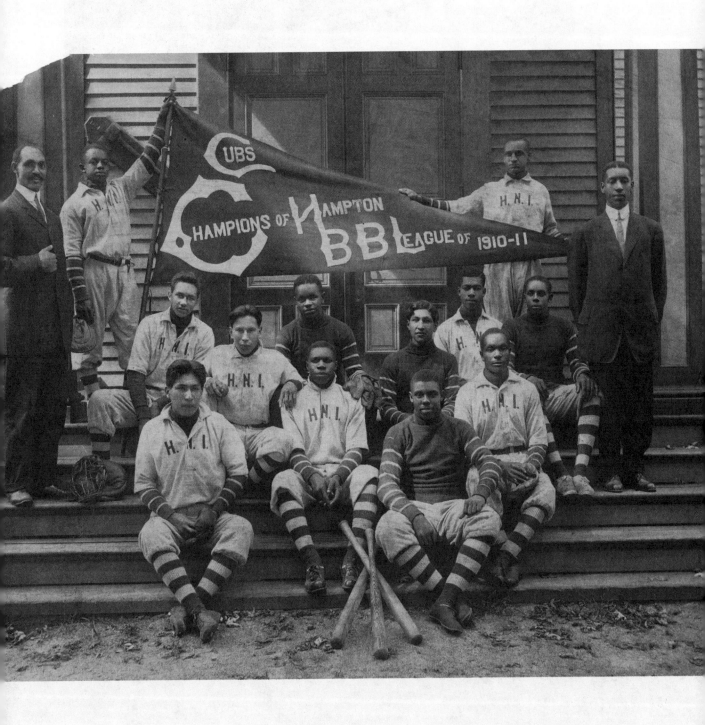

"A man has to have goals—for a day,
for a lifetime—and that was mine,
to have people say, 'There goes
Ted Williams, the greatest hitter
who ever lived.'"

—Ted Williams, 1970

Ted Williams demonstrates his impeccable batting form in the clubhouse, circa 1942. The San Diego native set out to become the greatest hitter who ever lived, and he had a head start thanks to a physique perfectly designed to hit a baseball. Swinging from the left side, the lanky Williams utilized his long legs to create a whip action. This, combined with an unquenchable obsession with studying and perfecting his craft, enabled him to achieve his goal.

Photograph by Frank Bauman

" [Dick Allen is] having the greatest individual year of any player I've played with or seen. And I've played with Hank Aaron, Eddie Mathews, Joe Adcock, Ernie Banks, Minnie Miñoso, and guys of that nature."

—White Sox manager Chuck Tanner, 1972

White Sox slugger Dick Allen relaxes in the dugout at Chicago's Comiskey Park during the 1972 season, arguably the finest of his 15-year major league career. After playing for three big league clubs in the prior three seasons, one of the game's most feared hitters had a tarnished reputation. But in 1972, Allen enthralled Windy City fans with an American League Most Valuable Player Award, thanks to league-leading marks of 37 home runs, 113 RBI, and a .603 slugging percentage.

"Take your camera out to the ball game, and you'll both have fun."

—Photography writer Erwin Bach, *The Chicago Tribune*, June 20, 1979

A rmed with their cameras, baseball fans Millie Bosworth and Henrietta Hornbostel take photos prior to the All-Star Game at Chicago's Wrigley Field on July 30, 1962. At the time, the rise of the amateur photographer was well underway. Gone were the days of laborious, pricey, and cumbersome photo equipment. The personal camera had democratized the medium, and photo enthusiasts proliferated. Today, our smartphones offer us instant gratification as we document everything at the ballpark from players to food to family and friends.

"I gave my life to the game. And the game gave me everything."

—Orestes "Minnie" Miñoso, 1993

Minnie Miñoso, the first Black athlete to play for the White Sox, kneels on the grass at Chicago's Comiskey Park on August 29, 1951. Adored by his many fans, "The Cuban Comet" began his career with local industrial teams in his home country. Miñoso went on to play in the Negro National League, the American League, the National League, the Mexican League, and various minor leagues, leaving his mark on the varied landscape of the game as a player and coach.

Photograph by Robert Lerner

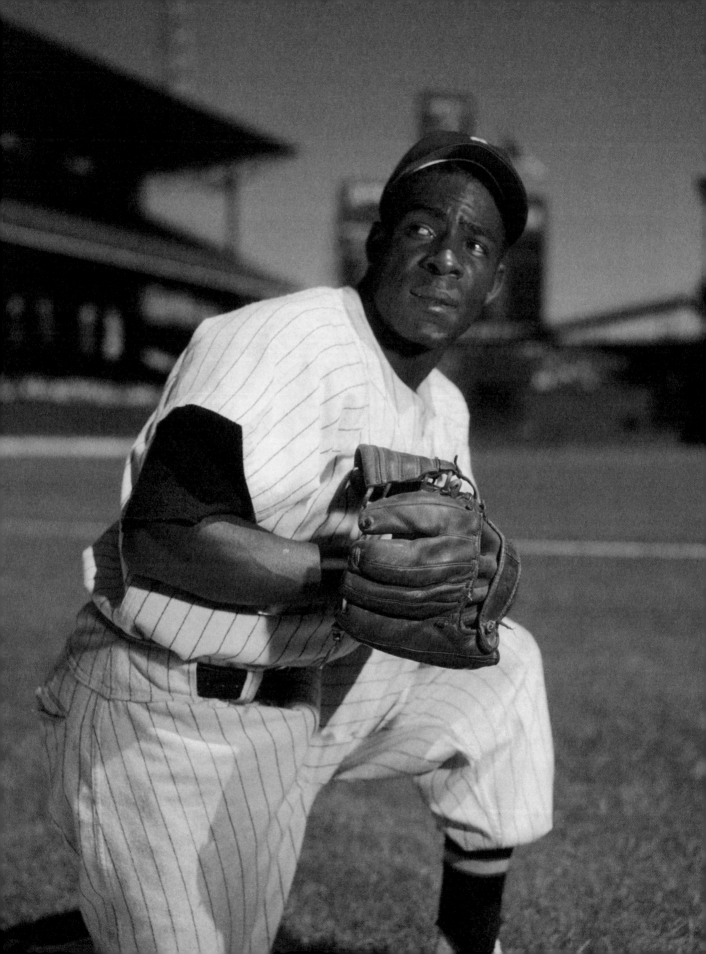

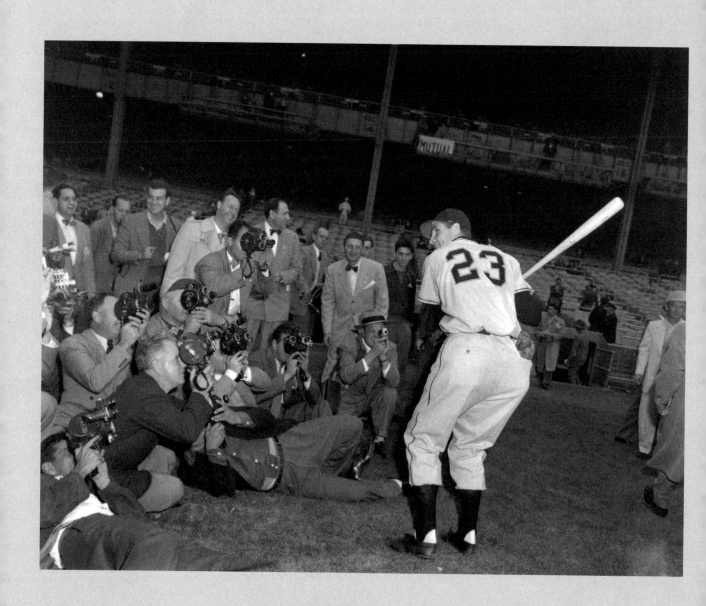

"I didn't run around the bases— I rode around 'em on a cloud."

—Bobby Thomson, October 4, 1951

Prior to the start of the 1951 World Series, and just one day after hitting arguably the most famous home run in baseball history, New York Giants hero Bobby Thomson reenacts his now famous swing for a bevy of cameramen at Yankee Stadium. On October 3, Thomson hit a three-run, walk-off, ninth-inning homer—forever to be known as "The Shot Heard 'Round the World"—off Brooklyn's Ralph Branca to give his team a 5-4 win and the National League pennant.

Photograph by Osvaldo Salas

"Every citizen of this country who is blessed with organs of vision knows that whenever the elements are favorable and wherever grounds are available, the great American game is in progress, whether in city, village, or hamlet, east, west, north, or south."

—Albert Spalding, 1911

A group of eleven ball players pose for the camera in Seattle, circa 1915. Some photographs tell a detailed story, while others remain a mystery. Just who these young men and women were, what clubs they played for, and why, when, and exactly where they took the field is unclear. What is clear is that they played baseball and they wished to have their picture taken. They succeeded on both accounts.

Photographer unidentified

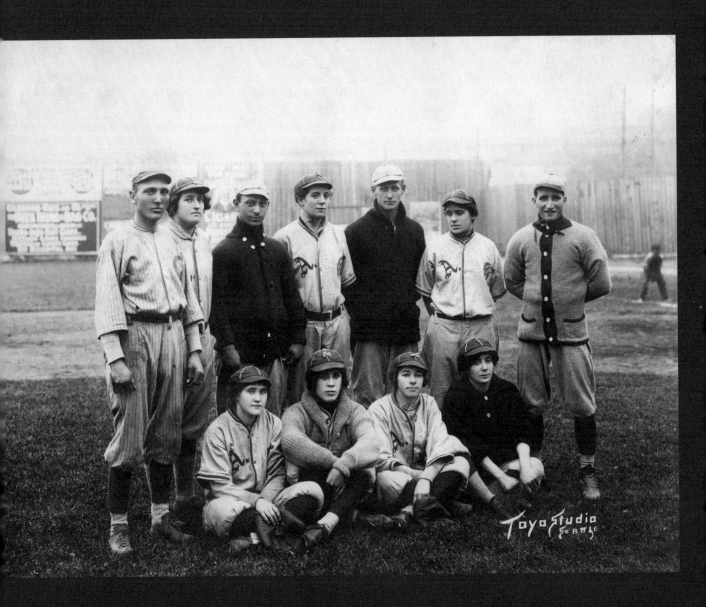

Index

About the National Baseball Hall of Fame and Museum

The National Baseball Hall of Fame and Museum is an independent not-for-profit educational institution, dedicated to fostering an appreciation of the historical development of baseball and its impact on our culture by collecting, preserving, exhibiting, and interpreting its collections for a global audience as well as honoring those who have made outstanding contributions to our National Pastime. Opening its doors for the first time on June 12, 1939, the Hall of Fame has stood as the definitive repository of the game's treasures and as a symbol of the most profound individual honor bestowed on an athlete. It is every fan's "Field of Dreams," with its stories, legends, and magic shared from generation to generation.

Mango Publishing, established in 2014, publishes an eclectic list of books by diverse authors—both new and established voices—on topics ranging from business, personal growth, women's empowerment, LGBTQ studies, health, and spirituality to history, popular culture, time management, decluttering, lifestyle, mental wellness, aging, and sustainable living. We were recently named 2019 *and* 2020's #1 fastest growing independent publisher by *Publishers Weekly*. Our success is driven by our main goal, which is to publish high quality books that will entertain readers as well as make a positive difference in their lives.

Our readers are our most important resource; we value your input, suggestions, and ideas. We'd love to hear from you—after all, we are publishing books for you!

Please stay in touch with us and follow us at:

Facebook: Mango Publishing
Twitter: @MangoPublishing
Instagram: @MangoPublishing
LinkedIn: Mango Publishing
Pinterest: Mango Publishing
Newsletter: mangopublishinggroup.com/newsletter

Join us on Mango's journey to reinvent publishing, one book at a time.